TO THE RESCUE
OF ART

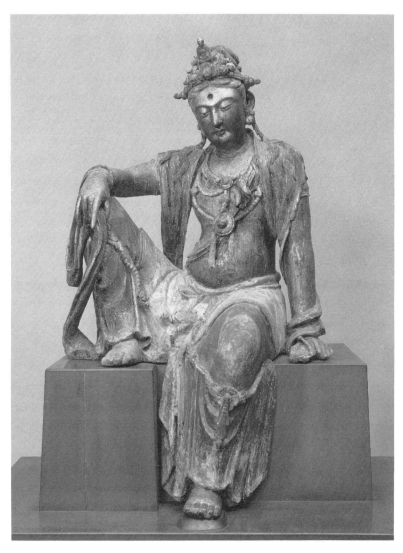

Bodhisattva Kuan-Yin. Twelfth century. Chinese. Boston Museum of Fine Arts.

TO THE RESCUE OF ART

OF ART

TWENTY-SIX ESSAYS

RUDOLF ARNHEIM

UNIVERSITY OF CALIFORNIA PRESS

BERKELEY · LOS ANGELES · OXFORD

University of California Press
Berkeley and Los Angeles, California
University of California Press, Ltd.
Oxford, England
©1992 by
The Regents of the University of California

Library of Congress Cataloging-in-Publication Data

Arnheim, Rudolf.
To the rescue of art: twenty-six essays / by Rudolf Arnheim.
p. cm.
Includes bibliographical references and index.
ISBN 0-520-07458-0 (cloth).—ISBN 0-520-07459-9 (paper)
1. Art. I. Title.
N7425.A64 1992

700—dc20

91-9038 CIP

Printed in the United States of America
1 2 3 4 5 6 7 8 9

CONTENTS

IV

V

VI

INTRODUCTION

Have the arts ever before been in need of rescue? Yes, of course, you might say. Works of art as material objects have required protection from floods and earthquakes, from human violence, greed, and thoughtless neglect. The heads of statues have been chopped off by fanatics, and in our own time industrial pollution has erased the faces of ancient marble figures. Selfish princes, both secular and ecclesiastic, and profit-seeking dealers have forced the hands of their artists, and narrow standards of what is considered beautiful, correct, and well mannered have almost routinely delayed the acceptance of bold achievements. Even so, art as such, art as an indispensable component of human nature and functioning, has never been in doubt. It has survived in any kind of society, in prisons, and on the islands of the shipwrecked. Only when the existence of art as such seems to be questioned and endangered do we truly have to worry. *yes*

We have reasons to admire what we know about cultures, mostly early cultures, whose objects of utility and ritual we preserve and cherish in our ethnic museums. We recognize these tools and decorations as art, and we have a good idea of the social and psychological conditions that account for their high quality. These art objects are indispensable aspects of the beliefs that govern a community as a whole, not just select individuals. They are inspired by shared ideas about nature, about life and death, and about the powers that control human existence. And whatever shape is given to buildings and crafts is guided by an intuitive sense of economy, propor-tion, and harmony. *doesn't always work or is present.*

A similar natural sense of beauty distinguishes the simple artwork of our own children. At the highest level we find it also in our best artists. But the great artists are exceptions, few in number, and it seems fair to observe that in our time the true achievers have succeeded mostly in the face of

vii

unfavorable conditions. Some of the obstacles are educational. The spontaneous quality of our children's imagination is often neglected in the schools or mistreated by pedagogical dogmatism. Many of the same difficulties have also hampered the training of artists. More fundamentally, however, and perhaps more importantly, our civilization seems to suffer from a lack of the fertile soil, a lack of the propitious disposition of the mind that promotes the happy sprouting of the arts in the early cultures I referred to.

We must not be deceived by the unparalleled number of art galleries, museums, and art schools in our present setting, by the astonishing number of professional artists and the absurdly high prices paid for prestigious works of art. We observe at the same time an unmistakable fatigue, a lack of discipline and responsibility. The weakness shows in the design of many of our buildings, our furnishings, and our garments. As its least attractive symptoms we notice an unbridled extravagance, a vulgarity of taste, and a triviality of thought. There is too much readiness to make do with too little, to be satisfied short of the ultimate effort, without the engagement of the full resources that used to be the *conditio sine qua non* of respectable art. The insufficiency shows up in the poor level of much of the work produced and the low standard of what is critically accepted in the mass media.

In a broader context, this decline in the practice of the arts goes with a fin de siècle mood in the general culture. I am reminded of a joke that circulated a few years ago about someone saying, "God is dead, Art is dead, and I myself do not feel very peppy!" We are shown that modern civilization is undermining the conditions of its own survival. We listen to a biologist proclaiming that natural science is coming to an end because it has already solved all its problems. In a similar eschatological vein, a political theorist asserts that democracy has overcome all its difficulties so that nothing remains to be done but to wait for the millennium. And we smile at a hasty philosopher who assures his disciples that art is about to be replaced with philosophy. *yeah sure !*

Low tides of culture come and go, with the arts as one of their components, and there is no way of telling whether the future will bring an upswing or a continuing depression. Nor is there much anybody can do to influence the course of events for the better. But there is an area in which important effects can be obtained and in which such an exertion is urgently needed. It is the area to which my own work has aspired and to which the present selection of essays applies. By temperament, I have not been much of a polemicist, although the present situation in the arts and more particularly the nihilistic attitude prevailing in the philosophy and theory of

the arts have increasingly alarmed me. The closest to an explicit protest comes in the opening essay, "In Favor of Confrontation." But this call for action ends somewhat abruptly, without spelling out the manner in which art is to be rescued.

What needs to be done, it seems to me, is to revive and explore the principles on which all productive functioning of the arts is based. If one believes that art is indispensable as a psychological and, indeed, as a biological condition of human existence, it must be assumed to grow from the very roots of our being. These roots must be traceable. The interpreters devoted to this task must also be heralds of the principles they are retrieving—an obligation of which they must be constantly aware. They must be convinced that those objective principles exist, and even though their concern in any particular case may be quite specific, they must not be distracted by the many accidentals of convention, fashion, and deviant motivation that camouflage the essential base. We cannot afford to avoid discussing what constitutes the true core of art by focusing instead on social determinants or esoteric theory. It is comparatively easy, although not irrelevant, to talk about the historical derivations of a style or the economics of a period. It is much harder to deal with the primary conditions that distinguish art as art. Speaking for myself, I confess to be thoroughly uninterested in such current notions as modernism, premodernism, or postmodernism. They are products of the myopia generated by the *faits divers* of the day, which look to the busy commentator like milestones marking history, whereas actually their noise hides the slow and silent growth of true cultural achievement. *nice !*

Dominant among the principles supporting the vitality of the arts seems to me that art possesses certain characteristics not replaceable by other activities of the human mind. Its uniqueness consists in being able to interpret human experience by means of sensory expression. In the visual arts, regardless of whether an artist sculpts or paints in the traditional manner or whether he nails mattresses on plywood, the criterion remains the same. The works of architecture, literature, and music also obey the same basic axiom—they speak by means of the senses with which we are endowed: vision, hearing, and touch.

An effective means of rescuing the arts from their present predicament consists, therefore, in pointing, quietly and patiently, to the life-giving common core of sensory expression in all its manifestations. One can do this systematically, as I have done at other occasions, or be satisfied, as I am in the present collection, with filling in gaps and clarifying obscurities by examples derived from various areas.

To this end, I have chosen as one contribution of this book ("For Your

Eyes Only") a few good works of art from the Boston Museum and have discussed them in miniature monographs to point to the visual features that make the particular object speak to whoever comes to see it. The examples are meant to supply viewers with the experience that must precede any appreciation of the work's historical conditions, the explication of its subject matter, or the analysis of its perceptual and theoretical components.

In other essays I have sampled the artwork of blind persons ("Perceptual Aspects of Art for the Blind") and that of psychotic patients ("The Artistry of Psychotics") to help us see that deficiency and deviation from the standards can be in keeping with the fundamentals and can even highlight unexplored aspects of what we usually neglect. Some of my more technical recent studies on the principles of gestalt psychology are intended to remind readers that, grasped at its core, human striving has shown itself to be governed by a tendency to order, clarity, and meaningful organization. And when one tries to look beyond the dogmatic crust of conventional religion, as I have done in two essays ("Beyond the Double Truth" and "Art as Religion") to be found near the end of the book, one discovers that religion rallies with the arts to praise the beauty of nature and the inexhaustible wealth of human experience.

Perhaps my search for what I sense is glimmering under the ashes is best accompanied by the warning I found in Richard Wilbur's poem "The Eye," in which he says:

> Preserve us, Lucy,
> From the eye's nonsense, you by whom
> Benighted Dante was beheld,
> To whom he was beholden.

And at the poem's end:

> Let me be touched
> By the alien hands of love forever,
> That my eye not be folly's loophole
> But giver of due regard.

Believing is seeing —

PART I

IN FAVOR OF CONFRONTATION

K INSHIP CAN MAKE for trouble. This is true for the relations between the various disciplines of knowledge, such as the sciences. It is also true for the present interaction between psychology and philosophy, about which I wish to register a complaint in the following. To be sure, if one prefers to cling strictly to one's own specialty, one need not worry about contradictions between neighboring occupations. That, however, is a convenience one cannot afford if one is convinced, as I am, that one's own field of work and philosophy are inseparable.

For my purpose, philosophy is not a self-contained discipline; it is the crowning superstructure of efforts in the various fields of study to advance to ultimate principles. It is those principles on which the work of philosophy is based. And just as philosophy is threatened with sterility when it fails to replenish its resources from pertinent areas of knowledge, work in any specialty may succumb to narrow drudgery when it no longer focuses on the larger objectives that are the territory of the philosopher.

This symbiotic relationship seems to me particularly indispensable for psychology. Philosophy must refer to other sciences, such as physics or biology, when required by its particular tasks to do so. Psychology, however, is always involved in this symbiosis because philosophy deals with the mind and the mind is the subject of psychology.

Conversely, in my own work on the psychology of art, I find it hard to decide where, for example, my study of the artist's dealing with the world of reality trespasses on epistemology as a chapter of philosophy. Or, to pick another example, where does an investigation of the artist's moral

Derived from "In Favor of Confrontation," *Salmagundi*, no.67 (Summer 1985), pp. 129–134, and from "The Vanishing World and Köhler's Inkwell," in *The Legacy of Solomon Asch*, edited by Irvin Rock (Hillsdale, N.J.: Lawrence Erlbaum Assoc., 1990).

obligations become simply an application of philosophical ethics? Similarly, my analyses of thinking turn without warning into matters of logic. Thus, by its own intrinsic dynamics, my work moves from specific observations to ever more general propositions and hence into a precinct of thought whose present rules of the game may not suit mine.

Empirical investigations in the natural sciences as well as in the humanities rely on certain axioms without which they lose their meaning. Their principal axiom affirms that the target of any acceptable inquiry is a set of objective facts that the researcher undertakes to verify and to explain. The indispensable assumption is that there exists a final truth about, say, the universe or a work of art. Regardless of whether researchers rely on quantitative methods of measurement and proof or on qualitative analysis, they are faced with the task of searching the objective facts by means of their own particular perspectives and resources.

It may seem that the artist is exempt from this commitment because there are as many ways of representing a fact of human experience truthfully as there are artists. Actually, however, the artist is no less obliged to do justice to the facts than is the scientist, except that the artist's own view of the subject is included in the conception to be represented. The arts, taken altogether, offer infinitely many aspects of the same truths, complementing rather than contradicting one another. Although the validity of an artist's worldview can be argued only in its own terms, it can, and must, be argued.

In practice, the commitment to this basic axiom is hardly in doubt. No science is conceivable without the assumption that facts exist objectively. What we cannot be sure of is whether our best description of a fact is correct and whether it is in our power to attain correctness. No honest scientist would have the courage to publish and teach were he not convinced that he was conveying the best approximation to the truth available to him. Nor is the situation different in the arts. I have yet to see an art historian offering an interpretation of a work of art without the conviction that what he is telling is objectively correct or at least deserving to be so considered. And any painter, sculptor, or instructor of architectural design criticizes the products of his students with the certainty of a person who is applying valid criteria with professional expertise.

So complex, however, is our present civilization that this indispensable foundation of our professional ethics is overlaid with a theory of knowledge that asserts the very opposite—namely, that there is no such thing as objective truth. This theory originates from philosophy, whose practice seems to preclude just such an assumption. Is it not true that philosophers are as obstinately convinced of the validity of their theories as are their

colleagues in the sciences and the arts? In fact, those who hold that there is no objective truth are among the most obstinate defenders of their own convictions.

I recently opened a book on philosophy and the mirror of nature, whose ideas I take to be symptomatic of today's philosophy, and I read that "the notion of 'accurate representation' is simply an automatic and empty compliment which we pay to those beliefs which are successful in helping us to do what we want to do" (Rorty, 1979). Further on, the book says that "we understand knowledge when we understand the social justification of belief, and thus have no need to view it as accuracy of representation." *don't agree* And the upshot: "Once conversation replaces confrontation, the notion of the mind as a Mirror of Nature can be discarded." When I, an outsider, alight on the scene of today's philosophy and read such statements, I am seized by the suspicion that the work crew charged with erecting the edifice of our principles is infiltrated by termites. To judge by the standards in any field of research and education I am acquainted with, anyone who replaced confrontation with conversation in the manner recommended in the preceding quotations would deserve to be chased from his job for behavior unbecoming a seeker of the truth. And as for the doubts about the mirror of nature, I can do no better than quote Elsa Morante in her novel *L'isola di Arturo*. "I am reminded," she says, "of the fairy tale about *good* the hatter who wept and laughed always at the wrong occasion because he had been made to observe reality only through the images of a bewitched mirror."

The approach illustrated by the aforementioned terrifying quotations has spread, like a cloud of poison gas, from philosophy through our intellectual world and, as I indicated, has even enveloped the theoretical thinking of many people who in practice do not doubt the validity of their own work. Perhaps it has aroused some sympathy in a population that has come to distrust the reliability of its political leaders. The young, in particular, are readily captured by an attitude in support of their skepticism.

But how did this pathology get into philosophy? If I am not mistaken, this view acquired its destructive power from the fusion of two influential trains of thought. One is the insistence of the British empiricists on accepting the reality of nothing but the most immediate and tangible evidence of the senses, which, for example, leads David Hume to say about necessity that it is "nothing but an internal impression of the mind or a determination to carry our thoughts from one object to another." And further: "The efficacy and energy of causes is neither placed in the causes themselves, nor in the Deity, nor in the concurrence of these two principles, but belongs entirely to the soul, which considers the union of two or

more objects in all past instances" (Hume, *A Treatise of Human Nature*, part 3, sect. 14).

The other ingredient of this toxic philosophical concoction derives from the Continent and from an entirely different frame of mind. It claims the privilege of powerful individuals, and more broadly of human beings in general, to mold the world according to their own wishes and needs. The most eloquent promoter of this claim is, of course, Friedrich Nietzsche, who in *Der Wille zur Macht* has a section on the will to power as cognition [*Erkenntnis*]. There, inveighing against "causalism," he asserts that "truth," which he puts in quotes, is not "something that exists and is to be found and discovered but something to be created, something that provides a name for a process or rather for a will to overpower, which is actually endless" (*The Will to Power*, book 3, para. 552).

Evidently, this blend of a cognitive insistence on subjective perception as the sole generator of connection and interaction and the moral license to willful interpretation has had an irresistible influence on the mood of our time. In the art world, which concerns me particularly, it has led to a radical neglect of objective standards in at least two ways. First, an awareness is lacking that art fulfills particular functions for the human mind and thereby is distinguished from other occupations. Second, a widespread belief holds that the criteria by which one determines, intuitively or explicitly, whether a given work deserves to be held in aesthetic and social esteem no longer exist.

One can hardly blame an artist for proclaiming that art is anything he chooses to call art if the very people who are supposed to supply the standards by which to judge what is and is not art assert that there are no such objective criteria. This leads to a widespread agreement that anything goes, be it art or not, cheap or rare, profound or superficial, mechanical or creative. Undoubtedly, changes and innovations are taking place in artistic practice. But precisely for this reason, it is incumbent on us to recall the unique qualifications by which the arts promote the common good. Rather than indulging in the easy pleasures of relativism and answering with a superior smile when students ask what is meant by art, we should come forward and confront the issue.

REFERENCE

Rorty, Richard. 1979. *Philosophy and the Mirror of Nature*. Princeton: Princeton University Press.

ART AMONG THE OBJECTS

Et l'on trouverait mille intermédiaires entre la réalité
et les symboles si l'on donnait aux choses tous les
mouvements qu'elles suggèrent.—*Gaston Bachelard*

not translating is bullshit! Arrogance of the pompous.

WITH THE EMERGENCE of man from nature, art emerged among the objects. There was nothing to distinguish or exalt it in the beginning. Art did not separate one kind of thing from the others but rather was a quality common to them all. To the extent that things were made by human beings, art did not necessarily call for the skill of specialists. All things took skill, and almost everybody had it.

This is how an eighteenth-century essayist might have begun a treatise on our subject. By now, this recourse to a mythical past would sound naive and misleading, mainly because we have come to pride ourselves on making distinctions rather than on seeing similarities. Thus, art is laboriously separated from objects supposed not to be art—a hopeless endeavor that has increasingly disfigured our image of art by extirpating it from its context. We have been left with the absurd notion of art as a collection of *not true –* useless artifacts generating an unexplainable kind of pleasure.

Rescue from this impasse in our thinking is likely to come not primarily from those of us who, established on the island of aesthetic theory and practice, look around at what else exists in the world but rather from those who, on the contrary, start from human behavior in its totality. These latter explorers are interested in what people are surrounded by, what they make, and what they use. In the context of such investigation, these explorers run into objects prominently displaying the property we call art. Psychologists, sociologists, and anthropologists have been driven to view art in the context of nature, ritual, shelter, and the whole furniture of civilization. As a characteristic example I mention a thorough interview study, *The Meaning of Things*, by Mihaly Csikszentmihalyi and Eugene Rochberg-Halton (1981), in which three generations of families from the Chicago area were questioned about their favorite possessions. Pictures,

sculptures, and all sorts of craft work turned up at a more or less modest place in the inventory of the home, and the reasons given for their value make wholesome reading for specialists in aesthetics.

As the subtitle of the Chicago study—*Domestic Symbols and the Self*—indicates, its authors were concerned mainly with the psychological questions of what those cherished objects did for their possessors, what needs they satisfied, and what traits they acquired by the uses to which they were put. This leaves room for further studies focusing on the nature of the objects themselves. Seen in the context of the rest of the world, what are the characteristics of the objects we single out when we talk about art? This, too, is a psychological question and is the subject on which a few observations are offered in the following.

Art objects, like all other physical things, are known to us exclusively as perceptual experiences—that is, as things we see, hear, touch, or smell. In this respect, no difference exists among a tree, a chair, and a painting or between the two ways we deal with these experiences. We can handle objects, as when we fell a tree or carve a block of marble or crate a painting; or we can contemplate them, as when we admire a waterfall or listen to a concert.

Likewise, the ways in which we initially come to know objects as independent entities do not differ fundamentally. Although we can influence the percepts of objects by handling them or by changing our position in relation to them, we learn soon that they have an obstinacy of their own. They cling to their place or move at their own initiative. It is the recalcitrance of the perceptual object's behavior that makes us experience the world as existing independently of our own selves. Psychoanalysts have taught us that this realization causes a traumatic shock, which is overcome only by a considerable cognitive effort. At the very beginning of life the infant has to cope with the illusion of what Donald W. Winnicott (1971) has called the primordial omnipotence of the self. Gradually the infant learns how to come to terms with the other wills, embodied in living and nonliving things—a task made easier by the assistance of "transitional objects." The thumb, the teddy bear, and the blanket are called transitional by Winnicott because they are more readily at the beck and call of the child than other things are. They also begin to acquaint him with the limits of his power. They will do some things for him but are unable or unwilling to do others.

The problem survives through everybody's lifetime, and a scale of compliance develops that reaches from the most amenable objects to the most unconquerable. On this scale, somewhere between a kid glove and a Tibetan mountain, lie works of art. It stands to reason that manmade things

are among the most obedient, but it is also true that our acquaintance with the nature of physical materials teaches us to be patient with the limits of the service to be expected from tools and furniture. Wood will not bend, and water will not stay put.

The maker of practical implements therefore conceives an object he plans to make in terms of the materials of which he will make it. Given his knowledge of what suits the material, he generally is able to predict the outcome of his work. The mental image guiding him in the making of the object tends to be reliable. There are few surprises. That is, normally the mental goal image of the work, the realm in which the maker's imagination rules with complete freedom, is not frustrated by the physical materials through which the conception is carried out.

In the arts this gestation process tends to be much less smooth. The goal image, to be turned into physical existence, is much less prescribed by convention; at least in our particular civilization this is the case. Therefore, the goal image tends to be less explicit, less finished. Quite frequently, it is not really available before realization. Rather, it comes about gradually in interaction with the medium. The image proposes, and the medium reacts, not always favorably. It makes objections but also suggestions and offers surprises. The artist has much to learn about getting along with the materials of his trade because nowhere does the infant's initial illusion of omnipotence seem to survive more naively than in the artist's trust in his own power. As the uncontested sovereign in the realm of his imagination, he finds it all the more difficult to cope with what Sigmund Freud called the reality principle. Works of art are the adult's transitional objects par excellence.

Hence the characteristic struggle of the artist with his medium, the exasperating discrepancy between the work as envisioned and its realization in the "flesh." The sculptor argues with the wood or stone, the dancer with her body. Trying to get around the problem by contending, as some aestheticians have done, that the mental conception of the work of art, uncontaminated by its material embodiment, is the true work seriously misrepresents the situation. The incarnation of the artist's vision, his version of the Eucharistic miracle, is an indispensable value of his work.

Through the struggle with his materials the artist comes to realize in a particularly dramatic way that the experiences we call physical objects are anything but inert matter. They are vehicles of their own behavior, embodied initiatives, and only when their dynamic nature confronts us actively are we likely to notice them explicitly. Martin Heidegger, in his essay "Das Ding" (1954), points out that in the European languages things are closely related to causes, *chose* or *cosa* to *causa*. In the same vein Hans-

Georg Gadamer (1976, p. 69) refers to the kinship of *Ding* and *Sache* in German. Objects are things that concern us in the original Latin sense of *objectum*, that is, of things thrown into our way as obstacles or signs, forbidding or inviting, calling for response. And soberingly enough, language defines the counterparts of objects as subjects, that is, as what is passively subjected to the things. This linguistic hint tells us that we are what we are by what we are subjected to. And the material things of our environment symbolize these counterforces most impressively. This insight was given most tangible artistic expression by the early filmmakers, who knew that their medium converted the props of the setting, immobile on the theater stage, into actors. The film mobilized the furniture of nature and the manmade environment by focusing on the items, giving them entrances and exits, making them approach or recede, and varying their appearance as demanded by their roles in the plot.

What character traits enable objects to play their active part? Remember that in the artistic practice of the last few centuries the objects populating paintings and sculpture and even architecture and the performing arts have lost much of the broader environment with which they used to interact. Within a single painting, to be sure, the figures of a dramatic scene, the apples and bottles of a still life, or the shapes of an abstract composition respond to one another; but the frame is the limit of this small world. The work of art has become a mobile facility belonging nowhere and ready to be put anywhere. Its effect on its surroundings is accidental, and the surroundings' influences on the work are unpredictable. Compare this vagrancy of paintings in our time with the established place of the mosaics on the walls of a Byzantine church or the stained glass windows of a Gothic cathedral, where the pictures were indispensable components of their setting and received their meaning from their setting. The same is true for sculpture, music, buildings, theater, and dance. By now, the single art object, instead of being supported in its particular function by its place and time, is expected to carry a total and complete message against the opposition of an incongruous neighborhood.

To properly view this special and in some ways pathological state of affairs, we have to take off from the more normal situation in which objects, whether natural or manmade, are components of an integral environment and have to be seen in that context. Under such conditions, the total space in which these components operate is primary and dominant. In the practice of daily life this setting acts as a pattern of constraints and offerings, such as a path in a landscape, the streets in a city, the walls and the doors. Only secondarily is this "life space," as psychologist Kurt Lewin

(1935) has called it, broken down into a configuration of objects, each endowed with its own messages.

Lewin defines the behavior of objects as their valence or demand quality (*Aufforderungscharakter*). Naturally, to call forth human responses, objects must be known and understood, and the perceiver must feel the urge to approach or avoid them. As Freud has remarked, "But if I have a path open to me, does that fact automatically decide that I shall take it? I need a motive in addition before I resolve in favor of it and furthermore a force to propel me along the path" (1943, p. 43). Even so, the perceiver experiences the attractions and repulsions as issuing from the objects themselves.

In their most radical social manifestation, the motivating forces of objects are revealed by the pathology of what Karl Marx refers to as the fetishism of merchandise. Recently, Gaspare Barbiellini Amidei and Bachisio Bandinu (1976, p. 24), in what they call "a disquieting investigation of our captivity among the objects," have derived from the Marxist concept an analysis of traditional and modern attitudes based on this observation: "Il fatto è che le cose parlano e che gli uomini parlano attraverso le cose" (the fact is that the objects speak and that people speak through the objects). I shall refer later to this book but will cite here a striking illustration of its thesis in a short novel, *Les choses*, by Georges Perec (1965), which describes a group of Parisian students in the 1960s. Employed by market research agencies to trace the responses of customers, these students are themselves hopelessly addicted to the lure of objects offering comfort and prestige. "In their world it was almost the rule always to desire more than one could acquire. This was not of their own making, it was a law of the civilization, a given fact most aptly expressed in publicity quite in general, the magazines, the art of window display, the spectacle of street life, and in certain ways even in all of what goes by the name of cultural products" (1965, p. 44). The novel opens with a long, ghostly panorama of a dream apartment filled with all the luxury objects of enviable living, an assembly of silent sirens, each displaying its seductive charms, but all this in the total absence of human beings. This description presents valence in the abstract, attractiveness as such.

It is particularly pertinent to the valence of art objects that so many of their properties inviting response are directly contained in their perceptual appearance. Lewin speaks of forces going out "from a sharp edge, from a breakable object, or from the symmetrical or asymmetrical disposition of objects on both sides of the path taken by the child" (1935, p. 50). Another psychologist, James J. Gibson, has elaborated somewhat on the description

of the perceptual qualities that invite action and has given them the name "affordances" (1979).

The basic affordance of a work of art is that of being readily perceivable. Because the human senses are geared biologically to the apprehension of relevant signals, a bugle tune, a fire alarm, or a piece of music detaches itself from a background of noises by its definable tones, and this comprehensibility arouses in the hearer the urge to respond. Similarly in painting, sculpture, or architecture, the orderly visual structure of shape, size, and color in a well-made work attracts viewers through its immediate readability. This primary affordance gives access to all the obvious allures deriving from the subject matter of the work and the various personal associations that may bind the consumer to it. In the most general sense it is the very order and harmony of its appearance that distinguishes the art object as an oasis in a disturbingly chaotic world. And this organized perceptual structure enables the art object spontaneously to illustrate definite constellations of forces that underlie physical and mental functioning in general. The purified experience of such basic dynamic themes as harmony and discord, balance, hierarchy, parallelism, crescendo, compression, or liberation is an affordance of fundamental cognitive value.

What I am describing here as the principal affordance of art is not lost when the range of the artistic statement is limited to the confined, isolated, and mobile object, which, as I said, has come to be so characteristic of our particular culture. In fact, such confinement can be said to enhance the compositional unity of the work. Take the highly expressive qualities of spatial distance. Within a painting, distances between objects are strictly determined by the meaning they convey. For example, in Georges Seurat's *Afternoon on the Grande Jatte*, chilling gaps keep the figures at a psychological distance from one another. As soon, however, as we step beyond the frame of the painting and consider the canvas as an object in the physical space of, say, the museum gallery, the distance of the viewer from the painting becomes as arbitrary as is the total setting of the works of art kidnapped and stored in a neutral space. Compare this with a defined architectural interior where the particular nature and message of a picture or statue are meaningfully determined by its particular place and distance from the various functional features of the building.

In a very broad sense, Heidegger, at the beginning of the essay cited previously, deplores our losing the meaningfulness of spatial and temporal relations. The relation that used to distinguish close by from far away, present from past, has been leveled by modern technology to a uniform optimal distance. Heidegger asserts that this practical convenience has destroyed true "nearness" between the viewer and the object viewed. His

observation reminds us that in an undisturbed spatial and temporal context, the variety of distances symbolizes degrees of belonging together or being remote. One is close to a lover but distant from a judge, close to one's workshop or away from home.

The more the work of art is isolated from its setting, the more it is singularly burdened with the task it used to share with its total environment. Here again a reference to Heidegger is illuminating. He expects a humble water jug to reflect nothing less than the cosmic quaternion of heaven and earth, the divine and the mortal. More modestly, we may be willing to limit the symbolism of the jug to the humanly relevant activities of receiving, containing, and giving (Arnheim, 1966, p. 192). But even this smaller request insists on "making the objects speak." Gadamer (1976, p. 71) has observed that any talk of "respect for things" has become more and *TRUE* more unintelligible in an ever more technological world. Things, he says, "are simply vanishing, and only the poet still remains true to them. But we can still speak of a language of things when we remember what things really are, namely, not a material that is used and consumed, not a tool that is used and set aside, but something instead that has existence in itself." *OBJECTHOOD*

Fortunately, respect for the things made by humans for humans is not entirely limited to the poets. If, however, we want to observe objects in their full involvement with man's daily existence, we must have recourse to one of the few communities left in which the users of tools are not yet separated from their makers and the shape of objects still reflects the way they were made. Barbiellini Amidei and Bandinu, in the book I mentioned earlier, offer a moving description of one of the most primitive populations left in Europe, the shepherds of the Barbagia plains on Sardinia. Their simple huts are equipped with two kinds of objects. A few are gotten in town and have to be paid for. "Not being natural objects, they are not protected by nature: they are always in possible danger and may suddenly refuse to function." All the other objects are made by the shepherd himself of granite, wood, hide, bone, or cork. "They don't cost money nor can their price be translated into working hours." Making them emerge from nature "is never a chore, even though they serve practical needs; in making them there is always an element of playfulness. They are essential but replaceable, and their presence can be invented at any time. The things of nature offer themselves as materials. Therefore the attitude is not one of anxiety but of trust, almost an affectionate carelessness. [The shepherd] treats them as he pleases because they are his, and he understands their course from life to death" (1976, p. 68).

All these tools and implements are carved and kept in good shape with the knife the shepherd always carries in his pocket. There is a closeness

between making and consuming that most of us rarely enjoy. There are no paintings on the walls of the shepherd's home, no objects that specialize in providing images of distant worlds, but there is a family resemblance between the utensils and their makers because the objects reflect the style of life of their users. Having been made the right way from the right materials, the objects reflect standards of honesty and solidity for human conduct. They are guiding images leading the thoughtful mind by the symbolism of their appearance to the foundations of life and behavior. They do so without giving up their primary location as tangible agents in the world of bodily action. Their intimacy with the setting in which they operate as companions of their users makes it easier for them to be handled as well as seen and heard.

In a world like ours in which objects, limited to practical function and endowed with artificial values, no longer speak, works of art require a special dispensation to do their duty, and their users have to be awakened for a couple of hours at a time to be able to look and listen. Whereas more normally it is the eloquence of the objects that makes art possible, our hope for reviving the objects now comes from the arts.

REFERENCES

Arnheim, Rudolf. 1966. *Toward a Psychology of Art*. Berkeley and Los Angeles: University of California Press.

Bachelard, Gaston. 1964. *La poétique de l'espace*. Paris: Presses Universitaires.

Barbiellini Amidei, Gaspare, and Bachisio Bandinu. 1976. *Il re è un feticcio*. Milan: Rizzoli.

Csikszentmihalyi, Mihaly, and Eugene Rochberg-Halton. 1981. *The Meaning of Things: Domestic Symbols and the Self*. Cambridge: Cambridge University Press.

Freud, Sigmund. 1943. *A General Introduction to Psychoanalysis*. Translated by Joan Riviere. Garden City, N.Y.: Garden City Publishing.

Gadamer, Hans-Georg. 1976. *Philosophical Hermeneutics*. Berkeley and Los Angeles: University of California Press.

Gibson, James J. 1979. *The Ecological Approach to Visual Perception*. Boston: Houghton Mifflin.

Heidegger, Martin. 1954. *Vorträge und Aufsätze*. Pfullingen: G. Neske.

Lewin, Kurt. 1935. *A Dynamic Theory of Personality*. New York: McGraw-Hill.

Perec, Georges. 1965. *Les choses: Une histoire des années soixante*. Paris: Julliard.

Winnicott, Donald W. 1971. *Playing and Reality*. New York: Routledge, Chapman & Hall.

WHAT BECAME
OF ABSTRACTION?

I

NEARLY EIGHTY YEARS have passed since the art world was presented with abstract art and began to cope with it. In this time, abstract art has proved to be much more than a passing fashion. Indeed, it is still very much with us, although it has not attained a monopoly. (After a few de- *NOT TRUE* cades, naturalistic art recaptured the market with a vengeance.) The time has come for us to ask, What do we know about the nature of abstract art? What has it done for us during this century? And what do we recognize as its limitations?

The general public continues to be puzzled by abstractions. "What is this about?" is the question still commonly faced by teachers and museum guides. Most receptive are children not yet trained to assume that paintings *yes!* and sculpture must have a subject matter. They are therefore willing to accept the shapes and colors of abstract art at face value. Among practicing artists, many are still devoted entirely to abstraction, but fewer claim that representational art has forever lost its reason to exist. In the early days some artists were willing to say, "To make a picture into an object is violence against painting." But we also note that a leading artist, Wassily Kandinsky, was not ready right away to abandon representation once and for all. Not only did he continue to combine abstractions with landscapes, but as late as 1917 he was not averse to painting Biedermeier illustrations, whose pretty officers on horseback and crinolined ladies now make us blush.

Once we cease to think of abstraction as something easily defined, which came and stayed, even its name poses problems. Historically the term *abstraction* was well suited to describe the final outcome of a development

Derived from "What Became of Abstraction?" *Salmagundi*, nos. 82–83 (Spring–Summer 1989), pp. 70–71.

*why must we agree or disagree in a total sense?
Parts are true and parts are false.*

that gradually withdrew from representational subject matter. In the paintings of the Impressionists, trees, buildings, and figures gave way to patches of paint, which crystallized in the work of the next generations into objects of their own, such as the dots of the Pointillists. The angular solids in the portraits of the Cubists all but replaced the men and women they represented. Abstraction, then, described the moving away from the objects of physical reality.

Such a negative term, however, failed to do justice to the new art. Piet Mondrian explained why some artists objected to the name *abstract art*. "Abstract art is concrete and, by its determined means of expression, even more concrete than naturalistic art" (Mondrian, 1945, p. 17). But what exactly was this "determined means of expression"? Once the depiction of natural objects had been given up, something else had to take its place. The elementary shapes of geometry had always been available as a counterworld or antimatter that provided another set of objects, and since they were not representations but could offer themselves as a universe of their own, they were indeed concrete rather than indirect.

Clearly, however, detachment from the outer world was not easy, one main problem being the three-dimensionality of space. Sculpture by its very nature had to maintain its citizenship in the physical world. Although sculpture could forswear the portrayal of human bodies and animals, it replaced them with an equally physical population of "nonobjective" shapes. In painting and drawing, the space of the pictorial surface offered itself as an alternative realm. But even this surface was never quite flat. By simply drawing a line on a piece of paper, one obtained an object in front of a ground—a betrayal of "concreteness" in that the space thus created for the eyes was already indirect, was therefore a representation! Mondrian, anxious to attain the total celibacy of abstraction, was irritated to find that even the reduction of his patterns to an arrangement of a few straight bars at right angles left him with a tangible trellis suspended in a fictitious space.

The more concretely defined the "abstract" shapes were, the more undeniably did they dwell in the space that had been the habitat of representational painting. The eerie landscapes of an Yves Tanguy differed from a Venetian Canaletto only by presenting objects of the painter's own invention. Tanguy's secession from traditional art was limited to giving up subject matter, but he kept the convention of naturalistically depicted space, light, and materiality.

Another striking phenomenon in the twilight zone of abstraction can be observed in those early paintings of Kandinsky where the horseback riders, the cannons, and the castles are still intended to be there but have

become all but unrecognizable. If one ignores the subject matter and sees the picture as an arrangement of pure shapes and colors, one finds that the composition does not work. One sees an incoherent accumulation of colorful shapes, unbalanced and unreadable. This happens because a known object, such as a tree or a locomotive, has a visual structure of its own that is a part of the composition and cannot be ignored. A symmetry or repetition known as a property of the object but abandoned by the painter remains nevertheless in the memory of the viewer as an indispensable component of the composition as long as the presence of the object is acknowledged. Once, for example, a picture is recognized as a landscape, its contents may organize in the depth dimension, whose organization differs radically from what is seen when the same shapes are reduced in perception to the two-dimensional filling of a surface.

This relation between subject matter and perceived pattern remains relevant whenever an abstract work refers to a representational theme. A piece of music representing the four seasons may do so without imitating the noises of thunder or birds. It may limit itself to offering the equivalent of a season's general mood by translating its dynamics into entirely musical shapes. Similarly, it makes a difference whether an abstract painter depicts the subject of "deluge" or "revolution" by purely visual shapes or by half-hidden allusion to remnants of rushing floods, bursting bridges, or milling crowds. In the latter case, the representational elements must remain consciously present in the image received by the viewer.

When subject matter recedes, the works of art tend to be taken over by the basic geometrical shapes. The "abstract" world of circles, squares, and triangles is by no means shabby, as we know from the precious ornamentation of, say, the Alhambra. But painting and sculpture are always called on to go beyond mere decoration, that is, they do not limit themselves to representing the world at its most harmonious and undisturbed. They present human experience as dramatic, problematic, full of striving and suspense. This is where the basic geometrical shapes reveal their limitation. Undoubtedly they are of fundamental importance in our conception of objects; they are the elements on which all conceivable shapes are built. Owing to their simplicity, however, they are also limited to a minimum of dynamics. This shows up as a shortcoming in styles of representational art kept to such basic shapes. It makes the paintings of the Native Americans, for instance, look more conceptual than alive, more playful than dramatic. In abstract art, it threatens the highly geometrical compositions of some of the Bauhaus painters, such as Herbert Bayer or the late work of Kandinsky, with the formalism of decoration.

In the physical world of inorganic and organic life, the basic elements of

yes!!

shape are inexhaustibly enriched by the complexity of interaction that makes the forces of nature generate ever new combinations and variations. Many abstract artists are in the habit of constantly consulting nature for formal inventions they can use without adopting naturalistic representation. Look at the wealth of shapes and colors that come about in nature when water eats into rocks or when a human body twists the folds of a garment. Such patterns are so unpredictable that they do not easily occur to the painter as long as he tries to make do with his own imagination of shapes. *NOT TRUE! It can take place.*

The themes of nature have been amply drawn on, however, by representational painters and sculptors as they looked at their models. In fact, these themes have been preprocessed, so to say, by those artists, and there is nothing paradoxical therefore about an abstract artist such as Frank Stella refreshing his sense of space by studying the work of highly naturalistic artists such as Caravaggio. In his book *Working Space*, Stella calls the sense of space in today's abstractionists "shallow and constricted" (1986, p. 5). He complains that "human dynamics—something we could readily identify with, something that would really touch us—seems unavailable, essentially remote to abstraction" (1986, p. 99). Stella claims that Caravaggio's illusionism freed painting from architecture and decoration and that it offers a similar liberation to present-day abstractionists. "It seems obvious that the future of abstraction depends on its ability to wrest nourishment from the reluctant, unwilling sources of twentieth-century abstraction: Cézanne, Monet, and Picasso, who insist that if abstraction is to drive the endeavor of painting it must make painting real—real like the painting that flourished in sixteenth-century Italy" (1986, p. 160).

The question of abstract art being rich or poor is not merely a matter of visual form. It equally concerns the content and meaning of the work. One need only look at much of what currently calls itself "minimalism" to realize that the poverty of formal invention goes with the notion that abstract art is "about nothing," that it is "art for art's sake."

By no means, however, were all abstractionists willing to settle for such *FRUITLESS?* fruitless formalism. In 1974, for example, the German painter Hans Hartung asserted:

good –
> What concerns me is more the law than the object. What fascinates me is to see on canvas or paper at least part of the immutable and complex laws which govern the world, laws that bring about the vibration of the electrons and other parts of the atom, that combine to form matter, traverse the cosmos, form worlds, create light, heat, and even consciousness and intelligence; those laws without which nothing exists. (Ashton, 1985, p. 60)

Somehow the above has rich profundity and relevance. Realism is kid's stuff! Abstraction has maturity.

There is an obvious analogy between giving up physical subject matter and turning the meaning of one's work away from the material happenings of the practical world toward the general principles governing our existence. The two most influential representatives of abstract art committed themselves most radically in this respect, Kandinsky by stressing the "spiritual" in art and Mondrian by referring to the cosmic forces underlying the nature of the universe. WONDERFUL

It is not evident, however, to what extent these aspirations were fulfilled by the works intended to serve the purpose. In the case of Mondrian, we know precisely what he was trying to achieve:

> Impressed by the vastness of nature, I was trying to express its expansion, ORGANIC? rest, and unity. At the same time, I was fully aware that the visible expansion of nature is at the same time its limitation; vertical and horizontal lines are the expression of two opposing forces; these exist everywhere and dominate everything; their reciprocal action constitutes "life." I recognized that the equilibrium of any particular aspects of nature rests on the equivalence of its opposites. I felt that the tragic is created by unequivalence. I saw the tragic in a wide horizon or a high cathedral. (Mondrian, 1945, p. 13)

We can follow Mondrian when he says that he saw the tragic nature of *complex* boundlessness in the distance of the horizon or in the height of a Gothic *stuff!* church, but do we experience in his paintings the sense of the tragic being overcome by equilibrium with equal intensity and greater purity? I believe the answer is no. The cause of this shortcoming is not obvious. The painter has been successful in making us feel the tensions generated by distances and spatial orientations in his shapes and the way they can be compensated by delicate balancing. It is also true that viewers on their own can go farther. They can sense in this interplay of tensions the reverberation of discords and concords occurring in human experience everywhere. The paintings themselves, however, guide the viewers to such analogies only in *ok* a very general way. One is reminded here of religious symbols. The circular pattern of the Chinese yin and yang is intended to exemplify the interaction of complementary forces throughout the universe in every harmonious whole, and the six-pointed seal of Solomon points quite generally YES to the interpenetration of opposites. In 1777, Johann Wolfgang von Goethe designed for his garden in Weimar the Altar of Good Fortune consisting of a sphere balanced on a cube (Figure 1). This piece of abstract sculpture was intended to express his gratitude for his friend Charlotte von Stein, whose poise, he said, served as a stabilizing base for his own restless motility. As he expressed it in a poem addressed to Charlotte ("An Charlotte v. Stein") at the time: "You cooled my blood with drops of moderation. You straightened my wild, erratic course" (Heckscher, 1962).

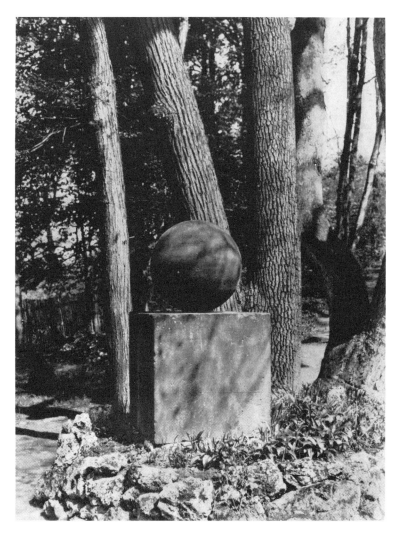

FIGURE 1.
Johann Wolfgang von Goethe, Garden sculpture in the Goethe House.
1777. Weimar.

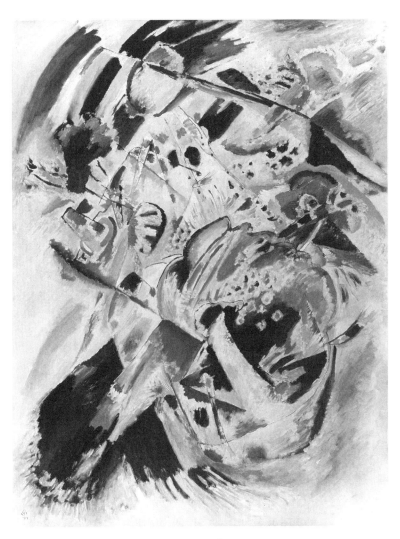

FIGURE 2.
Wassily Kandinsky, Painting Number 199. 1914.
Museum of Modern Art, New York.

Reflection of thinking, decision making pushed through by the Lord. NOT chaos.

Tropftest Mässigung dem heissen Blute,
Richtetest den wilden, irren Lauf

Clearly, such visual symbols are suited to convey the intended meaning; but they can hardly be credited with generating the powerful presence of spiritual forces a work of art would evoke. One would rather describe them as diagrammatic indicators translating intellectual concepts into their perceptual equivalents. *So ?*

Mondrian's late paintings surely go beyond the diagrammatic, but although their dynamic themes can touch us vividly, their cosmic connotations are limited to mere reminders. *OK* They rely on the reservoir of our own thoughts and feelings. To be sure, reminders are necessary resources of works of art everywhere, but when it comes to the core of art, to the nature of what distinguishes the particular virtue of art from other images, signs, *why not* or pieces of information, reminders are not good enough. Art must be expected to create an immediately effective presence for the essentials of its message. *True but so is reminders —*

Abstraction at its most ascetic leaves us at one extreme of artistic presentation. It is not necessarily devoid of meaning, but it tends to fall short *no —* of the vitality of life-giving forces to be expected from art. The defect is not due simply to the absence of subject matter. By itself, subject matter would not remedy the dilemma. The proof of this is available to us from recent experience: at the other extreme of artistic presentation we have seen paintings of motorcycles or shop windows minutely copied, often by *excellent* reliance on photographs, or life-size casts of human figures, some naturalistically colored, and we have had to admit that these ample supplies of subject matter were as unable to evoke the experience of art as their abstract opposites.

What, then, is the way out? The answer, of course, is supplied by almost any successful work of art of any style whatever. In the particular case of abstraction, the best solution to the problem presents itself when we look at abstraction's outstanding specimens, such as Kandinsky's paintings *I try to* from those few years in which he had given up all references to naturalistic *do this* subject matter while at the same time enriching his shapes and colors with an exuberance of invention matching that of nature itself (Figure 2).

✳ These passionate compositions are not limited to the purely visual celebration of what pleases the eyes. They reach beyond the world of the senses to symbolize the forces that activate life and the physical world with all their overwhelming complexity. Beyond the particulars of daily experience, such compositions capture the generalities without being dried by pure concepts.

I feel comfortable in what I'm doing!

REFERENCES

Ashton, Dore (ed.) 1985. *Twentieth-Century Artists on Art*. New York: Pantheon.

Goethe, Johann Wolfgang von. *Letters*. April 14, 1776.

Heckscher, William S. 1962. "Goethe im Banne der Sinnbilder." In *Jahrbuch der Hamburger Kunstsammlungen*, vol. 7, pp. 35–54.

Mondrian, Piet. 1945. *Plastic Art and Pure Plastic Art*. New York: Wittenborn.

Stella, Frank. 1986. *Working Space*. Cambridge, Mass.: Harvard University Press.

PART II

THE REACH OF REALITY
IN THE ARTS

A RT RUNS INTO the notion of reality in two ways. We ask: Is a work *good*
of art real in the same way in which an eatable apple, a live tree, and
a horse in the stable are real? And once a work of art represents such a real
object, a second question arises: How is its reality related to that of the
things it depicts? I will discuss the answers mostly for the visual arts but
will refer to problems of literature toward the end.

When the natural sciences call their subject matter real, they place it in
what philosophers describe as the transcendental realm, namely, a world
beyond the reach of our senses. The world to which physicists and chem-
ists refer is hypothetical. It is assumed to exist by inferences from the
world of perceptual experience, the only world to which we have direct
access. The reason for making the assumption is that the facts of experi-
ence can be more conveniently described if we behave as though something
beyond the reach of our senses continues to exist when we close our eyes,
lose our hearing, or go to sleep. We would also have trouble explaining
why the worlds of different persons are populated by the same things at the
same time if we failed to cling to the hypothesis that those individual
worlds are manifestations of one and the same transcendental source.

The transcendental world is a reality to which the arts refer only pe-
ripherally. The objects a painter or sculptor represents are sensory per-
cepts, and so are the images he creates. For practical purposes, artists deal
with the chemistry of pigments or the statics of three-dimensional struc-
tures, and out of curiosity they may inquire about optics or the nervous

First published in *Dispositio* nos. 13–14 (1980), pp. 97–106.

Lichtenstein

system. Their decisive realm, however, is the phenomenal world, the world of perceptual experience. ORGANIZED PERCEPTION

As we explore this world of our experience, we soon discover that it, too, contains a fundamental split, not unrelated to the ontological distinction between the perceptual and the transcendental realms. There is a split between facts that are invariably given to us and others that can be influenced by our own behavior. As I walk around a statue or scan it from top to bottom, each view contains elements of form and color that are imposed on me by the object out there. I cannot alter those objective properties by the way I look at them; I can only accept them for what they are. At the same time, the changes that occur as I move from one station point to the other and let my eyes concentrate on different portions of the statue are clearly dependent on my own activity. In this respect, what I see is different from what the person next to me is seeing. The ability to distinguish within the world of experience between properties that exist independently of the observer's mental manipulations and others that are due to these manipulations is of fundamental biological importance for our getting along in our environment. It is equally important for the reality status of the arts. TASTE?

A primary fact about works of art is that they belong to the independent, objective world given to us in experience. The extent to which my looking at the picture of a tree can change that picture is neither greater nor smaller than that of my looking at a "real" tree in my garden. To primary perceptual experience, works of art are objects of the same nature as all the other things of our world. They reach us through the same channels: the eyes, the ears, the sense of touch, as well as through verbal reports. Fundamental for works of art is what they have in common with other natural and manmade things, not what distinguishes the former from the latter (Arnheim, 1966).

This means that the difference between things and their images, the difference between the signified and the signifiers, is not as decisive to primary experience as it is to our philosophical thinking today. Take the example of an early type of sculpture, the pre-Buddhist Japanese Haniwa figures, made of pottery clay and intended originally perhaps to replace the actual human beings and horses that had been sacrificed in ancient times at burials to accompany the dead (Figure 3) (Seiroku, 1960). It seems to me essential for the understanding of art that those figures are not primarily mere likenesses of "real" humans and horses but rather equally real things, although of different characteristics. They are made by human craftsmen, not by nature, and of clay, not of flesh and bones. They neither

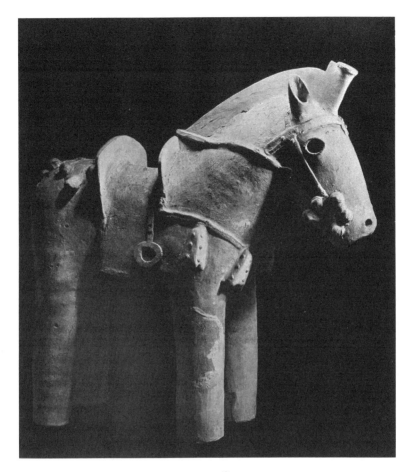

FIGURE 3.
Prehistoric Haniwa Horse. Saitama prefecture, Japan.

move nor eat. But they resemble live humans or animals in their visual appearance and fulfill some of their functions.

In addition, such images have invariably some of the properties we call art. Through the economy and intensive expressiveness of their appearance, they display certain qualities with particular purity and strength. This perceptual distinction predisposes them also for the possession of magic power. The presence of a religious image, such as an African fetish, may be considered indispensable for the well-being of a community. It is essential to realize, however, that similar powers are attributed to certain objects of nature for similar reasons. A holy mountain, like Mt. Fuji, attracts attention through the abstract geometry and the smoothly rising

curve of its volcanic shape. Its particular perfection invites worship. It is and remains a mountain among mountains, but because of its heightened appearance, it associates readily with the divine.

To repeat, art emerges in the world of things without in principle distinguishing itself from that world. Art has the same reality status but emphasizes special virtues. The expressive qualities given to it by its maker do not differ in principle from those possessed by the creations of nature. Nor is art's main function necessarily that of serving as a representation of something else. The Haniwa horse, although historically a stand-in for a live horse, acted essentially as what it was by itself, and what it visibly expresses are its own properties. *what all art should do!*

This peculiarity of an icon to characterize its own nature by its appearance is found especially in early art but survives also in the arts of today—for example, in religious images. A statue of the Virgin Mary is not first of all a portrait of a historical or transfigured woman who dwells or dwelled somewhere else in space and time. The figure is the Virgin herself with the essential prerequisites pertaining to her status. She listens to the supplicants and may grant their requests. In a more secular way, a portrait or landscape painting may enjoy the privilege of sharing a family's living space, rather than being exiled to the nonspace of a museum. It permeates the house with some of its powers. The painted person's particular character and the mood of the landscape become a perceivable component of the setting.

This property of art is most clearly active in nonrepresentational works, in music, in architecture, and in abstract painting or sculpture. Although music, like anything that carries expression, points by its meaning beyond itself, it has essentially the character of an event happening at a particular place and time and appearing as a part of the setting. This is especially evident when music fulfills a defined function in a social setting, a ceremony, a funeral, a celebration.

Architecture, of course, is hardly ever thought of primarily as a representation of something existing somewhere else. The splendor of a palace is among the properties of its owner. And even a church or temple is not first of all a mere image of the deity but an indication of the god's actual presence. Thus, in general, buildings are not just visual tales about ways of living but are much more directly the proof and manifestation of such varied existences.

What I am saying here about the reality status of works of art relies, of course, on what was asserted in the beginning; namely, that works of art share with other items of objective reality their resistance to any modifi-

cation caused by the perceptual activity of the viewer. Just as a given tree remains that tree regardless of the versions of appearance anybody finds in it, so does a painting or sculpture.

But is this really true? Nowadays, the experience of perceiving a work of art is often described as a mere recreation of the mind. The work is said to be entirely at the mercy of how it is being apprehended. Actually this is not so. Anybody trying responsibly to ascertain the composition of a painting or a piece of music will be struck by the realization that the work rejects certain structures tried on it for size. In such cases, the work's objectively given perceptual properties will refuse to conform to the requirements of the interpretation. In the last analysis, the work will fit only one of those structures.

The same is true for the meaning we attribute to these structures. It is precisely this resistance that qualifies works of art as belonging to objective reality, like boats and mountains. This is not to say that all people see the same things; but whatever someone sees asks him the question, Do you see me the way I am?

A similar objective quality exists also in literature. I am not referring here to a reader's belief in the factual truth of a story that is being told, such as a faithful believer's conviction in the truth of the Bible. I do mean to deny a reader's right, now so commonly affirmed, to deconstruct the nature and meaning of a valid literary statement. A successful literary statement carries conviction in the same sense in which a good portrait or landscape takes the viewer into the presence of what is represented, without, however, creating the illusion that this presence is physically real. Similarly, readers immersed in the *Odyssey* or a story by Boccaccio experience the account as taking place even though they know that they are dealing with a piece of writing invented and recorded by someone, perhaps ages ago. The author of such a tale has no place in the story. He may invoke the muse on the first page, but then he better vanish if he is to avoid the ontological muddle observable, for example, in Dostoievsky's *The Brothers Karamazov*, where the narrator keeps talking about "our town" and says things like, "Why Ivan Fyodorovitch had come among us I remember asking myself at the time," even though no such person as the narrator appears in the story. If he is telling the story, there is no way of understanding how he managed to attend the scenes he is describing or know the thoughts he reveals. By abstaining from any such reference to a narrator, the awkward figment of an omnipresent, omniscient witness is avoided. The story is experienced not as a report but as a happening, a reality taking place in the mind of the reader.

a work of art requires careful, prolonged viewing ... certain people have a greater capacity than others to delve deeper into works and therefore the KNOW BETTER but NOT ALWAYS.

The partial physical reality of perceived events is particularly strong on the stage, where the presence of actors and scene is physically confirmed. The resulting immersion makes for participation, which is what Bertolt Brecht (1957) wanted to avoid in his epic theater when he asked the people in the audience to sit back and smoke a cigar. He wanted to reduce the reality of his plays to a mere demonstration of exemplary fables to be judged politically. Unfortunately for his Marxist pedagogy, Brecht was too good a dramatist to succeed.

By contrast, the immediacy of authentic reality is exactly what Alain Robbe-Grillet wants to protect when, in his book *Pour un nouveau roman* (1963), he complains about critics interpreting Franz Kafka's stories as allegories. The "absolute reality" he rightly attributes to Kafka's reports may be said to be the indispensable condition of their principal effect. They demonstrate by direct evidence the ghostly absurdity of the world as it really is.

In a related argument, Robbe-Grillet also objects to the literary use of what he calls analogical references, especially the attribution of human qualities to the world of things. By calling a mountain "majestic," he says, one reduces its status to that of a mere reflection of the human condition and one interferes with the mountain's own inherent reality.

What interests me here is not the legitimacy of analogies but the ability of the verbal medium to use them. It is an ability that derives from a fundamental property of verbal language. A painter cannot call a mountain majestic; he can only make it rear up. This is due to the difference between perceptual and verbal concepts. Perceptual concepts are qualities found within the perceived object itself, whereas words are the husks of concepts they evoke in order to make the percepts appear. Therefore, verbal concepts can be taken freely from categories that do not coincide with the intended percepts. They may be too large, or they may merely overlap the percepts. The concept "majestic" overlaps the percept "mountain." Clearly, it has its center elsewhere, among emperors and kings.

I will illustrate this property of language by citing a famous example of its literary use. At the beginning of his *L'éducation sentimentale*, Gustave Flaubert describes the departure of a river boat with all the concreteness of which only a master magician is capable. Young Frédéric watches the villas, hills, and trees on the banks of the Seine glide past the boat. The picturesque groups of the travelers on board come into sharp focus as in an old photograph, and so does the figure of the mercurial entrepreneur, Jacques Arnoux. We see him flirting with a peasant woman and find out how he looks and what he wears. We learn about the first conversation between the two men. Then, wishing to return to the first-class section of

the boat, Frédéric pushes the gate open and climbs across two hunters and their dogs. Suddenly the narrative runs us into the shock of a concise statement of five words: *Ce fut comme une apparition*, roughly translatable as, "It came like an apparition." Before we are told what Frédéric sees, the abstract concept of apparition enters personified, covering the scene with the connotations of a religious miracle, hallucination, dream, phantom, or illusion. Apparition precedes appearance, and the sublimation of Mme. Arnoux's beauty defines her before we see her.

No other medium could match this effect. A painter or film maker could bathe a seated woman in a silky light but could not use the abstract concept itself as a powerfully condensed perceptual substance. Yet precisely this absence of direct fit between language and subject matter is objectionable to a writer such as Robbe-Grillet, who, in the manner of most innovators, wishes to go back to the authentic substance of reality. He demands that the writer strip the things he describes of all signifying power. They should possess nothing but their existence; they should simply be *there*. Spatial dimensions should be rendered as nothing but dimensions, distances as nothing but distances. And, indeed, when Robbe-Grillet describes the box of his inkwell as a cube of certain measurements, the object is chilled by being deprived of function, expression, familiarity.

But does this procedure reduce the object to mere meaningless existence? In the arts, I can think of only one condition at which something can succeed in "just being there," and that is when it does not belong. Think, for example, of a bronze statue of Abraham Lincoln standing upright and behind him, equally of bronze, a chair, and let us assume for the argument's sake that the viewer tries in vain to relate the chair to the figure— visually, compositionally, or connotatively. In that case, the chair is indeed reduced to mere silly existence, but at the price of no longer being art. In the descriptions of the *nouveau roman*, the reduction of objects to their purely formal properties succeeds in expressing their independence of, or alienation from, man, which is far from a lack of significance.

But this vain attempt to reduce an object of art to mere existence suggests a final observation, without which my argument would be lopsided. I asserted that a work of art, being a percept just like all the other objects that can be observed in this world, belongs among the real things that populate the phenomenal world. I must add now that in one important respect the work of art is not like the creations of nature. It can never just *be there*, the way a stone, an animal, or an ocean can just *be there*. Being a product of human beings, the work of art can be there only for a purpose or, at least, for a reason. This difference does not show up at early levels of human thinking because for early man everything in this world was

motivated by some intention. Only when, with the advent of natural science, the things of nature stood revealed as being due to nothing but their causes, the difference between a statue and a living creature could no longer be overlooked. A lion in the wild is no longer questioned as to why it exists; a stone lion is. Similarly, a live human being is just *there*, but an image of man, made by a human craftsman, owes its reality to a purpose.

REFERENCES

Arnheim, Rudolf. 1966. "The Robin and the Saint." In *Toward a Psychology of Art*. Berkeley and Los Angeles: University of California Press.

Brecht, Bertolt. 1957. *Schriften zum Theater*. Frankfurt: Suhrkamp.

Robbe-Grillet, Alain. 1963. *Pour un nouveau roman*. Paris: Editions de Minuit.

Seiroku, Noma. 1960. *Haniwa*. New York: Asia Society.

SPACE AS AN IMAGE OF TIME

THE HUMAN MIND is burdened with the task of coping with mortality—
the coming and going of things. Experience tells us that the physical
existence of anything in this world is limited. But we also make a psy-
chological distinction between the durability of what is unique and what is
not. The objects of daily consumption, for example, do not last beyond
their physical presence. One pair of socks is replaced by the next without
leaving in our memory a trace of its particular nature. But perhaps there
was something about a particular pair of shoes that still distinguishes it in
our memory from the shape and feel of other pairs and connects it with
experiences unique to this pair. The more unique a particular object or
kind of object is in our consciousness, the more it resists mortality. When
we deal with human beings, whose individuality tends to outweigh their
anonymity in their species, their uniqueness generally prevails. Their per-
sonality occupies a special place in our mind, ready to be brought into our
presence, regardless of where their physical counterpart happens to be
located, regardless in fact of whether they are alive or dead.

Space and time behave differently, depending on whether we are con-
cerned with the existence of things in the physical world or in our con-
sciousness. I cannot be aware of the physical presence of an object unless
its lifeline runs parallel to mine for a period of time. Physically, the en-
counter may be limited to a short moment, as when I look at a flower. But
that moment may suffice to give me a sense of the harmony, symmetry,
and wealth of its form—a visual experience sufficient to endow the image

Derived from "Space as an Image of Time," first published in *Images of Romanticism: Verbal
and Visual Affinities*, edited by Karl Kroeber and William Walling (New Haven, Conn.: Yale
University Press, 1978), and from "Visual Dynamics," *American Scientist*, 76 (November–
December 1988), pp. 585–591.

with some immortality in my mind and thereby distinguish it from the coming and going of so many things around me.

My exposure to the flower did not involve any change of the image, therefore, although time passed on the clock while I was looking. It took place outside of time, in space only. My looking told me nothing about the flower's story, nothing about its growth and decay. Happenings enter experience only when the passing of clock time is accompanied by the perception of change. Change presupposes that the differential of clock time encompasses more than one location in space. It takes at least two locations to establish a direction (Lewin, 1957, pp. 43–59). This means that, strictly speaking, perception must always be supplemented by memory, the two being inseparable. Time, to be graspable, must translate into the simultaneity of space.

I have had occasion elsewhere (Arnheim, 1974, p. 373) to point out that, to be grasped by the mind as a whole, a perceptual entity must be given in the synoptic condition of visual space. The sense of sight is the only one that offers spatial simultaneity of reasonably complex patterns. Accordingly, a musical composition, choreography, novel, play, or film, to be conceived as a whole, must be available in the form of a synoptic image. And this is so although the medium may be aural and the structure to be scrutinized not an immobile picture but a succession of happenings in time. If a musical composition were made up moment by moment without any conception of a larger whole, it could only be a loose improvisation, raw material perhaps for something to be organized later; and a listener who perceives only what strikes his ear at any particular instant cannot comprehend anything of the whole piece, except perhaps its overall texture. Note here that the so-called *Urlinie*, the term by which Heinrich Schenker describes the fundamental structure underlying a musical composition, is an eminently visualizable notion (Schenker, [1931] 1969).

One can hardly make any general statement on how, in the course of creating a work of temporal sequence, a composer, choreographer, or dramatist conceives of the work's synoptic image while establishing the action of events in detail. There must be an intricate interplay of visual and nonvisual imagery. What can be affirmed with some certainty is that for human cognition in general, the conception of static situations precedes that of sequential ones. This may seem surprising given that information reaches us in sequence and events are what arouse attention. One might assume that the more automatic and elementary the storing process is, the more closely it should cling to happenings in time. Actually, more nearly the opposite is true. To be sure, events are narrated as events; but when

it comes to describing situations, the more elementary form of imagery consists of static configurations.

Static configurations are spatial, and the preference for them is certainly due in part to the nature of memory. The physiological basis of memory is still poorly understood even in its most elementary features. Are the traces of specific experiences located in specific places of the brain, as some clinical observations suggest? Are these traces field processes spread over broad brain areas and dependent on overall organization? Or is the totality of memory holdings perhaps completely represented in every particular area, as in a hologram? Whatever the answer, one fact is indisputable: the inputs, arriving in temporal succession, are stored in some sort of spatial arrangement, and the human mind can correspondingly confront and compare images independently of their sequential succession. Memory enables a person not only to perform in his head an entire symphony for the mind's ear—in which case the sequence is preserved—but also to survey the structural pattern of the whole composition the way he scans a landscape, with all its formations, spread before his eyes. Surely this second ability is the more admirable one. Involving a reorganization, it is less mechanical, and it enables us to overcome the ephemerality of time and see interrelations.

To do the same for a historical sequence, to cross-connect events ordered by their succession in time, is much more difficult. Going against the grain of the original structure does it violence. Even so, spatial synopsis is the primary approach of the human mind. Taxonomy precedes history. Spatial synthesis may also be called the vision of ultimate wisdom, attained when mere sequence has been overcome and the world presents itself in the simultaneity of its whole. Hence, the power of such visions as Plato's *eidola* or Dante's architectural structure of vices and virtues, which classifies human types regardless of their historical location. From there it is not far to the thought that an omniscient being would transcend the sequence of events in favor of a synopsis of the whole. In a curious meditation written in 1787, the German philosopher Karl Philipp Moritz suggested that the events experienced by humans in unrolling sequence exist in the consciousness of God as a simultaneity. In God, he said, "the entire life of a person stands eternally in juxtaposition like a painting, in which light and shadow intermingle beautifully, whereas the human being must live through it to comprehend it" (1981, p. 307).

The translation of temporal succession into spatial simultaneity may facilitate an individual's coping with sequences. This brings to mind the curious history of what Frances Yates (1966) has described as the art of "artificial memory." It was developed in antiquity as a mnemonic crutch

for orators to help them remember the correct sequence of their argument. On the dubious assumption that the location of items in a perceptual setting is more easily remembered than are the links of a logical disquisition, rhetoricians proposed the use of an imaginary architectural environment. The orator was to picture in his mind the various components of this environment—doors, windows, walls, furniture—so as to deposit on each of them a fictitious object that was relatable to a particular aspect of his presentation. An anchor reminded him to speak of naval operations, a weapon of military matters, and so on. As he scanned the imaginary setting, he safely proceeded from item to item, in the order in which he had deposited them.

This method transforms the temporal sequence of the argument into spatial simultaneity but without taking advantage of the opportunity for synopsis. Rather, the spatial elements are processed one by one as a means of reconstructing the sequence. It is a mnemonic trick different in principle, for instance, from the medieval practice exemplified by Ramon Lull. There, memory serves to visualize a cosmological and philosophical system, a spatial pattern, whose relational aspects are explored by the searching mind.

The spatial image of a historical array may, at its most primitive level, present itself as a mere unstructured accumulation of items. For example, a student of art history may at an early stage of learning conceive of the painters of the Quattrocento as a mere set of individuals: Mantegna and Raphael, Gentile da Fabriano, Piero della Francesca—all in the same container. Only gradually does the student begin to see the causal relations that interconnect the various artists in a coherent structure.

It is useful here not too hastily to identify causal connection with temporal sequence. Although technically any causal relation involves a temporal sequence, the time dimension may be overshadowed by the factual influence (Arnheim, 1986). For example, when Thomas Mann at the beginning of his biblical novel *Die Geschichten Jaakobs* (Joseph and His Brothers) tells the story of the Hebrew forefathers, he compares the sequence of generations from Abraham through Jacob to Joseph with that of promontories appearing one after the other as one walks along a sea coast—an intrinsically spatial image in which similarity, repetition, and imitation are as relevant as the temporal sequence (Mann, 1933, Prelude). In fact, the sequence of the sights can be reversed or otherwise altered: tradition and prophecy are exchangeable. In Mann's story, the sequence derives its dynamics from the emphasis on the progenitor, the man from Ur of the Chaldees, the first embodiment of a pattern that is reenacted in the behavior of his descendants. But the arrow can also run the other way

when in such a series the emphasis is on the end rather than on the beginning as, for example, in the prefigurations of Christ drawn from the Old Testament (Auerbach, 1959). Here the dynamics of the power structure is not that of an imitation of what has been but of an anticipation discovered in retrospect.

In the arts, the timeless media such as painting, sculpture, or architecture can be thought of as the human mind's refuge from the Heraclitic flow of events, by which things located at different moments of time are, in the strictest sense, unrelatable. The artist may synthesize in a single image aspects of a story remote from one another in time and thereby make their relation directly visible. A famous example is the coalescence of nativity and pietà in Christian imagery: the Madonna cradles her child in her arms while at the same time holding the body of her dead son after the crucifixion.

This synthesizing power of timeless art tends to be understood spontaneously by unprejudiced viewers. But one can also overlook the difference between the media out of pedantry, as happened historically when painters who used the plots of theater plays as subjects for their pictures were accused by critics of showing persons and actions together that appeared separately in sequence on the stage. For an example I will rely on an article by art historian James Henry Rubin (1977) that recounts what happened in 1802 when French painter Pierre-Narcisse Guérin exhibited a painting derived from Jean Racine's tragedy *Phèdre*. The play tells the mythological story of Phaedra, wife of King Theseus, who falls in love with her stepson, Hippolytus, and is persuaded by her confidante, Oenone, to accuse the son of trying to seduce her. The enraged king has his innocent son killed, while Phaedra, overcome by her sense of guilt, takes poison. The death of the two leading characters releases the tension created by the conflict. The painter Guérin, a classicist follower of Jacques-Louis David, shows the principal themes of the plot in their direct interaction (Figure 4). Hippolytus rejects the accusation; his father listens to him with deep apprehension; and the queen, in the turmoil of her conflicting impulses, turns away from the confrontation and is urged by her confidante to insist on the false accusation.

Guérin, whom the poet Charles Baudelaire calls an abstractor of quintessences, reduces each figure to its dynamic theme. Hippolytus, petrified and detached by some distance from the group, does not actively engage in his defense. The verticality of his stance and the right angle that straightens his gesture of rejection freeze his response into immobility, whereas the king, closed off by a rectangular back wall, is swept away from his son in a powerful diagonal wave. The queen is caught in this rebound

FIGURE 4.
Pierre-Narcisse Guérin, Phédre. 1802. Louvre, Paris.

but is nevertheless kept out of it by her frontality, which ties her to the equally frontal position of Hippolytus. The innocent youth and the guilty woman are kept parallel by their detachment from the sweep of the accusation, while the confidante seeks to increase the intensity of the attack.

Because memory is a biological instrument brought about in evolution for a definite purpose, it cannot collect things indiscriminately as a waste-basket does. It must operate intelligently. Freud once compared the human mind with the city of Rome as it would be if all its historical shapes, from the oldest settlement on the Palatine hill to the metropolis of today, continued to coexist, nothing having ever vanished from the site (Freud, 1930). It seems evident that such a spectacle of interpenetrating phantasms would constitute a functioning image only if each pattern of memory traces either kept its autonomy or organized its relation to the other patterns in a new, more comprehensive whole.

Also, accession to memory must depend on the value of the item for the organism, and the length of the item's survival in the mind must depend on its impact and usefulness. Compared with the purely physical life span of material things, selective survival in memory demonstrates a superior wisdom and an intelligence. There is something vulgar about clinging to existence just for existence's sake. When it comes to belief in survival after death, the dignity or indignity of such a belief depends on whether survival

is conceived of merely as a primitive extension of physical existence and therefore is granted automatically to everybody or whether survival is the purely mental persistence in the memory of posterity.

To the extent that memory is determined by the value of what it preserves, it clashes with the apparent arbitrariness of the purely physical and biological life span, its dates of appearance and disappearance, and its duration. By the standards of reason, such facts often look meaningless: Why did a certain person live a long life, another a short one? Why did someone make his entrance on the stage of history when he did and neither earlier nor later? There is always a temptation to read rational sense into physical events. Thus, when Goethe was sixty-four years old, he once startled a visitor by talking as though death were an intentional act of the person. He said that "Raphael was barely in his thirties, Kepler hardly in his early forties [sic] when both suddenly put an end to their lives, whereas Wieland [lived to be eighty]" (1909, letter of Jan. 25, 1813). When the visitor objected to this notion, Goethe replied that it was a liberty he often permitted himself to take. He then proceeded to improvise a natural philosophy according to which "the ultimate constituents of all beings" persisted in time according to a hierarchical order. It is tempting enough for an artist like Goethe, accustomed to shaping imaginary worlds in conformity with an underlying meaning, to treat the entrances and exits of human beings as though they were the behavior of players.

If one looks at actual courses of life as though they were meaningful creations, long and short lives appear not so much as biological accidents but as displays of various structures, whose character depends on their length, just as a short piano piece, or lied, offers different opportunities from those of a grand opera. The long lives of a Titian or a Paul Cézanne are experiments with extended structures, as distinguished from the short ones of a Vincent Van Gogh or a Georges Seurat. A long life of activity, by its dependence on the biological curve of youth, maturity, and decline, suggests distinctive qualities for each phase of the work, whereas the short life goes with the incompleteness of a fragment or the rapid unfolding of an early but final flower. We tend to impose a curious interaction on the relation between the chronological length of a person's life and the substance he invested in it. Thus, although both Beethoven and Marcel Proust lived about fifty years, we may think of the composer's life as incredibly compacted because it reached from the courtly music of the eighteenth century to the tragically modern discords of his late work, whereas Proust's life seems spread like a gossamer because so much of it was given to a single work, toned to a persistent key.

We tend to challenge and manipulate the temporal conditions of physical

things and events. On the one hand, Leonardo's *Last Supper* survives for us in its essentials despite the precarious flakes of much adulterated color of which the painting consists today. On the other hand, the durability of works that deserve to be forgotten seems almost offensive. Less obvious but equally influential are the ways in which history is subdivided into periods and styles, depending on how their characteristics are defined and to whom they are attributed. In relation to these periods, we envision individuals as placed centrally or transitionally; we pair and group them; we see them as companions, adversaries, or followers. All these relations are not so much chronological as structural, and the structural relations tend to be experienced as spatial.

It would be interesting to study the answers of semieducated people to questions about the dates of birth and death of prominent persons or the years in which certain events took place. Mistakes, that is, deviations from the correct dates, often derive not from random guessing but from the placement assigned to the person or fact in the historical image. I remember while I was a student having often been surprised to discover that great men were still alive. The independence and completeness of their work and their identification with a period of the past seemed to militate against any overlap with my own place in time. How could an Impressionist or the founder of psychoanalysis or a leader of the Russian Revolution still be around while I was living in the next chapter of history?

By the same token, it will seem anachronistic to some that Claude Monet still lived and painted in the years of Cubism, whereas others will locate him comfortably in our century because they consider his influence on the Abstract Expressionists of the 1940s. If someone conceives of Michelangelo as having had a substantial part in the early Renaissance, it may come as a surprise to find that in 1500 the artist was only twenty-five years old. Similarly, if someone thinks of Michelangelo and Leonardo as a pair of parallel figures, he may be disturbed to discover that Leonardo was born twenty-three years earlier and Michelangelo lived forty-five years longer. Structural relations suggest spatial configurations within our image of history. If the chronological dates do not fit them, too bad for the dates! Depending on which role one attributes to the Council of Trent, the earthquake of Lisbon, or the invention of photography, one will assign them their places.

As I began this discussion by pointing to the human mind's coping with the mortality of existing things, I will conclude with a reference to two conceptions that continue to offer serenity to believer and unbeliever alike. One deals with individual existence and its place in the broader context of persistent reality and amounts to an overcoming of the parochial notion of

temporality. This conception can take the form of a relay pattern, as in the religious doctrine of the transmigration of souls. It thereby extends the individual life span to a chain of continuing existences. Or, less dynamically, this conception can propose a permanent world soul, of which the individual is a partial manifestation. A psychological version of this view was alive in Marcel Proust when he wrote, "For no man of genius can give birth to immortal works unless he creates them in the image not of the mortal being he is, but of the example of mankind he carries within himself. In some way his thoughts are loaned to him during his lifetime, of which they are the companions. At his death they return to humanity and teach it" (Proust, 1970). Translated into the philosophy of a scientist, a similar view is reflected in the reply given by Albert Einstein when he lay gravely ill and was asked whether he was afraid of death: "I feel so much solidarity with every living thing that it makes no difference to me where an individual begins or leaves off" (Einstein, 1969).

The other source of serenity I have in mind shifts the liabilities of physical time conditions to the more rational regime of human memory. A person given to contemplation, a thinker perhaps or an artist, or simply someone whose life internalizes itself through the effect of advancing age, can afford to say with Edmund Husserl that "for the consideration of essences the difference between direct perception and mere reminiscence is irrelevant" (Husserl, 1964). Such a person tends to cultivate the world of his images as the real one, a world where presence and persistence depend on value and where access to his masters, friends, lovers, and loved ones no longer depends entirely on their being among the living. It is a world in which past events are available for retrieval and precious objects are safe from vandals and from the acids of the chemical industry. Whatever the world of the mind has to offer or would be able to offer becomes the world as it is. In the safety of the timelessness of space, one appreciates the ancient words of Alcmaeon, a Pythagorean philosopher who taught that "men die for this reason that they cannot join the beginning to the end" (Kirk and Raven, 1963, p. 235).

REFERENCES

Arnheim, Rudolf. 1974. *Art and Visual Perception*. Berkeley and Los Angeles: University of California Press.

―――. 1986. "A Stricture on Space and Time." In *New Essays on the Psychology of Art*. Berkeley and Los Angeles: University of California Press.

Auerbach, Erich. 1959. "Figura." In *Scenes from the Drama of European Literature*. New York: Meridian.

Einstein, Albert. 1969. *Briefwechsel 1916–1955 von Albert Einstein und Hedwig Born und Max Born.* Munich: Nymphenburger Verlagshandlung.

Freud, Sigmund. 1930. *Das Unbehagen in der Kultur.* Vienna: International Psychoanalytic Verlag.

Goethe, Johann Wolfgang von. 1909. *Goethes Gespräche.* Edited by Flodoard Frhr. von Biedermann. Leipzig: Biedermann.

Husserl, Edmund. 1964. *Die Idee der Phänomenologie,* Lecture 5. The Hague: Nijhoff.

Kirk, G. S., and J. E. Raven. 1963. *The Pre-Socratic Philosophers.* Cambridge: Cambridge University Press.

Lewin, Kurt. 1957. "Defining the Field at a Given Time." In *Field Theory in Social Science.* New York: Harper.

Mann, Thomas. 1933. "Prelude." *Die Geschichten Jaakobs.* Berlin: Fischer.

Moritz, Karl Philipp. [1787] 1981. "Fragmente aus dem Tagebuche eines Geistersehers." In *Werke.* Edited by Horst Günther, vol. 3. Frankfurt: Insel Verlag.

Proust, Marcel. 1970. "En mémoire des églises assassinées." In *Pastiches et mélanges.* Paris: Gallimard.

Rubin, James Henry. 1977. "Guerin's painting of *Phèdre* and the Postrevolutionary Revival of Racine." *Art Bulletin* 59, pp. 601–618.

Schenker, Heinrich. [1931] 1969. *Five Graphic Music Analyses.* New York: Dover.

Yates, Frances A. 1966. *The Art of Memory.* Harmondsworth: Penguin.

THE READING OF IMAGES
AND THE IMAGES OF READING

VISUAL IMAGES AND verbal language are the two principal means by which human beings tell their life experiences. The visual arts and literature are ways of using these means of representation and communication artistically. In some regards the two kinds of media differ profoundly from each other; in others, their objectives and ways of attaining them seem strikingly similar. A few of these differences and similarities will be illustrated in the following.

Both visual perception and speech depend on images, but in neither case can those images be identified with the optical projections of the physical world produced on the retinal surfaces of the eyes. Among experiences, the closest to the physical raw material of vision is what happens when we open our eyes and expose ourselves passively to the presence of the outer world. Within the range covered by the visual field, the projection of that outer world seems to present itself completely and objectively. In practice, however, this primary presence of the world is immediately modified by the active processes deserving the name of perception. Instead of the mechanical recording of stimuli, vision consists of selecting and organizing, which are cognitive activities directly related to recognizing and understanding.

Language presents itself as a distinctly different medium, in that it consists of abstract sounds or shapes to which meaning is attached by mere convention. "Meaning" refers here primarily to the sensory experiences on which human consciousness relies. The words of a language, then, acquire

Derived from "The Images of Pictures and Words," *Word & Image 2* (October–December 1986), pp. 306–310, and from "The Reading of Images and the Images of Reading" in *Space, Time, Image, Sign*, edited by James A. W. Hefferman (New York: Peter Lang, 1987).

meaning by conjuring up the kinds of percepts to which social tradition has related them.

Although both visual art and literature rely on images, the images called up by words are indirect. They are mental images deriving for the most part from direct perceptions that are gathered during the person's life. The nature of these images varies from the most complete to the most insubstantial, and in the latter case the images may seem to possess no perceptual quality at all. Those closest to optical projection are the so-called eidetic images, faithful recordings of things seen, which are experienced by few people. They are best described as physiological stimulations rather than as the more typical products of the mind we call mental images.

When mental images are conjured up by literature, they may be quite concrete. Some readers of a story may readily describe the hair color and dress of the heroine even though no such details are supplied by the author. Others experience nothing but fleeting expressive qualities carried by shadowy vehicles of figures, settings, or happenings. These, in fact, are the better readers when their imagery is limited to the features actually supplied by the writer. A good writer takes advantage of his power to limit his description to what he cares to select, and readers will be unable to apprehend the particular level of such abstraction unless they keep their imagery to what is being offered.

Painters and sculptors, of course, are even more compellingly empowered to determine the level of realism at which their works are to be received. Even viewers intent on misusing their "imagination" would find it difficult to supply, say, a highly stylized African wood figure with the details of lifelike anatomy and equipment.

Thus, essential similarities seem to exist between the ways the two kinds of media communicate their messages. Differences, however, become particularly apparent when the artistic tasks consist not simply in describing physical situations and actions but in rendering the thoughts that distinguish human experience. Language refers directly to concepts such as "love" or "ambition," whereas visual art is equipped with nothing but shapes, colors, and, sometimes, motion. How does one reason in images? I shall try to illustrate the answer to this question by referring to the different ways a poet and a painter deal with a theme intended to reflect the basic philosophy of life.

The painter Eugène Delacroix used scenes from Shakespeare's *Hamlet* for some of his paintings and lithographs. He depicted Hamlet facing the ghost, taking leave of Ophelia, killing Polonius, and acting out other scenes of the play. Delacroix was especially attracted, however, by the meeting of Hamlet and Horatio with the gravediggers. In that scene Shakespeare displays the whole range of his brilliance. He has Hamlet

FIGURE 5.
Eugène Delacroix, Hamlet and Horatio with the Gravediggers. 1839.
Louvre, Paris.

argue about suicide, and he compares the chilly anonymity of the skull
with personalities of the politician, the courtier, and the lawyer to whom
it may have belonged and with the tender humanity of the jester Yorick,
to whom it did belong. Hamlet muses on the heroic greatness of the con-
queror Alexander coming to dust. When from this firework of spirited wit
we go to Delacroix's painting in the Louvre, we may be tempted unfairly
to confront the picture with the play and complain that the painter gives
us none of these precious thoughts but merely the physical scene of the
prince and his friend standing there by the grave (Figure 5).

The confrontation is particularly inviting when we consider a passage in Delacroix's *Journals* (September 23, 1854) where under the heading "About silence and the silent arts" he says:

> I confess my predilection for the silent arts, for those mute things of which Poussin said that they were his profession. Language is indiscreet, it goes after you, it solicits your attention and stirs up discussion. Painting and sculpture seem more dignified—one must go and seek them out. . . . The work of the painter and the sculptor is all of a piece like the works of nature. Its author is not present in it, he does not engage you like the writer or the orator. He offers reality that is somehow tangible, yet full of mystery. (p. 276)

What, then, accounts for this mysterious tangibility of pictures?

How is Delacroix's painting constructed? Close to its geometrical center our attention is caught by the death's head, whose isolated compactness displays the conceptual symbolism of mortality as the theme. The challenge of death is brutally launched by the gravedigger, who emerges from the ground and initiates a powerful diagonal aimed at the sensitive face of the prince. Such a diagonal is one of the most active, dynamic moves at the disposal of the visual artist. Here it attacks, as though with a cannon ball, the vertical tower of the two figures, the prince and the courtier, who represent worldly prosperity and are centered high up in the clouds. The theatrical scene is condensed to an abstract clash between the brightness of sovereignty and the darkness of matter, between up and down; and the defiance is not without effect. The two men's heads surrender some of their verticality. They offer as a response a slight counterdiagonal, which is reinforced by the gesture of withdrawal performed by Hamlet's hands.

One could elaborate this analysis as further evidence of the intelligent symbolism to which the painter submits the visual scene in his composition. None of the thoughts Shakespeare devoted to the encounter at Yorick's grave is spelled out explicitly by the painter, but the immediacy of his visual metaphors has no counterpart in the indirect medium of verbal language.

Shakespeare's dialogue, of course, is not charged with the task to which Delacroix's painting is devoted. It does not need to describe the outer events of the scene taking place on the stage. Instead, it deals with the ideas presented by the play's characters. Conceptual thoughts, however, do not keep the literary statements from dressing their presentation in imagery. For each such statement a stage of its own is invented, a stage quite different from the one on which the play is taking place. Take the

gravedigger's demonstration of the ethical and legal difference between drowning oneself and being drowned:

> Give me leave. Here lies the water—good. Here stands the man—good. If the man go to this water and drown himself, it is, will he nill he, he goes, mark you that. But if the water come to him, and drown him, he drowns not himself—argal, he that is not guilty of his own death, shortens not his own life. (5.I.10)

The mental performance displayed by the debating mind differs from the material robustness of an actually perceived visual scene. At the command of the speaker's reasoning, his mind can conjure up two scenes instead of just one, that of the man who drowns himself and that of the other man who is drowned by the water. It can reduce the scenes to their essential elements, to nothing but the man moving toward the water and the water moving toward the man, and it can place them in the schematic opposition from which the moral verdict derives.

The acrobatics to which thought can subject imagery in verbal speech is well illustrated by another passage from the same scene of *Hamlet*. The prince, marveling at the sophistication of the gravedigger's reasoning, says, "By the Lord, Horatio, this three years I have took note of it, the age is grown so picked that the toe of the peasant comes so near the heel of the courtier, he galls his kibe" (5.I.130), that is, he rubs the sores on his heel. The comparison between the intellectual powers of two social classes is translated into the bodily contiguity of two individual persons standing next to each other, and the mental irritation caused by the closeness becomes the physical affliction of the courtier's sensitive heel. This metaphoric transformation of an abstract fact into a concrete image is the stuff of which art is made.

The combination of theoretical assertions with narrative images is further enriched in literature by the expressive sound qualities of words. Rhythm, in particular, characterizes the nature of speech and of the events described in the story. One more example, this one taken from Proverbs (7:1–18), will make the point.

This passage from the Bible (Authorized Version) contains the admonitions of a father to his son and thus begins with a set of imperatives. Dynamically, by means of repetition, the father's commandments hammer the message in, with the rhythmical pounding of a pile driver. The first imperative is the most abstract: "My son, keep my words and lay up my commandments with thee." The following two step up the imagery: "Keep my commandments, and live; and my law as the apple of thine eye. Bind them upon thy fingers, write them upon the table of thine heart." The very

multiplicity of the metaphors, however, makes them neutralize one another by preventing the mind from fastening on any one image. Two more imperatives now introduce the theme of woman: "Say unto wisdom, Thou art my sister; and call understanding thy kinswoman." The perceptually pallid terms *wisdom* and *understanding* receive the breath of life by entering the family relation, but, conversely, the sister and the kinswoman lose some of their presence by serving purely figural speech.

Now, however, by a stroke of virtuosity, the writer infuses the image of woman with ever increasing concreteness. The allegorical generality of the sister and kinswoman changes into the tangible picture of the temptress: "That they may keep thee from the strange woman, from the stranger which flattereth with her words." The preacher turns into a narrator, a peeping neighbor who tells a story that enriches the reader's mental image with all the trappings of an individual event: "For at the window of my house I looked through my casement. And behold among the simple ones, I discerned among the youths a young man void of understanding. Passing through the street near her corner." And here the writer applies a technique comparable to the montage of short pieces by which filmmakers speed up their action. Not only are the verbal elements kept short; they also interrupt the linear course of the story by accumulating different aspects of the same fact. This device creates a breathtaking intensification when it accelerates the darkening of the night in which the seduction occurs: "And he went the way to her house, in the twilight, in the evening, in the black and dark night." By the same cinematographic device the writer captures the hectic rushing of the man-hunting woman: "And her feet abide not in her house: now is she without, now in the streets, and lieth in wait at every corner." Then the story of the seduction unfolds.

Notice here also that whereas a painter or sculptor would be strictly limited to the one modality of vision, the literary narrator enlists the cooperation of the various senses. In our example, vision carries the action along, but also present are touch and kinesthesia—"So she caught him and kissed him"—and sound: "She is loud and stubborn." And finally the sense of smell lends a primitive immediacy to the seduction: "I have perfumed my bed with myrrh, aloes, and cinnamon. Come, let us take our fill of love until the morning."

The visual arts can aim at a similar enrichment when they add sound to the image. The mobile image of theater and film makes use of speech, noise, and music. Yet a significant difference obtains. The writer can switch from medium to medium, from sight to touch, from talk to smell, with the same ease with which in daily life attention makes us move among the modalities. He can do that not only because technically mere words

suffice to conjure up a smell, a street corner, or a military march, but also because the indirectness of the perceptual sensations evoked by speech raises them to a level of abstraction that facilitates the joining of the sensory dimensions. Instead of the direct sensory qualities that distinguish the image of a tree from the sound of water, the mental images called up by language are limited to the expressive qualities that are shared by all sense modalities. At that level, the sound of a cello may go with the darkness of a red wine, which provides the kind of direct comparability on which all art must rely.

In practical everyday life, perception is not hampered by the sensory discrepancy of the media. But in the arts, any statement must rely on the direct sensory connections among the constituents. One cannot combine a painted still life and the sound of a trumpet in the same perceptual unit. Therefore, the combination of media in the realm of direct image and sound is dependent on rules not binding for literature. I have tried to suggest elsewhere (Arnheim, 1957) that in opera, theater, or film, the combination of the media works best when the visual action and the sound action, be it music or speech, amount each to a complete structure of their own, so that the total work is not an inseparable conglomerate of visual and auditory ingredients but a combination of parallel, related, but separable patterns. A good opera, well performed, can be listened to as a coherent musical composition that is not torn to pieces by a lack of visual action, although the opera is incomplete without that action. And the well-directed stage action of an opera has a pantomimic wholeness of its own, even when none of its sound is heard. The same can be said for the spoken dialogue in theater and film. This aesthetically beneficial combination of separation and parallelism is particularly evident when the media are not fused in a unitary happening but complement each other, as do dance and music or the chanted narration at the Japanese puppet theater.

We have observed that language is the richest of the art media in that it draws freely on all sensory modalities as though they were the register of a single instrument. What is more, language can rarify its referents to so radical a degree that their images evaporate into intellectual concepts. Even so, when a poet writes—and I do not remember who did— "Perhaps my semblance might deceive the truth," the abstractions perform as concretely as do visible actors. At the same time, however, language pays for its sovereignty by being confined entirely to the realm of indirectness, the mental images of hearsay. In comparison, the visual arts win out by presenting a perceptual world in its sensory directness. To be sure, the immediacy of this presence confines the painter or sculptor to the tangible qualities of shape, color, and movement and makes concepts available only

indirectly as metaphorical derivates of sensations. Thus, the human mind, which does its work by constantly combining thought and image, profits from the virtues of language and perception and makes them compensate for each other's limitations.

REFERENCE

Arnheim, Rudolf. 1957. "A New Laocoön: Artistic Composites and the Talking Film." In *Film as Art*. Berkeley and Los Angeles: University of California Press.

WRITERS' POINTERS

WE TAKE OUR words so much for granted that it is useful to be reminded of some of their basic traits. The most influential of these traits is that words stand for concepts, which means that with the exception of proper names, a word refers not to a single being but to an indefinitely large number of them. The words *Mark Twain* point to a single person, but the word *mark* describes the activity of making a mark in general, and *twain* stands for twoness, be it twins or couples, pairs or doubles, or the measurements of any two units.

As words stand for concepts, they make us approach the world from a distance. Whatever is on your mind when you write the word *tree*, it implies the broadest category, and you have no way of foretelling whether in the mind of your reader it will conjure up a specific maple standing in the front yard or nothing but the schematic skeleton of an upright trunk with branches sticking out sideways. The difficulty created by this generality of connotation is that, however particular the image in the mind of the writer, a special effort must be made to create in the mind of the reader an equally particular image.

This effort consists in putting the word in context by giving it company. A company of words, each of them broad and generic, makes for a mutual narrowing of meaning until, if the writer so wishes, the tree stands as a maple in the front yard with yellow leaves dropping from its branches, while the autumn wind is blowing. But even if you are an experienced writer, it happens easily that you project the image in your mind on the words you are putting on paper and see something written there that your words do not contain. Your task, then, calls for alienating yourself from

First published in *Disciplinary Perspectives on Thinking and Writing*, edited by Barbara S. Morris (Ann Arbor: English Composition Board, University of Michigan, 1989).

your writing and looking at your words with the cold stare of the stranger who needs to be talked into anything you want to say.

Writing is so laborious because the world for which we want to account is fully given, whereas writing takes off from empty space. On the nothingness of a bare site we place brick after brick to slowly approach the whole. Here, however, hides another pitfall because the whole of a thing we attempt to describe is never identical with the whole circumscribed by our concept and hence in our writing. Remember here that neither the scientist nor the artist presumes to duplicate the world. If you try to accomplish such a duplication, you will deserve to be disappointed. Duplication is an inferior occupation, and although it can be barely brought about in plaster casts or sound recordings, it is luckily impossible in language. In fact, if you accumulate too many words to inventory a given subject, that subject may tend to vanish from the page.

We are not after completeness of rendering. To be sure, the world is given to us through our senses, and that means through individual concrete instances. Our senses are presented with *a* tree, *a* person, *a* feeling of pain. All we need to know about those instances, however, are some of their essentials, properties that are relevant to our needs. We need concepts. Even the instincts and learnings of nonverbal animals are geared to kinds of things and only rarely to unique individuality. Neither animals nor humans could have survived if their minds were limited to the distinction of particulars. This is why a language is a relatively small assortment of concepts, not an infinitely bulky directory of single instances.

Note here that in this respect proper names are no exception. Although the name *Mark Twain* refers to just one individual, it is generally used to designate the concept of Mr. Clemens that has been formed in public consciousness. To describe him, it is not enough to name him. The task of describing Mark Twain is much like that of describing a tree.

Writing, then, involves the intelligent occupation of accounting for the essentials of any subject by selecting the words that add up to our image of the whole. This is done by enlisting not as many words as possible but as few as possible. Homer, according to Gotthold Ephraim Lessing, "commonly uses only one trait for one thing, either the black ship or the hollow ship or the fast ship." In other styles of writing, the suitable choice of words and the way they are put together in the narrative sequence take real mastery. Here is an example from *Daisy Miller*, by Henry James:

> Presently a small boy came walking along the path—an urchin of nine or ten. The child, who was diminutive for his years, had an aged expression of countenance: a pale complexion, and sharp little features. He was dressed in

knickerbockers, with red stockings, which displayed his poor little spindle-shanks; he also wore a brilliant red cravat. He carried in his hand a long alpenstock, the sharp point of which he thrust into everything that he approached—the flower-beds, the garden-benches, the trains of the ladies' dresses. In front of Winterbourne he paused, looking at him with a pair of bright, penetrating little eyes. "Will you give me a lump of sugar?" he asked, in a sharp, hard little voice—a voice immature, and yet, somehow, not young.

The presentation starts with an action, the entrance of the boy, and bits of action are interspersed among bits of description to make the whole passage an eventful narration rather than a static catalog of traits. Also, a persistent theme—the spindliness and aggressive sharpness of the unattractive youngster—holds everything together and facilitates the creation of a unified image in the mind of the reader.

By the art of a skillful writer, a chain of separate words is turned into a coherent image whose components coexist in space. Here we become aware of another fundamental problem of writing. By its very nature, expository language is made up of chains of words following one another in sequence. Writing has no chords or double stops as music does. Writing must transform the world into a single file of things waiting for their turn in the course of time. This can work reasonably well for the narration of events, but in the world we know through our senses, relations in space are just as numerous and important as relations in time. Plenty of things happen at the same time all the time. How to account for them in a medium of communication that can channel only sequences is a problem that faces the writer whenever interrelated items are to be described in words.

Examples to illustrate this dilemma are easy to come by. Art historians are called on constantly to analyze, on paper, paintings, works of sculpture, or buildings. Detailed discussions of this kind have to be skillfully written if they are to hold the attention of their readers. And the panic of doctoral candidates faced for the first time with the task of organizing a book-sized piece of writing is largely due to the onslaught of facts and thoughts jostling for attention in no particular order but being variously intertwined by a jumble of connections. Or think of a historian trying to do justice to a multiplicity of political events whose complex interrelation has caused, say, the outbreak of a war. The challenge so masterfully met in the brief passage from Henry James repeats itself at every level of size and purpose, from a short sonnet to a legal brief or a literary essay, a scientific treatise, or a long novel.

A successful piece of writing looks like a gleaming engine in which a multitude of streamlined shapes fits together in a surveyable order. Ev-

erything is clearly needed, nothing is superfluous, and nothing needed is missing. But how is one to obtain such an enviable result? I will offer here one item of practical advice: never write drafts, if a draft means a piece of writing done with the explicit understanding that it is not to be final. Some people are proud of the large number of drafts they produce, mostly at great speed and in a half-daze. But such drafts are nothing to be proud of; they encourage sloppy writing. I am not referring to the ample notes everybody must make to preserve the thoughts and formulations that crowd the mind, especially at the early stages of a project, and that should be jotted down quickly and without any consideration of form, just clear enough to serve as memory aids. I mean to suggest that as soon as you begin to formulate the text of your writing, you should do it with the intent of finality. Wrestle with your words as Jacob wrestled with the angel saying, "I will not let you go, except you bless me." Insist on stalking the right expression, which hovers darkly in your mind, until at a lucky moment wording and meaning click together. The pages turned out by a great writer tend to look in manuscript like a massacre because he kept shaping, rejecting, and replacing his text in a pitiless fight for perfection. If instead you say, "This is good enough for this time; I shall do better in the next draft!" you dilute the discipline required for good work, and you are unlikely to arrive at your possible best in the end.

I said that words stand for concepts and that whatever we talk about is said at a high level of abstraction. Conceptual abstraction, I said, is indispensable for thinking and learning. Therefore, the conceptual medium of language is a most human gift, but it can exert its virtue only if your verbal abstractions manage to remind your reader constantly of the concrete matters they intend to elucidate. To maintain this lifeline, however, requires much skill and care. The connection is disrupted all too often, especially in theoretical writing, where the temptation to be satisfied with an easy juggling of abstract terms is ever present. The result of the writer's floating in the weightless space of what one might call a verbal algebra is that the reader is left with a clatter of dry sounds, the mere husks of nutrition.

And yet language itself offers us wonderful means of avoiding this desiccation. The words that are used figuratively often still contain the reference to the life-giving practical situation from which they are taken. Those roots, however, are often hidden. In English this is true especially of the French and Latin words brought into the language by the Normans, not to mention the importations from the Greek. Thus, to write English colorfully, some education helps. When Emily Dickinson says in one of her poems that "the attar from the rose is not expressed by suns alone,"

she uses the verb *to express* in its original Latin sense of squeezing out, and she plays on the slightly humorous parallelism between exalted expression and homely squeezing (Schlauch, 1942). This resonance of the original meaning, however, is likely to pass you by if your language has been flattened by daily use. Recently, a newspaper writer quoted the actress Ava Gardner as saying, "Deep down, I'm pretty superficial," wondering whether the lady knew that she was being funny. She knew it only if she was aware of the concrete origin of her words, which reveals the amusing paradox of finding a surface at the core of depth. Most likely, none of this occurred to the lady, who was probably referring to depth and superficiality without any of their original connotation. This is a neglect no writer can afford.

There is a curiously twofold relation of popular speech to verbal metaphor. On the one hand, as I just said, the words of common language tend to lose their perceptual base. In the awareness of the speakers they cease to be metaphors. On the other hand, however, popular language abounds in beautiful folksy similes taken from the practice of daily life. This is not for the purpose of decorating the language with fancy refinements; it simply reflects the speaker's down-to-earth universe of discourse. This is particularly evident in the speech of U.S. politicians. I open today's newspaper at random and find a Washington official quoted as saying, "Certainly there aren't any burning domestic issues on the front burner." The poetry of such speech is unlikely to be appreciated by the speaker. In fact, as he does not take the adjective *burning* literally, he fails to consider the precariousness of something burning on the stove. The reference to the kitchen, however, of which he is certainly aware, is, in his case, not a literary grace note applied to theoretical speech in order to make it more palatable but merely a symptom of the level of domestic concreteness at which his simple mind commonly operates and to which more abstract issues are quite naturally pulled down. If he were asked, as Jesus was asked by his disciples, "Why speakest thou unto them in parables?" he would be astonished to learn that he did anything of the sort.

There are, then, two properties of popular speech that are of interest to anybody who would like to write well. First, there is the need to recover the sensuous tangibility of most of our words and to make our statements work coherently at both levels of discourse, namely, the perceptual level at which the words tell our mind about a situation that can be seen or heard, touched, or smelled and the theoretical level at which the intellect exercises its logic.

Second, metaphors are not fancy embellishments that make our sentences look brilliant; rather, they are the most natural and functional way

of driving an issue home in the abstract medium of conceptual language. It is true for all media that good form does not show. Nothing more self-defeating can be done by a writer than intending to write with dazzling originality. Like a pompous monument, such a writer stands as a traffic hazard in the midst of the road that is to lead the reader to the text. The reader is distracted by the conspicuous presence of the writer and is prevented from taking seriously what is being offered because the writer himself or herself seems to attribute only secondary importance to the meaning of the text.

We are back to what I said earlier: your prime duty as a writer is to keep your eyes firmly set on the target of your attention for the purpose of recording its image with the utmost fidelity. Whether you write poetry or prose, it requires a self-effacing obsession; for even if it deals with your own being and your own attitude toward the world, you must detach yourself to become an object of your writing rather than intrude as the person of the author.

Let me conclude with an example of this inescapable commitment to the world of experience by quoting a passage from the diary of Virginia Woolf. In the midst of a description of a summer afternoon spent in the country she writes:

> The look of things has a great power over me. Even now, I have to watch the rooks beating up against the wind, which is high, and still I say to myself instinctively "What's the phrase for that?" and try to make more and more vivid the roughness of the air current and the tremor of the rook's wing slicing as if the air were full of ridges and ripples and roughnesses. They rise and sink, up and down, as if the exercise rubbed and braced them like swimmers in rough water. But what a little I can get down into my pen of what is so vivid to my eyes, and not only to my eyes; also to some nervous fiber, or fanlike membrane in my species.

It is this fanlike membrane in your species that I recommend to your attention.

REFERENCE

Schlauch, Margaret. 1942. *The Gift of Tongues*. New York: Modern Age Books.

PART III

FOR YOUR EYES ONLY
Seven Exercises in Art Appreciation

T HE FOLLOWING BRIEF interpretations of seven works of art are meant to suggest how first-time visitors to a museum can approach the riches before them and answer the questions they whisper apprehensively to themselves: "What am I supposed to see? What is this about? What is so great about this?"

I remember once watching a teacher with her second-graders coming to a piece of abstract sculpture in a museum gallery. "What is this?" asked the children. The teacher, very unsure herself, went closer and looked at the label. "Gift of Mr. and Mrs. Oscar Verlinsky," she read. The children, satisfied, moved to the next object.

Teachers often solve the problem by limiting the visit to works of interesting subject matter. *George Washington Crossing the Delaware*—the teacher can recall the famous story, and everybody is entertained seeing it. The more enlightened art teacher may choose to introduce her charges to formal values: "How many reds can you find in this picture?" Such a treasure hunt will hold the children's attention for a few moments but will teach them next to nothing about the meaning of the picture. Gallery instructors for adults face the same problem, particularly in the case of modern paintings and sculpture, which puzzle and repel the average visitor; but the problem is by no means smaller for traditional art, where the meaning seems to be obvious, and therefore there is apparently nothing to understand.

Anecdotes about the artist who created the work and about the circumstances under which he did it serve as a popular solution to the predicament. At a higher level, the instructor, trained in art history, may offer some erudite facts about the style of the work and the social and political conditions of the period. Neither procedure, however, introduces the

viewer to the visual experience, which is the principal value to be discovered. Indeed, a narrow focus on the historical and psychological aspects of a work may draw attention away from what is seen.

The examples offered here will suggest ways of approaching artistic experience by what can be seen directly and spontaneously. Such seeing requires no scholarship, but it does require a willingness to look carefully at what the artist has put there. Once attention is locked on the target, the shapes and colors and the relations of sizes and distances yield their meaning.

When the eyes of viewers come to trust the immediacy of vision, works of any style, medium, or period will let their visitors in on what first looked like a secret. My examples happen to come from the Boston Museum of Fine Arts, but equally suitable opportunities for fruitful artistic experience can be found wherever good art meets the eyes.

TITIAN: *ST. CATHERINE OF ALEXANDRIA* (CA.1567)

Titian's painting (Figure 6) differs effectively and perhaps disturbingly from the many other religious paintings in which the crucified Christ is contemplated by kneeling worshippers. Such a scene tends to be safely confined to the frontal picture plane, with nothing much in the background to draw us away from the subject. The very opposite faces us here.

St. Catherine is placed somewhere along a passageway, and she is forlorn among the gigantic columns of a monumental interior that is anything but a dwelling. In fact, neither the Egyptian princess nor the crucifix is meant to be at home in the palace of the Roman emperor. This chilly estrangement, however, from the setting in which the intensely emotional scene takes place is as much as the painter cares to tell of a story of cruel persecution. The fairly small painting does dutifully illustrate an edifying legend; but it was intended to decorate an upper-class home with reassuring splendor.

The architectural perspective of the imperial setting is executed with the skill to be expected from a good artist who had acquired the recently discovered geometrical technique of depicting three-dimensional space. But far from distracting us by this flight into the distance, the aging Titian drew the very greatness of his symbolism from the new spatial vista.

The cross placed on a sarcophagus with the skull of Golgotha and a relief depicting the entombment of Christ is based solidly enough on the checkerboard floor of the palace; yet this evocation of Christ's sacrifice can be only an apparition. After all, the crucifixion took place elsewhere and a long time ago. How can a painting believably combine down-to-earth pres-

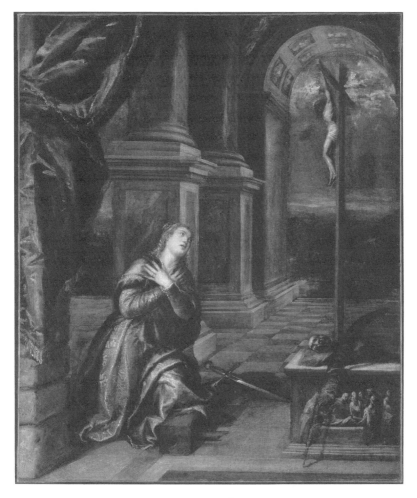

FIGURE 6.
Titian, St. Catherine of Alexandria. ca. 1567.
Boston Museum of Fine Arts.

ence with the transcendence of a spiritual sight? Where exactly is the cross located? As our glance rises along the stem of the cross, the crucified figure moves miraculously way back to dwell among the clouds of the nocturnal sky. The framing power of the archway creates a picture within a picture, a distant vision accessible to the mind but unreachable in actual space. Does Catherine truly see her savior? She does, but she can join him only by being removed herself from her earthly prosperity to the exalted no-where of martyrdom.

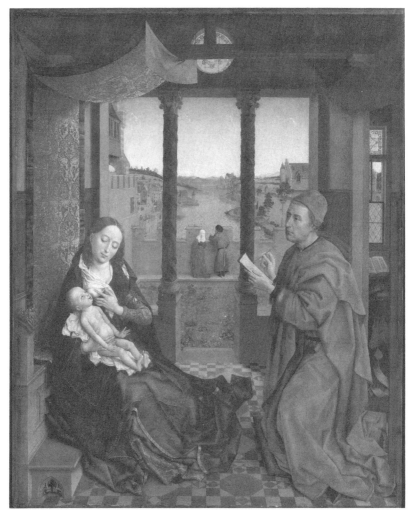

FIGURE 7.
Rogier van der Weyden, Saint Luke Painting the Virgin. ca. 1435.
Boston Museum of Fine Arts.

ROGIER VAN DER WEYDEN: *SAINT LUKE
PAINTING THE VIRGIN* (CA. 1435)

At first sight, this painting (Figure 7) looks straightforward in its rep-
resentation. A robed gentleman is making a small drawing of a lovely scene
deserving of depiction. The Netherlandish setting is quite convincing. At
second glance, however, two questions arise: If this is the lady's living
room, what are we to make of the throne, with its brocaded tapestry and
canopy? And if it *is* her room, how do we reconcile it with St. Luke's, the

painter's study, seen in the back, where his faithful ox is cozily at home behind the lectern?

Can an artist manage to show how the human meets the superhuman, especially when the supernatural is considered quite natural and down to earth? It is not enough for him to make the scene so tangibly present as to overrule the contradictions in the subject matter and thereby let us see that the miracle consists precisely in the meeting of two incompatible ways of being. He must also raise the entire scene from a domestic episode to the level of the spirit, where everything shown is the embodiment of an idea.

Rogier van der Weyden does this by subjecting his composition to the overall symmetry known from older altar paintings. Mother and child are anchored in the left wing, and the portraitist is confined to the right. Two columns frame and separate the two realms, the heavenly and the mundane, and the gap between them is emphasized by the perspective flow of the tiled floor, which moves between them toward the unconcerned remoteness of the river and city life.

Just to make sure that we acknowledge this gap, we are reminded of the normal closeness between man and woman by the small couple that interrupts the scene.

It is a saintly story, but there is also something reassuringly informal about it. The queen of heavens is lovingly concerned with her baby. She has chosen to sit on the footrest of the throne, and her abundant garment ambles across the central gap, approaching the visitor but also holding him back. And the painter, the patron saint of the painters' guilds near whose portrait of the Virgin the legend says the voices of angels could be heard singing, "Hallelujah," limits himself here to making a quick pencil sketch of his subject. It is as though liberation from medieval ceremony has awakened a traditional enactment to a new, casual spontaneity.

MINOAN DOUBLE AX (CA. 1500 B.C.)

This small object of precious gold (Figure 8) is the silent token of a bustling civilization that fell victim to catastrophic destruction some thirty-five hundred years ago. Perched on a hill in full view of Mt. Ida, on which the father of the gods, Zeus, was born, the Palace of Knossos is said to have been built by a son of Zeus, the legendary King Minos. Our ax originates from this palace.

The little object is too fragile to be a tool. As a picture of an ax, used by a warrior as a weapon or by a stonemason as an instrument, we must see it in profile, with its protruding edges cutting sideways, aggressively or

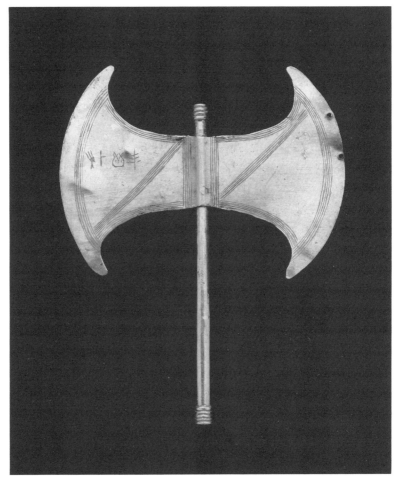

FIGURE 8.
Minoan Double Ax. ca. 1500 B.C. Boston Museum of Fine Arts.

productively. But because there is a visual contradiction in a tool hacking in two opposite directions at the same time, its symmetry seems self-defeating and suggests that we are looking at something more and other than an ax. What is preserved here is an image, reduced in size and wrought in the finest metal to express the high dignity of the portrayed object.

Larger double axes made of bronze were also found at Knossos, but they, too, served as ritual showpieces, displayed in sacral or ceremonial halls. This encourages us to look again, this time to see the object as an emblem, presenting itself frontally like a face. Its two sides no longer tear

their practical functions asunder, undoing each other, but like wings their opposite strivings hold the symmetry of the shape in a live balance. The handle has become a central backbone, and we now appreciate the elegance of the swinging curves, outward in the horizontal, inward in the vertical—a form beautiful enough to serve as the brandmark for a whole civilization.

Interacting with the space around it, advancing and receding, our shape need not stay alone. It readily admits company. In fact, as a painted decoration or carved on the walls and sacred pillars of the palace, the double ax appears quite sociably in whole rows or together with other symbols, intertwining with its neighbors like chains of dancers holding hands. The Minoan culture could afford to be peaceful. Protected by the ocean, the island of Crete exchanged goods, not menaces, and if the double ax was indeed a weapon, it was used to please some warlike goddess. Otherwise, the double ax joined the lively display of curly plant ornaments and winding sea creatures that delight us on Cretan vases.

DAVID SMITH: *CUBI XVIII* (1964)

Here we have an arrangement of seven cubes made from sheets of stainless steel and precariously held together by spot welds (Figure 9). Is this enough to attract our attention? Is this sculpture about something or about nothing?

Let us give some thought to the number seven, as it was intuitively chosen by the sculptor for many of his twenty-eight arrangements of this type. How different are the stories this number tells us, depending on whether we subdivide it as 5:2 or 4:3—a larger and a smaller group in each pair meeting at different distances from each other—or as the perfect symmetry of 3:1:3! And now transfer these seven simple quantities into visible space, where the sculptor can vary each element's location, proportion, and orientation. A great wealth of possible visual stories results, even though only one basic rectangular shape plays all the parts, and much of what is to be seen is limited to a fairly flat display in two dimensions.

The arrangement is precarious, but it does not look simply like a load of shapes scrambling down from the sky like the fall of the rebellious angels in a Rubens painting. Nor is the sculpture only a tower built of seven pieces on a base—"cloud-longing," as the sculptor liked to call it. Suspended in space between downward and upward, the whole is beautifully weightless, grouped around the horizontally reposing bar that holds the central position.

Certainly the world we are shown here is unsafe. Each participant is barely holding on to a momentary position. At the same time, however,

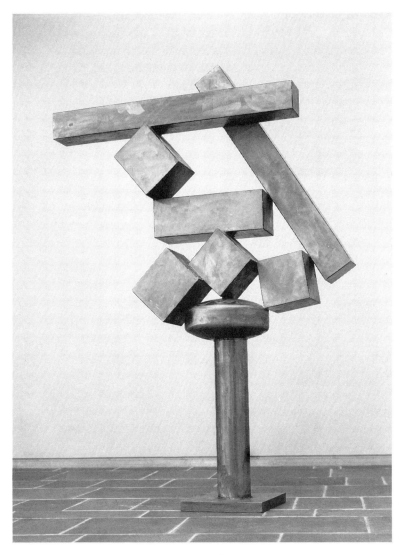

FIGURE 9.
David Smith, Cubi XVIII. 1964. Boston Museum of Fine Arts.

they are all kept in place, not just by arbitrary welding but by each piece's maintenance of a perfect balance with the equally momentary stance of its neighbors. The seven elements make each other possible. They also reflect a perilous world, whose insecurity they acknowledge. It is a world David Smith loved and accepted as his own by endowing it with a risky order. But an order it *is*, and the artist assures us that it is the one kind of order we can afford.

FIGURE 10.
Jean Siméon Chardin, Still Life with Teapot, Grapes, and a Pear. ca. 1764.
Boston Museum of Fine Arts.

JEAN SIMÉON CHARDIN: *STILL LIFE WITH
TEAPOT, GRAPES, AND A PEAR* (CA. 1764)

A small picture (Figure 10), less than thirteen inches high, greets us
with a sight of genteel pleasure: the warmth of a teapot, luscious grapes,
edible chestnuts, and a nicely ripened pear. Beyond a fleeting gratitude for
its presence, what more do we owe to such a picture? It turns out that it
speaks to us of weighty matters. The little French jewel arrests us by a
more direct appeal than do the Dutch outpourings of groceries and flowers
of a century earlier. Unexpectedly, something in Chardin's still life antic-
ipates the pictorial language of our own time. What we see is not simply
a scene from daily life but a display so ceremoniously assembled as to
create, we are tempted to say, a worldview. The dark and empty back-
ground, more like an ominous sky than a household setting, isolates the
select objects and exposes them by contrast to a theatrical light that seems
to call for heightened attention. What do we see?

Singled out by their upright stance, the pot and the pear invite us to
compare the work of the ceramist with the art of nature. Both objects are
voluminous and proudly upright, as architecture is, and they suggest a
stable world that can afford to indulge in the voluptuous pleasure signified

by the grapes. The golden balls of the grapes ignore the severe edge of the table. They overflow the limits of convention and mock the geometrical symmetry of their upright guardians. They let go, like those slightly dissolute nudes who lounge on couches in the paintings of Chardin's contemporaries. Nothing about this well-protected earthly paradise foretells the great revolution that will soon smash all the royal rococo.

What calls to us here from across the ages is the almost austere order of the small composition and the sensuous temptation faced by this order. An artist of the past raises the implements of daily living to a level of abstraction that makes them speak of poise and of unruly passions challenging secure values. We understand why some of the great forerunners of twentieth-century art, among them Paul Cézanne, revived the memory of the older painter and why Chardin's work evokes in us a kindred spirit that transcends the tasty refreshments on the table.

WILLIAM MICHAEL HARNETT: *OLD MODELS* (1892)

How did all these venerable objects come together in just this way (Figure 11)? They look so real that the original of the painting has to be protected with a glass cover from the fingers of incredulous visitors. Yet, still lifes are the most improbable subject matter of all figurative painting. Neither a practical purpose nor the accidents of messy disorder can account for such an arrangement, and a household crisis would occur if someone needed to get something out of that wall closet behind the door.

Assemblies like this have often been used in the past to warn against the sinful temptations of luxurious goods or to carry symbolic messages. Despite these lofty pretexts, however, such objects were commonly shown as sharing the solid ground familiar to us from domestic life. They were mounted on a table top and subject to the force of gravity. Paradoxically, this reassuring worldliness has been all but abandoned in our painting, which otherwise could not be more mundane. The supporting base has been reduced to a narrow ledge, and although we can guess that the bugle and the tattered piece of music are safely attached to the door, our eyes see them as floating in the nowhere.

The safety of the horizontal base gives way to the liberty of the upright back. This happens gradually. In the lower left corner, the Dutch jar reposes solidly enough on the pedestal of the two books, and its substantial whiteness confirms its power as a center of reference. Close by, however, the unruly sheet of music negates the base, and the violin, weightless like a dancer, sways on its round bottom.

Free from the coordinating pull of gravity, each of these objects depends only on its own law. One obliqueness is as good as the next, so that

FIGURE 11.
William Michael Harnett, Old Models. 1892. Boston Museum of Fine Arts.

FIGURE 12.
Edgar Degas, Edmondo and Thérèse Morbilli. 1867. Boston Museum of Fine Arts.

we are presented with a world whose spatial order is curiously pluralistic. Each object pursues its own orientation with an obstinate, isolating blindness; yet they all respond to one another with supreme sensitivity. It is a distinctly modern sight, for whose conscious acceptance the arts still had to wait more than twenty years. The shock of Cubism, the spectacle of alienated units conforming to a bold new unity, is anticipated here in the pettiness of an old-fashioned living room. Presumably, although perhaps dimly sensed, such an anarchic conception of the world was far below the

awareness of an artist whose contemporaries were satisfied with the virtuosity of harmless deception and the celebration of the home.

EDGAR DEGAS: *EDMONDO AND THÉRÈSE MORBILLI* (1867)

The sitters for a double portrait have a double task. They must present themselves to the perusers of the picture, but in doing so they must also enact some kind of relation between themselves. Edgar Degas's eloquent painting (Figure 12) of his sister and her husband, the duke of Morbilli, may chill us by seeming to limit that personal relation between the spouses to a purely spatial closeness. It is the closeness needed by the painter to fit the couple tightly into the frame and also to show that on the stage of the world the two belong together.

But the painter shows more. He illustrates the social constellation to which the lack of response between the man and the woman is due. Both are very much alone, although they are also tensely aware of what faces them from the outside. Called on to expose themselves to the public eye, the duke looks reserved and suspicious, while the woman seems almost frightened. In every way the husband dominates the scene. He occupies the major space of the canvas, and his elbows push expansively against the frame and into whatever little room is left to his wife. The same uncaring push moves his knee forward against the viewer. He is in front, and his head is highlighted by the curtain behind him. His wife is below him, tucked away behind him, and her face is half eclipsed by his cast shadow.

The message could not be clearer. Of course, such visual symbolism has always been the language of art; but in earlier times the actors in painting and sculpture, just as those on the stage, used to indicate by conventional gestures that they were displaying meaningful signals. What is new here is that the telling constellation is caught in the kind of accidental pose that may come about when the visiting brother asks the family to let him take a snapshot. This is particularly striking in the play of the hands. Hands are instruments of action and communication, but here, instead of signaling, they repose naturally and symbolize nevertheless. Thérèse holds on to her face, and with the slight, almost hidden gesture of her left hand she touches her husband's shoulder, acting out a timid contact, asking for protection and support, and propitiating the easily irritated master. All this is done in response to the almost brutal insensitivity of the husband's domineering right hand. This possibility of revealing the truth by catching the telling moment was suggested by the new art of photography.

PICASSO AT GUERNICA

HALF A CENTURY can be a sufficiently long time to make works of art undergo a decisive change from a place in the present to one in the past. Some works are spectacular rockets, propelled to an almost instant fame, illuminating the landscape for a moment and then dying out forever. More interesting is the opposite case of works that, after partial recognition, gradually make their way to the top, drawn by their own buoyancy and pushed by the forces of the times.

Pablo Picasso's painting *Guernica* has so reached the heights now that it is enshrined in its chapel-like setting at the Prado in Madrid, but it began not quite in the valley. It must have been evident in 1937 that an event of importance had taken place when one of the most recognized artists contributed, by means of a large public mural, an official comment on the dictatorial brutalities of the day. And yet, so filled were our ears during those years with the noise of Fascist violence in Spain, in Germany, in Italy, so convulsed by turmoil and rebellion was every European city, that the Spanish pavilion's inauguration in Paris will have been experienced as just one event among many. To be sure, the latest work of the Spanish artist was considered worthy of much attention—even the preparatory sketches for the painting were published by *Cahiers d'art* that very same year—and the fact that he identified himself with the Spanish government in exile was significant.

But it took time for this work not only to reach its proper social altitude but also to secure its place in the historical context of cause and effect. When in the late 1950s I undertook an analysis of Picasso's mural, I was concerned mainly with the work in and by itself. An interest in creativity

First published as *"Forty-five Years After Guernica,"* *Michigan Quarterly Review* 22 (Winter 1983), pp. 1–8.

and the processes of development it entails attracted my attention especially to the fact that a large number of preparatory sketches had been carefully preserved, numbered, and dated by the artist. Together with a set of photographs taken of the final canvas at various stages of completion, *Guernica* offered a unique opportunity for a detailed case study of how a work of art comes about. Since the publication of my book in 1962, the *Guernica* literature has been greatly enriched, notably by the thorough monograph of Frank D. Russell, the equally excellent anthology edited by Ellen C. Oppler, and the more recent, comprehensive work of Herschel Chipp.

These books have contributed more to the documentation and interpretation of Picasso's work than I could have anticipated in the early days. In particular, they have told us much about the historical circumstances that led to the work's commission for the Spanish pavilion at the Paris World's Fair in 1937 and also about its position within the artist's oeuvre as a whole as well as its parental assonances to paintings by various masters of the past. In my own thinking also, *Guernica* has taken its place in a broader context, and when in 1982 the director of Madrid's Prado Museum invited me to lecture in front of the original painting, I formulated the thoughts on which the present essay is based. They concern mainly the problem of how the artist as an individual is related to a historical event to which he was to do justice.

We know very little about what raises particular episodes now and then above the *faits divers* of daily heroism, suffering, or violence. With an almost artistic power, the history of a time and its media of communication focus on happenings in which some compelling aspect of the human condition is dramatized to perfection. The Fascist attack on the traditional sanctuary of Spanish civic freedom was such an event, and the form in which a great painter responded to it did more than just concretize its image in the minds of generations. It also gave a remarkable turn to the general attitude artists assume toward the history of their time and indeed to that of the modern individual to society.

As long as the dependence of artists on their feudal patrons lasted, one of their tasks was that of depicting warlike events for the purpose of what nowadays we call "public relations," that is, as feats of glory. To this end, brutality and suffering were translated into mere manifestations of courage and power. Only when in the course of the nineteenth century artists emancipated themselves from their patrons, and even from the politics and economics of their society, could they turn scenes of war into reflections of the horrifying outrage suffered mentally and physically by the victims—individuals who, like the artists themselves, felt no share in the cause for

which they were said to be fighting. Significantly enough, the most pow-
erful artistic comments on the history of our own century have come from
the politically noncommitted, whereas the dictatorships of the right and
the left have generated the anemic products of enforced alignment.

Picasso always remained a Spaniard. He wrote his poetry in his mother
tongue; and among the many styles he developed within the idiom of
French art we seem to discover a Spanish accent here and there. He re-
sponded very strongly to what was going on in his country, but he was an
exile, after all, removed from the immediate impact of the civil war, which
some other European artists and poets had joined like a crusade. He looked
from a distance. He was a participant, but he was inside and outside the
struggle at the same time. The reverberation of this ambiguity has often
been sensed in the composition of his painting *Guernica*.

As an uprooted exile, Picasso could feel all the more strongly the home-
lessness characterizing the modern artist in general. No longer an indis-
pensable helper of the ecclesiastic or secular powers, the artist had been
forced into the role of a supplier of distraction, decoration, and social
prestige for his customers. The market values of supply and demand rather
than a true need for the revelations of art controlled the artist's function.
Most clearly in literature, but inevitably also in the other arts, this social
detachment expressed itself through telling symptoms: protest, contempt,
rebellion, estrangement from the accepted language of form, and a pre-
carious balance between statements about the world at large and manifes-
tations of the artist's own strivings and conflicts.

Inevitably, the problem arises whether the unresolved relation between
the artist and the world in which he has to live will reflect in his work
without endangering its unity. Will the effort to coerce the two into a
coherent image distort them both? In the case of Picasso's *Guernica*, the
problem embodies itself in the figure of the bull (Figure 13).The bull is
clearly at the climax of the scene. The other actors are turned toward him,
looking up to him expectantly, imploringly, hopefully. Supported by a
long iconographic tradition connecting the bull with Spain, the animal
effectively represents the undaunted spirit of the country in the hour of
criminal assault. The bull does justice to his part by his heavyset, towerlike
presence in the picture. But he may also be said to behave in a way un-
becoming to a monument. Beginning with the early sketches Picasso made
for *Guernica*, the bull turns his back to the happening, thereby occupying
the very center of the scene with his hindquarters. And this diffident
ambiguity remains throughout the development of the work. At one point
the bull is even in flight. The final stage of the mural, in which the an-
imal's body has been pivoted around the stable axis of its head and neck,

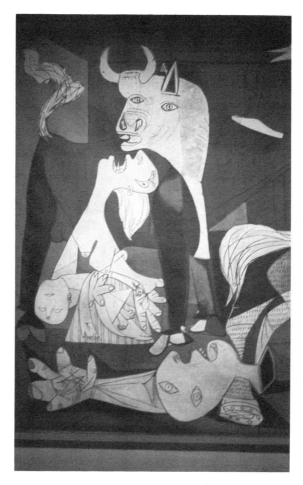

FIGURE 13.
Pablo Picasso, Guernica. 1937. Detail. Museo del Prado, Madrid.

displays the double impulse all the more strongly: the body on its four legs is now indeed turned toward the center, in response to the demand made on the symbolic animal by the victims of the Fascist attack; but the head, the decisive agent of the spirit, remains turned away, and the double aspect of the face, conveyed by the contradictory position of the eyes, expresses an uncertainty of attitude.

Is this hesitation unseemly, inappropriate? It is so only, I believe, if one approaches Picasso's composition with the standards of the history paintings of the past, in which the artist's power of characterization was ex-

pected to be entirely consumed in the heightening of the depicted event. Objections may also be raised by critics who request that the art be entirely at the service of ideological doctrine. It seems to me, however, that one arrives at a more adequate appreciation if one perceives Picasso's mural not just as a picture of the bombardment, the war episode selected to symbolize the cause of humanity against the assault on democratic peace, but more complexly as a portrayal of a modern individual and artist in his response to the terrors of his age. Such a conception could not possibly offer the simple affirmation of a monument.

For Picasso, the national symbol of the bull had strong personal connotations. Interpreters of his work have easily understood that the minotaur, a beast in charge of a human body, and its opposite, the centaur, an animal dominated by human wisdom, mirrored the antagonistic powers of passion and reason in the artist's own soul. The minotaur as a lusty rapist and the equally shaggy, bearded artist, at work in his studio and in the embrace of his women models, are aspects of the same person; and the nature and fate of that same person are at stake every time the bull of the corrida is seen in his terrifying strength, murderous in his rage, assaulted, and overcome.

This awe-inspiring and multifaceted figure, then, offered the needed bridge between the person of the artist and the tragic cause of his country—a shared symbol that had to be visual to be used by the painter. In a famous Picasso etching of 1935, the *Minotauromachy*, the athletic beast faces the light and the sword in a mystery play in which great themes of Western iconography serve to illustrate a vision of the artist's very personal nature. A similar set of characters—the bull, the wounded horse in the center, the dead bearer of the sword, and at a window a woman brandishing a light—reappears two years later in *Guernica*, and this striking similarity alone suffices to indicate that the subject selected for the pavilion of the Spanish government is not simply a political statement.

The bull claims the dominant position in both worlds—as the embodiment of resistance and survival in the political manifesto and as the central figure of the personal world, the figure of the artist himself. Looking for the result of this daring synthesis, we cannot but trace, first of all, a hidden theme of personal wish fulfillment, a fantasy of the artist himself arising as the savior of his distraught people. But this unacknowledged dream would remain naive and immature, unworthy of the occasion, were it not checked by the realization that no such unperturbed strength qualifies the artist for the great task.

An element of human frailty modifies the stark monumentality of the historical scene. Just as in literature no drama since Shakespeare represents

the tragic hero as a mere instrument of fate, but must show him in his apprehensions, doubts, and remorse, so does Picasso's heroic figure amend the simple theme of violence, suffering, and faith by introducing an element of resigned wisdom: the realization of human fallibility. Dare we suggest that the melancholy shadow of Don Quixote has accompanied the conception of the modern hero even in the darkest moments of our history? And may we say further that the very complexity and sensitivity of this response reveal by contrast the dehumanized brutality of the enemy's assault?

I feel very strongly that psychological aspects of an artist's personality should not be called on for the interpretation of his work unless they introduce dimensions in keeping with the spiritual level at which the work itself is conceived. To be sure, psychologists should be free to examine art works as symptoms of the mechanisms that control the typical human mind, just as anatomists must dissect bodies. But when it comes to understanding a work's own nature and value, one must not pretend that the work is merely the manifestation of those basic strivings and traumata that determine the behavior of the average person. Such attempts, especially by psychoanalysts and their followers, have been applied to Picasso and his work. It cannot be excluded, of course, that early family experiences are reflected in the subject matter of *Guernica*. Such references, however, should not be intended to mean that the picture, instead of representing its intended subject, speaks "really" of something entirely different, something purely private, something not a matter of general concern. This kind of clinical diagnosis would also eliminate what Walter Benjamin has called the "aura" of a thing, or person, or event, namely, the uniqueness that imposes on us a sense of distance. A reverent distance cannot survive when the work of art is said to be simply one of the endless manifestations of predictable mental vectors. It is true that no analysis is ever intended to match the individuality of its subject. But when it applies to a work of art, its particular standards must point to the spiritual level appropriate to the work.

At no time was Picasso willing to say much about what he had meant to convey through his painting, and the work itself avoids immediate contact with the events. It makes its powerful statement as through a veil of indirectness. The setting in which the scene takes place does not directly depict sights from the town of Guernica. It represents, as has been convincingly shown, a theater stage, which in turn alludes to Guernica sights and is thereby twice removed from the actual scene of the bombardment. Looking back to the practice of earlier artists, one might be reminded of Raphael, who had his Madonna Sistina appear from behind an opened

curtain. Commentators have tried to diminish the distance between either painting and the common public by busily suggesting that both painters used the features of a favorite mistress to portray their symbolical figures— the Virgin in the case of Raphael and the woman with the light in the case of Picasso. Even so, the apparitions retain their remoteness.

The same tendency is also evident in Picasso's use of animals. Humans have always resorted to the images of animals for a simplified view of their own nature. The lion, the lamb, the snake impersonate courage, sacrifice, and cunning through their behavior—a relationship that can acquire various levels of abstractness. In a hunting scene by Delacroix, lions are, first of all, real animals, although they must be perceived as embodiments of ferocity and strength. The lions of St. Jerome or St. Mark, however, are primarily symbols, displayers of the virtues they are meant to represent. Picasso's antagonistic pair—bull and horse—is somewhere in between the two conceptions. His particular bull and horse cannot belong in a realistic report on the Spanish bombardment—they do not exemplify the cattle and horses of Guernica. Yet their symbolic abstractness does not keep them from acting in the story. They are somewhere between the fable and the reportage, and the very abstractness of their appearance intensifies the passions Picasso makes them enact.

Intensification through abstraction—is this not one of the devices of great art? We know that Picasso searched for the appropriate level of abstractness when he tried various styles for *Guernica*. The figure of the bull, for example, looks realistic in some of the preparatory sketches and classically beautiful in others. Or the subject matter hides in Cubist and Expressionist patterns. We might remember here that Picasso's life work did not simply lead, in the usual linear development, from an early style to a late one. If such a development occurred, it was surely overlaid by a constant acrobatic back and forth within the whole range of the vastly different styles made available by modern art. As we look back now at that completed oeuvre, we may be tempted to say that it gravitated around the style of *Guernica* as the hub at its center. An entirely abstract composition would have been incapable of referring explicitly enough to the message of the painting, whereas photographically faithful documentation of the slaughter would have made the accusation without the proclamation of faith and hope.

The style of *Guernica* cannot be identified with any one school of painting. Of the radical abstractness of Cubism, *Guernica* preserves the geometry of defined shapes. It employs the distorted limbs of Expressionism within the limits of a realistically recognizable scene; but it also has elements of classical perfection and symmetry.

At the center and height of his career, Picasso, in response to his most demanding challenge, settled for an image of awe-inspiring remoteness. The reduction of the color scheme to a composition in black and white transforms the reds of blood and fire into shades of light and darkness. The flattening of bodily volume extracts a maximum of expression from the curves and streaks of the contours. The sprawling intestine of the slaughtered horse is transfigured into a winged legendary bird emerging from the wound in resurrection. The artist himself, in the guise of his principal actor, stands erect in the terrifying and mystifying landscape of his age, to serve as best he can the enlightenment and the admonition of art.

REFERENCES

Arnheim, Rudolf. 1962. *The Genesis of a Painting: Picasso's* Guernica. Berkeley and Los Angeles: University of California Press.

Benjamin, Walter. 1973. *Das Kunstwerk im Zeitalter seiner technischen Reprodu-Zierbarkeit*. Frankfurt: Suhrkamp.

Chipp, Herschel B. 1988. *Picasso's Guernica: History, Transformations, Meanings*. Berkeley and Los Angeles: University of California Press.

Oppler, Ellen C. (ed.). 1988. *Picasso's Guernica*. New York: Norton.

Russell, Frank D. 1980. *Picasso's Guernica: The Labyrinth of Narrative and Vision*. Montclair, N.J.: Allanheld & Schram.

SCULPTURE
The Nature of a Medium

THE VARIOUS MEDIA of art are the instruments by which artists convey their visual images of human experience. What can be said artistically about our living in the world and how it can be said depend on the particular properties of the media. Sculpture accomplishes its task in ways that differ from those available to painting, to architecture, and to the nonvisual arts. Its specialty derives from the physical and perceptual characteristics of the materials at the disposal of the sculptor. Among these characteristics, the relation of sculptural objects to space and time is particularly revealing.

All artistic media have their place in space, but not all of them also operate within the dimension of time. Music, dance, theater, and film accompany life events with temporal actions of their own and thereby report, interpret, and comment on the human ways of handling such events. These media reflect processes of becoming and undoing. Not so the media of painting, sculpture, and architecture. Their works, once made, display a permanent state of being. Buildings provide protective security against the vicissitudes of time. Shaped by the architect to provide congenial living conditions, they continue to do so as long as they survive physically and as long as their users are satisfied with what the buildings offer. Beyond their practical utility, buildings symbolize through their style a unique manner of facing space and time. They show a preference for stability and compactness or for a graceful multiplicity of appearances, a clinging to the ground, or a striving toward the heights.

Art objects possess a curiously twofold position and function. On the one hand, buildings are one among many species of physical objects, such

Derived from "Sculpture," in *International Encyclopedia of Communications*, edited by Erik Barnouw (Oxford: Oxford University Press, 1988).

as trees, mountains, and water. On the other hand, buildings are images of the world of which they are a part. A similar double reality holds for works of sculpture. They, too, are not only images but objects among objects, and this creates a spontaneous intimacy with things of nature, such as human bodies. Even abstract but human-size figures arising from the ground display a kinship that is hard to ignore.

At the same time, however, much sculpture lacks the essential quality of life, namely, motion. This makes for a chill, which is somewhat relieved in kinetic sculpture. But not without good reason are sculptures rotating on turntables or mobiles animated by wind or water limited to rondo patterns that keep returning in an endless, timeless state. For if they were programmed to act out goal-directed plots, they would shift to the performing arts of puppet play and dance; that is, they would serve a function other than the one that distinguishes the atemporal media.

The timeless immobility of sculpture is not a drawback. Like painting, sculpture extrapolates from the ever changing spectacle of experience certain frozen states, appreciated for their enlightening validity and lasting significance. It connects the past with the future through a pervasive presence. It supplies us with stable images by which we can orient ourselves in space as we navigate the stream of protean events.

Although internally immobile, pieces of sculpture can be moved around, which is acceptable as long as they embody statements whose validity does not depend on their location. The meaning and expression of a human figure are certainly influenced by where the work is shown, but it need not be connected to a particular place. The figure will display its properties wherever placed, and when it is small, it can be handled like any other precious object. Religious icons, however, do tend to derive some of their dignity from a permanent location. When Le Corbusier placed the figure of the Virgin in the pilgrimage chapel of Ronchamp on a swiveling base, enabling her to officiate at outdoor and indoor services alike, he aroused some feeling of religious and aesthetic sacrilege.

Sculpture is rooted in the ground much more than framed paintings are, although less radically than architecture is. A statue is more like a tree than like a star. It transmits the experience of stable footing and is particularly suited to symbolize such foundation. The subservience of life on earth to the force of gravity is much more compellingly expressed in sculpted figures than in paintings. Therefore, when sculptures do hang suspended in the air, they display their anchorless freedom all the more convincingly. Examples are Ernst Barlach's soaring figure (Figure 14) originally designed as a war memorial for the cathedral of Güstrow in Germany or Richard

FIGURE 14.
Ernst Barlach, War Memorial. 1927. Güstrow.

Lippold's candelabralike metal clusters, which brighten the atria of banks and theaters.

At their most effective, then, sculptures are not handled as mobile objects but are tied to a place that is affected by their meaning and in turn determines theirs. Michelangelo's *David* loses much of its more particular character when today's visitors to Florence see the colossal marble figure confined to the empty rotunda of the Accademia delle Belle Arti. For the

past century only a copy of the statue indicates its original position at the entrance of the Town Hall (Palazzo Vecchio), where it had been placed in 1504 as "the incarnation of the two principal republican civic virtues: he is a *cittadino guerriero*" (Tolnay, 1975, p. 13).

The example of Michelangelo's *David* also demonstrates that sculpture lives up most fully to its nature when it is monumental. Monuments are places of pilgrimage, to be sought out like the great sights of nature. To exert their power, they need space. They stand on squares, in front of buildings, on the top of hills, where they concentrate the meaning of a cityscape or landscape in an articulate focus. This is why sculpture calls for the outdoors. Within the four walls of an interior, the compositional theme of the room's purpose tends to dominate the architectural design and the arrangement of the furniture so compellingly that the self-centered power of a sculptural bust or figure comes as a disturbance. Tucked away in a corner or impeding the traffic as an object without practical function, a sculpture proclaims its message in vain. It easily becomes an unwanted rival of the human inhabitant, the ruler of the place.

By the same token, however, sculpture plays an essential role when it is incorporated into the architectural plan as an intermediary between the abstractness of the building and the living bodies of its users. The Parthenon was designed around the statue of Athena in the central cella, just as the Lincoln Memorial in Washington is the shell for the bronze portrait of the seated president. The altar figures of saints or the Virgin Mary are focal points of chapels and churches, and in a more subordinate position the rows of religious figures in the porches of medieval cathedrals introduce the faithful to the spirit of their visit.

Let me reiterate that sculptures are physical objects like ourselves and that they share our physical space. Whereas pictures are detached images of our world, dwelling in a space of their own into which we can look but cannot enter, sculptures must cope with the double function of belonging to our life space as fellow inhabitants and simultaneously reflecting it as an interpretation. Their substantial presence invites bodily intercourse, which interferes with their appearance as images. In cultural periods in which the appreciation of visual symbols gives way to a careless indulgence in the company of congenial bodies, there are instances of disturbing intermingling, as when on the steps of the Hellenistic altar at Pergamon the marble gods fighting the Titans scramble up the steps of the sanctuary. Similarly, two thousand years later, Auguste Rodin proposed to place his bronze figures of the burghers of Calais directly on the pavement in front of the town hall as though they were actually on their way to meet the conqueror. The sculptor Pygmalion's desire to make his figure come to life is, of

course, the classic example of art perverted into the duplication of physical reality.

The ambiguous relation between sculpture and visitor expresses itself also in the varying degrees of isolation manifest in compositional form. Abstract sculpture, such as obelisks or the triumphal columns of Rome, tends to be self-contained and noninvitational. The same is true, for example, for the stabiles of Alexander Calder. Other works, however, acknowledge their function by exposing themselves to the visitors or even addressing them. Frontality is the most effective way of showing such a response. Religious icons face the worshipper and petitioner explicitly (Figure 15). Even in styles that develop the body's action fully in the round, an artist like Gian Lorenzo Bernini prefers to offer the essence of his message in a principal view.

In painting, the physical material of the pigments characterizes the medium but not the objects represented in the pictures—the character of oil paints contributes to the nature of a still life but not to that of the apples represented in the picture. By contrast, sculptured objects share the nature of their materials and derive effective symbolical connotations from them. Pliny reports that bowls of clay were often used to offer libations to the gods because clay reveals to thoughtful persons "the indescribable kindness of the Earth." Through the ages, a significant difference of meaning remains between materials manifesting the texture of natural growth and structure, such as wood or stone, and amorphous substances, such as plaster or poured metal. A carver like Henry Moore stresses the affinity between humanity and its natural origin and habitat by giving prominence to the strains of the wood grain and representing the human figure through shapes that derive from the growth patterns of trees (Figure 16).

The preciousness of materials such as gold, ebony, or bronze used to reflect on the social importance of the monument. Durability or the lack of it is often distinctly symbolical. A whole range of meaning leads from the porphyry and granite of Egyptian tomb sculptures in quest of immortality to the deliberately flimsy stuffs employed by some modern artists who denounce permanence. The least tangible works of three-dimensional visual art are plays of light in space created by neon or laser beams or the fugitive spectacles of fireworks and colored searchlights.

Another decisive character trait of sculpture derives from its way of representing its subjects without their context. Comparisons with literature or painting reveal the difference. G. E. Lessing, in his classic essay on the Laocoön, compares the Hellenistic marble figures of the Trojan priest and his sons attacked by serpents with the same episode recounted in Virgil's *Aeneid*. In the verbal narration the story is embedded in time and space:

FIGURE 15.
Isaiah, Maestro dei Profeti. Thirteenth century.
Cathedral of Cremona. Photo, John Gay.

it ties the event to a chain of cause and effect by explaining how human destinies come about and what consequences they lead to. It presents the life of the individual in its physical and social setting. Something similar is the case when paintings show human actions in a landscape or city, in a palace or stable. In contrast, the marble group of Laocoön and his sons is extracted from space and time (Figure 17). The sculpture limits its statement to the struggle between the attacking beasts and the suffering

FIGURE 16.
Henry Moore, Reclining Figure. 1935.
Albright-Knox Art Gallery, Buffalo, New York.

victims. Devoid of the time dimension of action, it displays a state of immobility rather than an event in progress.

Even so, the Laocoön group displays considerable complexity by presenting more than one figure. When limited to a single shape, for example, a single human body, sculpture often compensates its audience for this limitation by symbolically presenting within its own orbit such significant themes as parallelism and contrast, expansion and contraction, resistance and yielding, rising and falling. In this manner, the interplay among the spatial gestures of torso, head, and limbs in a figure such as Wilhelm Lehmbruck's *Kneeling Woman* (Figure 18) adds up to a symphonic image of moves and countermoves that reflects a whole world in a single body. Remember here that in the philosophy of the Renaissance the proportions of the human body were considered a microcosmic image of the universe, whose macrocosmic structure was beyond the reach of our senses.

More radically than the other arts, sculpture is monopolized by the subject matter of the human figure. Just as the first man in the Garden of Eden could be formed as a piece of sculpture from a lump of clay, human beings, once created, make their likenesses most readily from lumps of physical matter. This affinity between the signifier and the signified expresses itself at all levels of abstraction, from the purely nonrepresentational shapes of a David Smith or the highly stylized fetishes and totem poles in early cultures to the life-sized trompe l'oeil casts made by Duane

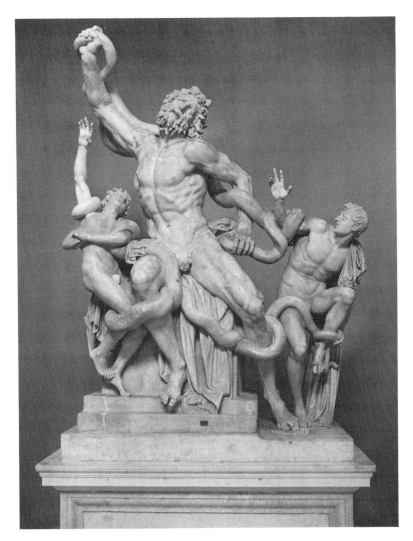

FIGURE 17.
Laocoön. ca. 50 B.C. Hellenistic. Vatican, Rome.

Hanson or George Segal and the less ambitious portraits of notable con-
temporaries in the wax museums.

The highly emotional responses to deceptively faithful duplications of
the human figure are twofold. On the one hand, the public welcomes the
familiar look of the figures, which seem to be taken directly from the daily
life of the streets. This response derives from the age-old appreciation of
skillful imitations of nature. On the other hand, sensitive viewers recognize
in modern products the specifically surrealist shock caused by creatures

FIGURE 18.
Wilhelm Lehmbruck, Kneeling Woman. 1911.
Albright-Knox Art Gallery, Buffalo, New York.

who look alive but reveal the iciness of dead bodies and an absence of feeling. Such dwellers in the no-man's-land between life and death descend from the wraiths and ghosts of the folk traditions, the golems, and the Frankenstein robots. They symbolize the awesome ability of the creative mind to conceive artifacts that display telling attributes of life while lacking life itself.

The existential twilight in which art and life meet provides an emotional affinity that encourages identification with the graven images. Sculpted likenesses serve to pay homage to gods and heroes, they embody ideals of physical beauty, and they preserve the memory of cherished individuals. The curiously ambiguous reality status of such images is of psychological interest. It may seem hard to understand that, for example, in voodoo rites a physical attack on a distant enemy is thought possible by means of a mere image. Nor is it obvious that faithful believers see no contradiction in addressing the portraits of gods and saints as though they were appealing to a present power while knowing that the figures are made of wood or plaster. To be sure, the medium of sculpture favors such identification. The church fathers who objected to the veneration of icons worried mostly about the compelling presence of three-dimensional figures but tended to accept paintings as nonverbal means of spreading the word of God.

Even realistic sculpture, however, rarely deceives the viewer into believing that the artifact is a living creature. How, then, can one account for people's willingness to approach graven images with requests and appeals that should be reserved for the living? One explanation derives from the psychological fact that all the objects of this world are known to us only as perceptual images. Sensory experience informs us about the differences between living beings and artifacts of wood or stone, but it also impresses us with a powerful similarity, namely, that of their visual expression. This common feature can be even more influential than naturalistic likeness. Some icons bear no striking resemblance to the kind of person they represent; rather, they convey a sense of power or fearfulness, participation or kindness. At this level of visual resemblance, the similarity of image and prototype can be more effective than the physical difference. It is the visual image to which one would appeal if one faced the saint or demon in person, and it is the visual image that confronts the viewer in the sculpture. Whatever the medium of incarnation, the particular spiritual quality coming across from its carrier transmits the message and matters to the receiver.

REFERENCE

De Tolnay, Charles. 1975. *Michelangelo: Sculptor, Painter, Architect.* Princeton: Princeton University Press.

NEGATIVE SPACE
IN ARCHITECTURE

THE TERM *negative space* may have been coined by painters because it connotes a conception of space closer to the experience of pictorial artists than that of, say, architects. Nevertheless, for both painters and architects, "negative space" refers to the opposite of solid objects. It describes the spaces left open around the objects and the empty hollows within them. But the painter's medium is the surface, a two-dimensional flatland into which the third dimension of depth is introduced only by indirection. The information received by the painter about the physical world tells him that the flatness of his medium can be overridden only by perceptual devices such as perspective or overlapping. But the very perception that conjures up depth also contradicts it, confirming the touch experience of the flat surface. This very flimsiness of pictorial depth, which makes it akin to fiction, induces painters to consider it not as real space but, in a way, as its opposite, the negation of what is the real and factual space of the painter, namely, flatness.

This way of looking at the situation presupposes that the conditions of the medium are given priority over what is depicted; this is the case only to the extent that visual art is representational. But the painter also looks at the space in a picture the way he looks at the physical world in which he lives and acts as a human being. That world is a world of substantial objects located in empty surroundings. It is a world in which the properties of objects—their size, shape, texture, and relative locations—matter visually. Early art, deriving from practical life experience, is object oriented. But because the formal demands of the medium are equally elementary, pictorial art is controlled from the beginning by varying relations between the exigencies of the medium and those of the reality to be represented.

In comparison, the architect acts more decisively as an inhabitant of the

physical world. He deals first of all with material objects and, like the giant Antaeus, is a son of Gaea, the Earth, and draws his strength from her. Although he may use drawings to give a first concreteness to his invention, he must remember that the medium of flatness, with all its peculiarities, is nothing but a preliminary version in a foreign language. The architect's drawings may be compared in this respect with a written film script in its relation to the actual film visible on the screen. The pictorial relation between positive and negative space concerns the architect only when, as a draftsman, he endeavors to give on paper an idea of what the executed building will look like in the physical world. While he draws in one medium, he invents in another.

All this is well known. Equally obvious is the fact that architecture, from its very beginning, combines the manual art of building with the visual art of organizing volumes in three-dimensional space. When the notion of three-dimensional space is transferred to a world of objects intended not only to be looked at but to be inhabited, it covers new properties in both the visual and the physical world.

For a further discussion of this question I will rely on Eduard F. Sekler's influential essay (1964) on construction, structure, and tectonics. Sekler defines structure as the principle and immanent order materially realized by construction. "But it takes tectonics to make structure and construction visible and endows them with expression." Thus, construction is meant by Sekler to concern solely the physical forces engaged in the building. It is what the builder and the bricklayer deal with. In this aspect of building, "negative space" is represented entirely by the empty spaces within and around the material volumes. Tectonics, as Sekler uses the term, deals with the perceived relations between visible shapes. This is obviously the architectural realm in which "negative space" is at home. But what is meant here by structure?

Sekler suggests that structure, although concerned, like tectonics, with the relations between visible shapes, reaches beyond tectonics by displaying a parallelism to the physical forces in the building. In the ideal case, he says, the architect creates a form that presents "eine direkte Reaktion auf das Kräftespiel im Bauwerk" (a direct response to the play of forces in the building). This statement points indeed to the essence of architectural composition. But it is not obvious how such a reflection of the physical on the perceptual is possible, given that physical forces, by their very nature, belong to an ontological realm different from that of sensory awareness. For example, the weights of the building materials, on which the statics of construction is based, are known but cannot be directly experienced. At best, we perceive, by the overcoming of weight when we are climbing up

a staircase, that we are at the mercy of a spatial configuration subject to the force of gravity. But if the relation between load and support is to be experienced perceptually, this cannot be accomplished by the direct effect of physical forces.

Rather, this can be done only through a translation of physical forces into visual forces, that is, by a symbolic analogy between the two onto-logical realms, the physical and the perceptual. The architect obtains this analogy by relying on shapes and size relations that arouse the dynamics of directed forces isomorphically in the observer's nervous system. Thus, the *Kräftespiel*, the "play of forces," of pressure and counterpressure that gen-erates the architectural expression of a column is not transmitted to the eyes by the physical forces inherent in a strictly cylindrical pillar but by such perceptual devices as tapering and fluting.

Has the dynamics of architectural space always encompassed the emp-tiness around and within the built solids? The answer is yes and no. Due respect for the right distances between buildings, for example, is observed not only by the trained sensitivity of the sophisticated architect but also by the natural intuition of the African tribesman or the Cycladic villager. Clearly, the criteria for what is not too far apart or not too close cannot be determined by metric geometry. Even when we decide on the right dis-tances between pieces of furniture in a room or between objects on a mantelpiece, we do so by responding to what we experience visually as the uncomfortable squeezing of things together and the alienating distancing of things from each other. To be sure, factors other than the purely visual, including the practical and the social, determine the correct distance be-tween objects. (Social factors are analogous to the rules dictating the proper distance between people.) But visually, distance is controlled by a sense of tension, by the ratio between compression and dilation, by felt dynamics.

Although the perception of tension is among our most basic sensations, we are all too familiar with the violations of this demand of human com-fort. Most everywhere we are condemned to look at an environment that cannot be seen as a coherent whole because its components do not respond to one another. Because socially and economically these components are the product of individual initiatives controlled mostly by what they let each other get away with, they present our eyes with agglomerations of shapes that at best make sense within each single unit. And just as the buildings do not add up to a reasonable whole, the negative spaces between them are not relatable to the buildings they separate. I have never forgotten the depressing experience of returning to my native city, Berlin, expecting to see a reconstruction that had profited from the opportunity to start afresh

with the overall vision of a meaningful order. Instead, I was shocked by still another instance of the discordant scrambling for space to which I had become all too accustomed in the United States.

What a relief to be faced, once in a while, with the perfect sites created when the sense of space is still intact. But as we have learned to protect ourselves with blinders from the visual chaos so hurtful to our eyes, it is almost exhausting to be returned to views that force us to look because they are so articulate.

Architectural practice continues to struggle with the problem of reconciling our inborn sense of space with the reckless accumulation of real estate. In the meantime, the perceptual problem of visual space attracts the attention of theorists in psychology as well as in the arts and has done so for some time. The interaction between figure and ground—between the objects constituting our world and the spaces separating and interrelating them—has been recognized as basic for our ability to orient ourselves in our world. But it is worth remembering that the conditions determining this perceptual phenomenon were not grasped right away but were recognized only one step at a time. In fact, we are only now beginning to view the special problem in the more general context of vision as a dynamic experience.

In the early days, when the Danish psychologist Edgar Rubin published his experiments on figure and ground in a book on "visually perceived figures," and when, two decades later, Kurt Koffka (1935) summarized their fundamental importance for gestalt psychology, the phenomenon was initially considered a static relation between perceptual objects and the empty spaces between them. Researchers emphasized what an observer sees first and what he neglects, what he sees in front and what lies behind, what belongs to the object and what is of the ground. When Koffka discusses the dynamic relations between figure and ground, as indeed he does, he seems to see them essentially as reflections of the corresponding physiological forces. As an example, Koffka cites Wolfgang Köhler as assuming that "within a certain area the process energies of figure and ground are equal. Then, if we have a small figure on a large ground it follows that the *density* of energy must be greater in the figure than in the ground, proportional to the ratio between the figure and the ground area" (Koffka, 1935, p. 193).

By now, psychologists realize that the visual forces one observes perceptually will eventually have to be related to the corresponding physiological forces in the brain, but they tend to deal with what occurs in consciousness as such, regardless of whether they can legitimize it by reference to what we know about the brain. Yet perceptual dynamics was

reserved first for the figure, while the ground was seen as the passive recipient of the forces generated in and by the figure and irradiating the environment.

In architecture, this one-sided effect on the surroundings takes two forms, which Wulff Winkelvoss (1985) describes as *Ausstrahlung* and *Umschliessung*. His terms refer to the difference between the emanation of energy from a central object and the effects deriving from the enclosure of a surrounded area. As a striking example, consider Donato Bramante's Tempietto in San Pietro in Vincoli (Figure 19). Instead of describing the architectural configuration statically as nothing but the combination of a cylindrical center and a rectangular frame, we capture its live expression dynamically by perceiving the center as a source of energy expanding like a balloon and sending forth its energy in all directions of the surrounding space. This expansive movement is counterpointed by the converging walls of the *cortiletto*, squeezing inward.

Described in this manner, however, dynamics is still reserved for the buildings, while the space between them, although not empty, remains the passive battleground for the encounter between the antagonistic forces of central core and enclosure. The next important step in the theory of figure and ground consists, as I have pointed out elsewhere (Arnheim, 1977, p. 96), in recognizing the ground as an active generator of visual energy that counteracts the forces of the figures and thereby acquires a positive role. As a formative power, the ground shares responsibility for the shape of the "figure." Now the ground, too, becomes a figure, and the relation between the two is reduced to a hierarchic difference. The material solids of the buildings remain dominant, but it becomes possible and indeed necessary for the architect to exchange the relation between figure and ground temporarily as a check on the intervening space.

Negative space acknowledges the active function of what can no longer be regarded as the empty in-between. At the same time, the term limits the meaning of what is called "negative" to the subordinate role of the openings around and in the interior of solids. At least, that is the case as long as we consider architecture simply as the relation between what is filled with building matter and what remains free of it. But obviously, the function of negative space is strengthened by the fact that in architecture the open spaces are the territory of the human occupant. What is more, the network of streets in a city is not simply the traffic system of connections between buildings. As an analogy, we can refer to the pattern of veins described by Peter S. Stevens as the plumbing system of trees and leaves when he discusses models of branching (Stevens, 1974, chap. 5). Such a network is not only a facility of canals but also a system of ribs holding the

FIGURE 19.
Donato Bramante, Tempietto at S. Pietro in Vincoli, Rome. 1502.
Etching by Paul Letarouilly.

structural whole together. As a primary example in architecture, we can think of the branching pattern of divergent avenues designed under Sixtus V for the city of Rome. Like a fan of ribs issuing from the Piazza del Popolo, the pattern holds the structure of the city together the way a leaf derives its stability from the system of ribs pervading it.

Thus, beyond its practical function as a principal means of communication, the skeleton of avenues serves symbolically as the representative of its owners. It describes the city as a dialogue between habitation and inhabitants. The question of what or who is dominant becomes moot. When the citizens of Rome climb up the steps of the *cordonata* to reach the square of the Campidoglio, there is no way of deciding whether architecturally the primary emphasis is on the public buildings waiting to receive the visitors or, conversely, on the visitors arriving to make use of their facilities.

The only way that the two versions can be held together is by the kind of switching back and forth known in the theory of figure and ground as multistability. Experimenters quickly realized that the two aspects of the perceptual phenomenon cannot be combined in the same act of vision. They belong together but exclude each other.* This baffling relationship is obvious to the architect when he envisages the interplay of concavity and convexity, which is strikingly evident in any cupola. The concave shape constructed by the builder is complemented by the convexity perceived by the visitor. Viewed in this fashion, it is no longer appropriate to describe this eminently active experience as "negative" space.

Once one is sensitive to the interplay of dynamic forces, the world of static solids gives way even in its simplest elements. I vividly remember a low wall attracting my attention at Thomas Jefferson's University of Virginia. Instead of a straight partition, it waved to the left and right in a sinuous fashion, transforming the rigid separation into an interplay of alternating thrusts. It taught me that even a straight wall needs to be understood architecturally as an encounter of antagonistic forces and that its uprightness must be defined as the resultant of the powers holding it in balance by pushing from both sides. This means that the wall must justify all its properties—its position, orientation, size, and thickness—as the visible creation of the pushes from its surroundings and the forces it generates itself in opposition. And what is true for the lowly single wall must hold for a building complex as a whole.

There are characteristic differences, however, between the spatial properties of built solids and their "negative" counterparts. One difference in

*Perhaps this interplay of mutual exclusion is the best example of the complementarity for which theorists such as Niels Bohr have sought analogies outside the field of quantum physics (see "Complementarity from the Outside" in this book).

FIGURE 20
Erich Mendelsohn, Einstein Tower in Potsdam. 1920.
Courtesy of Wolfgang Pehnt, *Expressionismus*, Hatje Verlag.

particular should be stressed. The design of buildings has always been controlled by the fundamental duality of verticality and horizontality. This duality is imposed on physical construction by our dwelling in gravitational space, and it visually supplies the strongest support for our orientation in the world of up and down as it interacts with expansion on the surface. Deviations from this basic framework have never been absent, but throughout the history of architecture they have always remained subordinate to the dominant framework.

In contrast, human beings, although dependent physically and psycho-

logically on that same framework, roam with their senses and thinking quite freely through the entire three-dimensional space of directions. To be sure, they, too, are tied to the horizontal plane and must make an effort to rise and climb, but they fly as much as they can, and at least with the glance of their eyes, they roam without inhibition through and around stolid structures.

Therefore, much importance in principle should be attributed to the few efforts by architects of our time to overcome the constraints of the vertical-horizontal framework and to conquer the entire range of shape variation. I believe that the free sketches of Erich Mendelsohn deserve our attention, although technology has had much trouble even in the age of reinforced concrete to emulate their vision. In fact, the Einstein Tower of 1920–1921 (Figure 20) has remained practically the only building in which Mendelsohn has been able to carry out some of his more unbridled ambitions. Yet there are similar attempts in the work of Hans Pölzig, Hans Scharoun, and Le Corbusier.

Not without good reason have these freewheeling shapes been related to the style of Expressionism in early modern art. We know by perceptual observation that any deviation from the standard straightness of vertical and horizontal enhances tension and transcends the either/or of basic direction by introducing the musical qualities of gradual deflection, crescendo, and decrescendo. Perhaps this freedom of spatial expression violates the nature of architectural statics too much to let architects ever go beyond what the great masters of the Baroque have already dared to accomplish. But it is useful to be reminded of the neverending dialogue between the boundless range of human vision and the strict conditions to which the laws of structural organization confine it.

REFERENCES

Arnheim, Rudolf. 1977. *The Dynamics of Architectural Form.* Berkeley and Los Angeles: University of California Press.

Koffka, Kurt. 1935. *Principles of Gestalt Psychology.* New York: Harcourt Brace.

Sekler, Eduard F. 1964. "Struktur, Konstruktion und Technik." *Der Aufbau* (Vienna), pp. 423–429.

Stevens, Peter S. 1974. *Patterns in Nature.* Boston: Little, Brown.

Winkelvoss, Wulff. 1985. *Architektur und Raum.* Stuttgart: Kohlhammer.

CARICATURE

The Rationale of Deformation

O N April 13, 1902, Paul Klee noted in his diary that he had seen a disappointing exhibition at the Galleria d'Arte Moderna in Rome: "The only good thing are the drawings, etchings, and lithographs of the French. First of all, Rodin with his caricatures of nude figures" (Klee, 1957). This remark confirms our suspicion that when we inquire about the nature of caricature, we are dealing with a concept whose meaning is not obvious.

Today, almost a century later, it would not occur to anybody to describe Rodin's quick figure sketches as caricatures. What did Klee see when he looked at them? The choice of the term *caricature* indicates that he saw those drawings as intended to deviate from the shape of the human figure as it "is." This does not mean that he thought they insisted on the negative or derisible aspects of their subjects. More likely in those days, he had no other words to describe a conscious deviation from lifelike representation. In any case, the term was not meant to put Rodin's watercolor sketches in an inferior category; Klee considered them the best works in an extensive show of graphics. In fact, his own graphics of those years contain caricatures, such as the well-known 1903 etching, *Two Men Meet, Each Suspecting the Other of Having the Higher Position* (Figure 21).

Although these drawings of Klee's are clearly caricatures, their style shades imperceptibly into that of other of his works of the same period that are not caricatures but modern art. During those years, the same held true for the work of artists such as the early Lyonel Feininger. A new kinship emerged between self-sufficient art, which was neither less nor more than aesthetic objects, and the humorous and satirical explorations of human

Derived from "The Rationale of Deformation," *Art Journal* (Winter 1983), pp. 319–324.

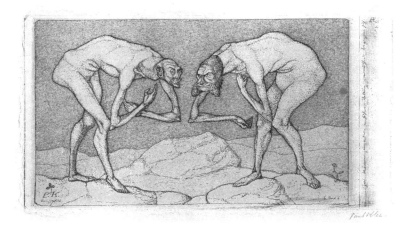

FIGURE 21.
Paul Klee, Two Men Meet, Each Suspecting the Other of Having
the Higher Position. 1903. The Art Institute of Chicago.

deficiency, which had developed into a flowering branch of applied graphics in the eighteenth and nineteenth centuries.

To be sure, the tradition of Hieronymous Bosch and Pieter Brueghel reminds us that humor and satire had an established place in the history of Western art. But I believe that until our own century a clearly understood difference existed between a faithful representation of nature, especially the human figure, and its deliberate deformation. Even when an artist such as Leonardo, curious about the aberrations of nature, drew a face in which a gigantic lower lip and a hooked nose snapped together like a vise, his style of drawing was as carefully naturalistic as usual. And even in the Dutch tradition, Rembrandt's depiction of Ganymede as a whiny brat differed in principle from the distorted figures of Brueghel, not to mention the liberties Honoré Daumier was to take with the classical norm in his heroes and gods of *Ancient History*. Throughout the post-Renaissance tradition, the rendering of nature was one thing, caricature another. It took the twentieth century to raise questions about the particular status of caricature in a setting in which deliberate violations of naturalistic standards had become the rule.*

Psychologically these differences derive from perceptual expression and

*Throughout the recent history of caricature, a distinction has existed between a style of willful pictorial deformation and the faithful recording of "caricatures" that are provided ready-made, as it were, by nature itself. Some artists are caricaturists mainly by the choice of their subjects but hardly by their manner of handling the shapes. Some photographers, such as Diane Arbus, have specialized in the deadpan presentation of deformed human specimens.

involve the general role of deviation from norms in visual perception. Far from being the monopoly of caricaturists or expressionists, deviation from norms is now recognized as being at the very root of perceptual dynamics and therefore of expression, artistic and otherwise. Nonnaturalistic styles of art have made us suspect that we are dealing here with properties germane to all art. And caricature, by its "pathological" exaggerations, draws our attention to a trait less obvious, yet universally present, in "normal" art.

The following sketchy exploration takes off from the assumption that an essential property of artistic representation is its reliance on perceptual dynamics. In the visual arts, it is not the shapes as such that convey expression aesthetically but the configurations of directed forces generated by those shapes in the nervous system of the viewer. A triangle, for example, contributes expression not because it is geometry but because it points and jabs and acts in straight directions rather than with the flexibility of curves. Now one of the main resources of visual dynamics is deviation. When a shape is seen as a deviation from a standard, it will be inhabited by forces that pull away from the norm or try to return to it. A tilted rectangle, like a leaning tower, makes its statement by its visually implied relation to verticality. Caricature is a spectacular demonstration of expression by deviation. But deviations come in many varieties, and only some make for caricature.

Nor are all deviations equally dynamic. A change of size has few dynamic effects as long as it applies to the entire image equally. An enlargement is a mere transposition that leaves the configuration of visual forces untouched; it contains no reference to the original size. It is true, however, that when bigness and smallness face each other like Goliath and David in the same image, the contrast generates dynamics by relation. Even in such a case, mere size difference expresses little as long as the dynamics inherent in the elements remains unaltered. Lilliputians are no caricature of Gulliver, nor is he a caricature of them.

It takes deformations of shape to get us to our subject. The simplest of those is the change of the ratio between the vertical and the horizontal dimensions. Things are made slimmer or taller or fatter. But here again we observe that the mere deviation from a norm is not by itself sufficient to obtain the effect. The deformation of a circle does make us perceive a range of ellipses as deviations from the circular norm, but ellipses do not appear by themselves compellingly as distortions of circles. Nor are rectangles necessarily seen as rubber squares pulled along one of their axes. We conclude that what counts for the perceptual effect of deviation is not the factual, geometrical difference between a given image and some norm

FIGURE 22.
Alberto Giacometti, Standing Figure. 1957.
University of Michigan Museum of Art, Ann Arbor.

in and by itself. Rather, such a norm has to be phenomenally present in the image as the base from which the given pattern deviates.

Similarly, if one changes the size relation between the dimensions of the x axis and the y axis in the network of basic coordinates, one obtains skinny and fat people, short and tall ones, but the change of proportion as such does remarkably little for the dynamic effect. To be sure, we see that Alberto Giacometti's figures are radically slenderized (Figure 22), but the perceptual presence of the norm from which they deviate is remarkably weak. The "correct" proportion of the human figure is present in memory only, and one can easily shift to a world governed by its own independent norm of proportion and by the particular dynamics derived from that proportion. The emaciated, contracted, and shrunken figures turn into creatures of their own kind whose adventures in space interpret our own trib-

ulations. Giacometti's figures are not thin humans and certainly not caricatures.

To accomplish their effect, these figures are alone, that is, they are deprived of a surrounding that might contradict the independent validity of their proportions. Such isolation is easily provided in sculpture. The lean figures of Wilhelm Lehmbruck profit similarly from their isolation. In painting, the entire setting must be subjected to the same formula as the figures. A consistent Mannerist such as El Greco slims his shapes throughout a picture and indicates thereby that he is presenting not abnormal proportions of the human figure but a translation of the visual world as a whole into a differently shaped world.

We should remember here that Mannerist slenderizing did not come about by the kind of mechanical compression or extension that results from optical astigmatism. The foolish notion that El Greco's style was due to a defect of his eye lenses may serve here to make us realize that a mechanical overall change of proportion does not generate pictorial dynamics.* An-amorphism has never been more than a trick used not to enhance images but to hide them. It blindly crushes the pictorial structure. The anamorphic skull in Hans Holbein's *Ambassadors*, whatever its intellectual meaning, mars the naturalistic scene of the painting as an unassimilated foreign body. It is an embarrassing flaw.

In Mannerism, the deviation from natural proportion derives organically from an enhancement of structural features inherent in the model objects. The elegance of arms and necks, columns and trees is strengthened by their spatial extension. Developed from within rather than mechanically imposed, the modification accentuates certain expressive aspects in a stylistically desirable manner. Particular parameters of deviation from the model tend to dominate artistic representation in other styles as well. Yet too much of such a dominance may result in a cheaply acquired uniformity and, indeed, in monotony.

More typical and more fruitful are complex constellations of dynamic features. These are more difficult to handle compositionally because they must be held together by an overall theme. On our way to caricature it is convenient to refer here to certain aspects of physiognomics, a once fashionable practice of interpreting visual expression whose historical connection with the art of caricature has been documented by Judith Wechsler (1982).

From the beginning, the teachings of physiognomics, together with

*The belief that Mannerist proportions were due to an eye defect of the artist is still not entirely extinct, although it was refuted for El Greco as early as 1914 by the psychologist David Katz (1914).

those of phrenology, aroused much controversy. Understandably enough, one was primarily concerned with the validity of such interpretations: how much could one trust an analysis of a person's character and attitudes derived from the external appearance of the body and especially the face and head? In his spirited attack on Johann Kaspar Lavater's physiognomics, which, he says, invaded Germany in the 1770s like an epidemic of madness, Georg Christoph Lichtenberg cites all the powerful arguments that have been leveled against the physiognomists ever since. "What an immeasurable leap," he exclaims, "from the surface of the body to the interior of the soul!" (1953, vol. 2, p. 44 ff). And while he does not deny the effect of the mind on the body, he urges us duly to consider the shaping power of "the whiplashes of fate, of climate, illness, nutrition, and the thousands of calamities with which we are afflicted not just by our own evil intentions but often by accident or duty." Lichtenberg realizes that we all draw constant inferences from looking at the faces we deal with. But he considers this practice justified only when it relies on pathognomic rather than physiognomic evidence, that is, on the behavior of the mobile parts of the body rather than on its anatomy. This limited endorsement would leave the arts precariously impoverished because painters, sculptors, photographers, and actors rely on characterizing their figures beyond their momentary feelings.

Fortunately, the arts are not touched by the problem of physiognomic validity, except where images are used for documentation. A historian trying to check on the character traits of Pope Leo X from a Raphael portrait will indeed run into this problem; but wherever images are dealt with as art, things are what they look like. The question is not whether we have a right to condemn one of Daumier's lawyers because of the haughtiness and slyness of his externally visible expression but whether we can determine what makes us see this particular appearance of face and deportment as haughty and sly. The answer takes us back to the psychology of deviation and, specifically, to the notion that just as a tilted rectangle is seen as a deviation from an upright one, each particular feature of a human body owes its expression to the norm from which it deviates.

The morphology of these deviations can be systematically dealt with in two ways. One of the procedures, pleasantly exact and simple, explores the modifications of the Cartesian network to which particular shapes conform. The biologist D'Arcy Thompson (1969) has studied evolutionary relations between animal species by showing that a simple tilting, curving, or flaring of the coordinates will transform the shape of one species into that of another (Figure 23). Which species deserves to be given the norm framework is somewhat arbitrarily decided—Thompson can treat the hu-

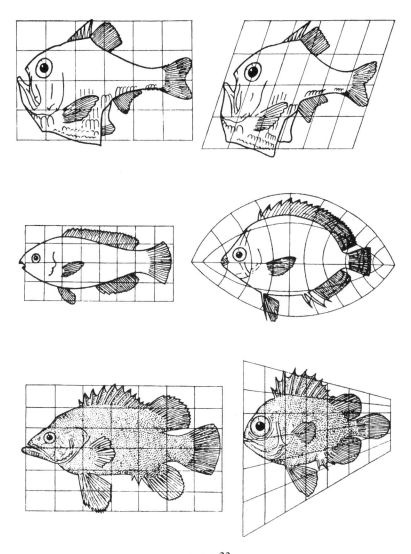

FIGURE 23.
From D'Arcy Thompson, *On Growth and Form*, 1969.

man skull as a deviation from that of an ape as easily as the other way around; and to the unprejudiced eye no one species is a caricature of the other.

For his part, Thompson relies on the harmonious, symmetrical, and geometrically simple deviations from the standard coordinates. Applied to the physiognomical study of racial variations in the human species, the unprejudiced procedure would offer a display of graded proportions, no

one better than the other. Given the prevailing biases, however, it is not surprising that even two hundred years ago, Lichtenberg in his aforementioned polemic was moved to defend the Negro race against the slurs derived from the preference for the Caucasian proportions. People insisted on the difference between the ideal and the imperfect, the beautiful and the ugly. The ideal, derived from Greek antiquity, relied on the balanced, equal apportionment of the basic components.

When, instead of being concerned with the variability of organic manifestation, one wishes to praise perfection and deride ugliness, less regular deviations from the Cartesian network lead to caricature. Thus, Albrecht Dürer obtains distortion by subdividing the vertical dimension irregularly (Figure 24).

A second procedure for dealing with the morphology of deviation is less accessible to tidy systematics; it aims much more directly at the dynamics of visual expression. Each feature of the human figure is shown to derive its expression from a corresponding norm base, the way musical pitch derives its perceptual character from the norm level of the tonic. This norm base of bodily expression comprises upright versus tilted, straight versus bent, advancing versus receding, rising versus sagging, ample versus lean, tense versus limp, and so on. An erect or slumping figure, a pointed nose or receding chin is read along these dimensions as a deviation from culturally given norms. Such deviations, which generate the perceptual dynamics of each element, are automatically perceived as manifestations of analogous states of mind. To some extent, these physiognomic readings take into account the known physical functions of the body and its parts. The expression of keenly observing eyes, for example, implies that the eyes serve vision; but the nose, that favorite utensil of the caricaturist, may owe little to its being the organ of smell. The nose is the prow of the face and derives its principal expression from how boldly or awkwardly it handles that visual leadership.

There are as many deviations from norm bases as there are structural components of the human body. Some refer to individual parts, such as mouths or skulls, some to more generic features, such as the angle of the profile or the curvature of the back. When Lavater and his avid disciples, among them the young Goethe, described the physiognomy of individuals, they were intuitively guided by the perceptually organized totality of the expressive pattern. Trying to be systematic, however, the same Lavater endeavored to define in his writings the expression of each separate part of the head and to determine the expression of the whole from the sum of the parts. To show that this procedure leads to misinterpretation, I conducted an experimental study many years ago under the guidance of Gestalt psy-

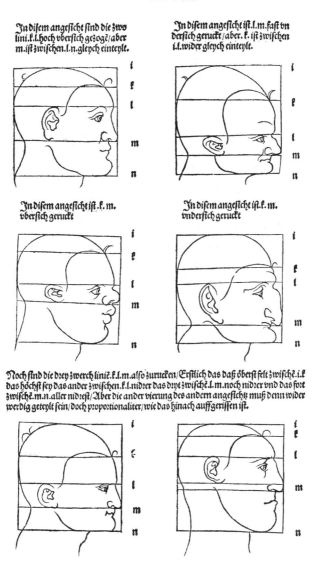

FIGURE 24.
From Albrecht Dürer, *Vier Bücher von menschlicher Proportion*, 1582.

chologist Max Wertheimer in which I demonstrated that the expression of a chin or nose can change radically when a different face makes for a changed context (Arnheim, 1928) (Figure 25).

In coping with physiognomic expression, an artist faces the problem that arises with every global structure: how to organize a multiplicity of dynamic vectors into a coherently functioning whole. The problem is par-

FIGURE 25.
From Rudolf Arnheim, Experimentell-psychologische
Untersuchungen zum Ausdrucksproblem. Dissertation. 1928.

ticularly acute in caricature when a variety of divergent features is forced
into a precarious union, when a "nosy" nose is trying to get along with a
hesitant mouth and vigilant eyebrows. A great artist such as Daumier is
able in a single face or figure to unify a group of outspokenly discordant
espressive traits under one viable, complex theme.

Remember now that we are concerned not with physiognomic expres-
sion in general but with the particular category of images that make us
smile or laugh. Although Henri Bergson in his book *Le Rire* points out that
laughter is a response to deficiency, this criterion is helpful but too broad.
In the practice of daily life, people should be laughed at only for defi-
ciencies for which they are to blame. This would exclude all physical
defects. There is no permissible way of blaming a person for being lame,
blind, or hunchback. For the same reason, mental flaws are in the precinct
of the humorist only insofar as they are dependent on a person's will—
vanity and gluttony, yes; psychosis, no.

One look at caricature, however, tells us that the world of imagery
responds to special rules. The arts enjoy licenses not granted in the real
world. Caricatures show physically deformed people afflicted with devia-
tions from the bodily norm. They have paunchy bellies, spindly legs, re-

FIGURE 26.
Honoré Daumier, Don Quixote. Brandeis University,
Trustman Collection, Waltham, Massachusetts.

ceding chins, bulbous noses, and they are derided and blamed for these deficiencies.

In the arts, which are a world of symbols, physical defects stand for moral faults deserving punishment, and in the case of caricature the punishment is limited to derision because caricature does not reach beyond superficial flaws. It presents a scene of foolishness, bungling, and petty misdemeanors, which confines the range of the artist considerably.

It is not easy for an artist of some sensitivity to limit a lifetime's conception to what can be laughed at. Remember that human frailty has been represented traditionally by the two profoundly related masks of tragedy and comedy, with the "normal" face reposing serenely between the two. Thus, comedians incline to melancholy, and the tragic reverberates in all great humor, in François Rabelais, Molière, or Charles Chaplin. *Le sage ne rit qu'en tremblant* is the theme of Baudelaire's essay *On the Essence of Laughter* (1961, p. 976 ff).

This tragicomic quality is movingly evident in the work of Honoré Daumier, who grew beyond his illustrator colleagues by developing into a great artist. His earlier work is populated by the customary shysters and crooks,

FIGURE 27.
Pablo Picasso, Rape of the Sabines. 1963. Boston Museum of Fine Arts.

imbeciles, and charlatans; but even there, if one looks carefully, one sees him reach beyond his fellow caricaturists, the Philipons and the Cruikshanks. Small human shortcomings transcend into the tragic, mere foolhardiness becomes courage, naïveté grows into cosmic wonder. And we are not surprised to see him arrive at his great images of Don Quixote (Figure 26), where visual deformity is no longer caricature and a former newspaper artist reaches a summit of the arts, the union of the comic and the tragic.

The use of bold deformity enabled Daumier to become the first modern artist of his generation. The freedom to deviate from the norms of realistic representation, which were still binding for every other painter and sculptor of his time, was granted to him by the licenses of caricature. Just as in the literature of those days Friedrich Hölderlin was liberated by psychosis from the bonds of classicism to become a great modern poet *avant la lettre*, Honoré Daumier, by the mandate of caricature, could extend the range of visual expression to a privilege that was otherwise reserved for the Expressionists of the next century.

We can now understand why in recent art the distortion of realistic shape has been exempt from derision. Just as nobody laughs at the spindly limbs of Daumier's Don Quixote, nobody acquainted with Expressionist art can afford to giggle at Willem de Kooning's or Pablo Picasso's deformed women. Artists are no longer tied to a universe of discourse that makes the image a faithful duplicate of its counterpart in the real world and therefore charges every deformity to the account of the figure represented. Look at Picasso's *Rape of the Sabines* (Figure 27). Surely the woman and her child are violently distorted. But they are not caricatures because, among other reasons, no particular features of the bodies are out of proportion with the rest. Rather, the bodies as a whole are evenly deformed, so that deformation is imposed as a general condition on the figures, which retain their integrity. In fact, the same deformation evenly translates the scene as a whole, the horses as much as the victims, the warriors, and even the small temple, which stands for the total setting of the work. The world as a whole is subjected to a mood of violent passion. And that is no laughing matter.

REFERENCES

Arnheim, Rudolf. 1928. "Experimentell-psychologische Untersuchungen zum Ausdrucksproblem." *Psychologische Forschung* 11, pp. 2–132.

Baudelaire, Charles. 1961. "De l'essence du rire et généralement du comique dans les arts plastiques." *Oeuvres complètes*. Paris: Gallimard.

Dürer, Albrecht. 1969. *Vier Bücher von menschlicher Proportion*. Olten: n.p.

Klee, Paul. 1957. *Tagebücher, 1898–1918*. Cologne: DuMont. Transl. *The Diaries of Paul Klee, 1898–1918*. Berkeley and Los Angeles: University of California Press, 1964.

Katz, David. 1914. *War Greco astigmatisch? Eine psychologische Studie zur Kunstwissenschaft*. Leipzig: Veit.

Lichtenberg, Georg Christoph. 1953. "Über Physiognomik wider die Physiognomen zu Beförderung der Menschenliebe und Menschenkenntnis." *Gesammelte Werke*. Darmstadt: Holle.

Thompson, D'Arcy. 1969. *On Growth and Form*. Cambridge: Cambridge University Press.

Wechsler, Judith. 1982. *A Human Comedy: Physiognomy and Caricature in 19th Century Paris*. Chicago: University of Chicago Press.

ART HISTORY
AND PSYCHOLOGY

IN THE MOST general terms, psychology claims to have a contribution to make to the understanding of art and its history because anything referring to the mind is in psychology's domain. The creation and reception of artistic experience certainly belong under this heading. Psychology can consider itself indispensable for any dealing with art because no theoretical statement on matters of the mind, put forth by experts or laypersons, can be better than the psychology on which it is based.

It is true, however, that before psychology is granted any part of this privilege, it has to overcome considerable distrust on the part of people in the arts. This distrust is directed most broadly toward all intellectual analysis, which is suspected of endangering spontaneous intuition. Ever since the Romantics, the paralyzing effect of conceptual reasoning and generalization has been denounced. In our own century, the poet Paul Valéry insisted on expressing this fear: "Quite credibly, we would be unable to carry out our simplest act or most familiar gesture and be impeded in our most trivial capacities if, to accomplish them, we had to make them explicitly present to our thought and know them fundamentally. Achilles cannot defeat the tortoise if he thinks about space and time" (1938, p.27). This prejudice, not entirely extinct even today, has been directed toward theoreticians and has supported the one-sided notion of art as a purely emotional activity.

The apprehension expressed by Valéry had already been eloquently exemplified by Heinrich von Kleist in his famous 1810 essay on the puppet theater ([1810] 1947). Kleist maintained that the natural innocence of a dancer's grace was in danger of being undone by conscious control. These early warnings were brought to mind again when psychoanalysis not only undertook to uncover the mainsprings of artistic activity but, in doing so,

suggested that creative impulses are generated at a lower mental level than is commonly assumed. Psychoanalysts described art as a second-best substitute for the satisfaction of instinctual needs such as sex, violence, or power. So one-sided an approach to artistic motivation could not but interfere with the reception given to psychology by people in the arts.

In the following, I will not offer an apology nor present a survey of the present state of art psychology. Rather, I will point to certain problems shared by psychology and art history and to solutions suggested by recent developments in both areas. To this end, I shall select as a partner an eminent art historian, Kurt Badt, whose *Eine Wissenschaftslehre der Kunstgeschichte*, published in 1971, offers a penetrating discussion of our subject. I have made this choice in part because I owe to the late Dr. Badt many of my most decisive experiences of art. At the same time, my own approach, strongly influenced by psychology, made for a very different view of the problems concerning us both. This fruitful constellation permits me to outline some of my own views by contrast.

For a start, let me point out that every science is twofold. In all scientific work, the observation of particular instances leads to the formulation and evaluation of general principles. These principles, in turn, can then be used for the elucidation of individual cases. In the natural sciences, these two activities are kept clearly separate in the sense that, for example, theoretical physics is professionally distinct from applied sciences such as astronomy, geology, or engineering. Similarly, medicine depends on physiology and biology but remains separate from them in practice. In the case of psychology, however, scientific theory is still too young to deal appropriately with the deeper mental processes, precisely those that are most pertinent to practical application. Consequently, indispensable general concepts have been derived in a jerry-built fashion from practical experience, a procedure not conducive to systematic explanation and scientific proof.

A similar situation prevails in the history of art. The theory of art can hardly be said to exist as a discipline. It is either left to philosophers under the heading of aesthetics or to the informal explanations of art historians, who go in search of usable concepts and facts elsewhere. The lack of an established tradition in this area can be seen in Badt's approach. When he undertook to submit a scientific exposition of art history, he decided to use as his model a work from another discipline: the German historian Johann Gustav Droysen's *Grundriss der Historik* of 1858 (1960). The need for a theoretical basis had already been evident to Heinrich Wölfflin, who concludes his 1886 dissertation with the admonition that "an organic understanding of the history of artistic form will become possible only when we

come to know which fibers of human nature connect with formal imagination [*Formphantasie*]" (1946, p. 45). The history of art, says Wölfflin, aspires to exactitude. Therefore, it wishes

> first of all to stay clear of the pernicious contact with aesthetics; and there are those who endeavor strenuously to talk about nothing but how things have followed each other in time, and not one word more. Although I am not inclined to overlook what is good about this tendency, I am convinced that the highest level of science cannot be reached in this fashion. When history does not want to go beyond acknowledging things as they followed one another, it cannot prevail. In particular, history would be mistaken if it believed to attain "exactness" thereby. Exact work becomes possible only when the flow of the phenomena is caught in firm shapes. . . . The humanities still lack this foundation, which can only be looked for in psychology. (Wölfflin, 1946, p. 45)

Such demands arose because art theory, like depth psychology, has to take a particular interest in the individual personality. To a biologist, one fruit fly is as good as the next, and in exploring particular phenomena, even the experimental psychologist is mostly concerned with what his human subjects have in common, not what distinguishes them. The depth psychologist, however, is induced by his own humanity to feel that it is his task to investigate his neighbor. He is concerned with the special qualities of the single person. Similarly, the art theorist may see the value of his work in the emphasis on the great creative personalities.

For this reason, research in these areas faces the fundamental methodological question of whether scientific procedure is applicable to the individual case. The matter became critical in the nineteenth century when the natural sciences increasingly stressed the importance of exact proof. Strict validity of the results was guaranteed in the laboratory when the object under investigation, say, a chemical substance, was stripped of all variables but the one to be examined. To this end, every experiment had to be carried out often enough and with enough observers to compensate for all accidental impurities. Statistical analysis separated the wheat from the chaff.

Such procedures, however, could not be applied when the investigation concerned individual cases. There was no point in reducing an individual to a single trait, nor could particularities be dismissed as mere "noise" in favor of generalities. This raised the issue of whether anything provable could be stated about individual instances. Beyond that, a more general and more interesting question arose: could individuality be described by means of general concepts?

Keep in mind that scientific description is not after completeness, nor

does it aim at the duplication of what exists anyway. Rather, it wishes to grasp certain general traits so as to formulate lawful rules. Such an analysis may seem impossible when one aims at envisaging an individual case, be it a person, a work of art, or some special event. This dilemma burdened the nineteenth century with the famous split between *Naturwissenschaft* and *Geisteswissenschaft*, which involved the untenable assertion that the former was concerned only with description and the latter with understanding.

In psychology, this split continues to be under debate. Sigmund Freud, in his day, had to defend himself against the assertion that psychoanalysis was not a scientific but an "artistic" procedure. He replied that what he and his disciples did was as scientific as Darwinian evolution or Copernican cosmology. Even so, complaints about the insufficient reliability of clinical diagnoses persisted.

In 1937 U.S. psychology arrived at a clarifying formulation when Gordon W. Allport, in his book *Personality*, adopted German philosopher Wilhelm Windelband's distinction between the nomothetic and the idiographic method. Psychology, says Allport, can rely on two scientific procedures. One searches for general laws of human functioning and employs exclusively the research methods of the exact natural sciences. The other aims at an understanding of the individual. In practice, says Allport, the two should complement each other. Actually, however, the psychology of personality employs two one-sided means of dealing with the problem of personality. One measures single traits, whose summation does not do justice to the integrated structure of a human mind, and the other speculates about psychological forces with theories whose empirical reliability remains largely a matter of faith. As an illustration of the present situation I cite a statement by Daniel N. Robinson in a recent handbook, *A Century of Psychology as Science*: "There is ample room and considerable need for both a nonscientific psychology and a scientific nonpsychology as human beings go about the important business of understanding themselves" (Koch, 1985, p. 73).

In art history, a similar division has been articulated by Badt, who was also a fine painter and whose attitude resembled Wölfflin's description of the artist's attitude: "It is well known that in general artists take only a moderate interest in discussions on the historical position of a work of art. They ask, What is the effect created by the work of art? Does it reveal a greatness of vision? Is its conception strong and original? Etc." (1946, p. 171). Badt raises the question, "Are works of art *examples* of the events constituting intellectual history, and is it at all possible to combine them in a generality?" His radical answer is that no laws exist in the history of

art, if they are to be understood as the kind of determination that, according to Droysen, represents what is constant and decisive in history. Nor is Badt willing to accept the "lawfulness of vision" of which Wölfflin speaks in his *Principles of Art History*. When it comes to subordinating works of art to the concept of style, Badt maintains that "the style of an epoch tends to be the most conspicuous feature of a work of art, but it is also its most trivial aspect, a mere abstraction drawn from the wealth of the artistic achievements as they occur together in time and space" (1971, p. 38).

Badt does not deny that a work of art must be viewed in its context, its place in the total oeuvre of its maker as well as its cultural location. But he wishes to restrict these influences to what is specifically artistic. Other causal factors are to be subtracted from the nature of the work as mere "negative determinants." Personal and cultural traits, including the stylistic tradition, are nothing but "conditions that are indispensable for the existence of particular works but do not constitute their essence" (Badt, 1971, p. 47). A psychologist, faced with this problem, would agree to sift essentials from accidentals, but he would not want to exclude the metabolic transformation of conventional, personal, or even purely technical factors into truly artistic substance.

In keeping with his approach, Badt sees a discontinuity in the relation between the artist and his work. One could expect, Badt says, that our deeper and broader knowledge of the human mind would make us all the more able "to trace the nature of artistic creation, but the opposite is the case. We now realize more clearly how little correspondence there is between the work and its maker. In his work, the artist surrenders the limitations of his particular character" (1971, p. 108). Elsewhere he comments, "It should be kept in mind that an artist's biography is more nearly the *consequence* of his being an artist and creating art than the other way around. In most cases for which the facts are known, the artist and the events of his life are irrelevant to his work" (1971, p. 25).

Categorical denials of this kind may be considered useful as antidotes to psychoanalytic interpretations in which childhood experiences are used to describe works of art as purely private utterances. If Leonardo's painting *Madonna and Child with St. Anne* were nothing but a reflection of his relation to his mother and stepmother, the universality of its artistic significance would be greatly impaired. More likely, if Leonardo's early family situation did indeed influence the conception of his painting, its relation to the essential meaning of his work was no more relevant than was Dante's meeting a nine-year-old girl in the streets of Florence.

To be sure, psychology in general has demonstrated that people's char-

acters manifest themselves in their activities. The term *projection* is used to describe the way persons, especially the mentally disturbed, transfer their drives and ideas to their environment. Even the normal personality expresses itself in projective tests such as the Rorschach inkblots. Empathy is also a pertinent mechanism (it was introduced into psychology by Theodor Lipps and was of such influence on Heinrich Wölfflin that he based his dissertation on the thesis, "We underlay all phenomena with the image of our own self" [Wölfflin, 1946, p. 16]).

Gestalt psychologists in particular, however, have insisted that effective human behavior depends on the ability to face situations appropriately, that is, in terms of their own objective requirements. In dealing with problems of perception and thinking, these psychologists have demonstrated that the environment exposed to the senses and cognition is not passive raw material at the mercy of purely subjective manipulation; rather, it possesses a structure of its own that must be respected if responses to it are to be successful. When applied to the arts, this notion means that the artist's freedom is not to be taken for arbitrariness but is to be understood as an obligation to render reality in his own manner of being truthful.

This leads me to the problem of values (see Arnheim, 1986, pp. 297–326), which offers additional insight into the relation between art history and psychology. Here we need to avoid the widespread misunderstanding that science eschews all dealing with values in its descriptions, whereas the arts place primary emphasis on values. Actually, the problems raised by evaluation are very much the same in both science and art. Both must deal with questions of ethics, that is, with the response to good and evil, and both must consider quality, that is, the difference between good and bad.

Professional ethics demands that the researcher not contaminate his findings with subjective inclinations. This risk of contamination has become especially manifest in the social sciences. In social science, says Kenneth J. Sergen, "knowledge is not an impartial reflection of 'the way things are,' as the empiricists would have it, but reflects the vested interests, ideological commitments, and value preferences of the scientists themselves" (Koch, 1985, p. 541). Evidently, a focused perspective is unavoidable because even in the natural sciences, the way problems are selected and treated is influenced by historical and personal circumstances, and actually, the resulting variety of approaches is entirely desirable, provided that the facts themselves remain undisturbed. In the arts, where originality is particularly appreciated, this leads to the demand that the artist interpret human experience faithfully, although in his own manner. It is worth remembering that when Freud wanted to show that art, just as dreams,

offers wish fulfillment, he limited himself to popular fiction (1941, p. 1906). He realized that the integrity of the genuine writer's worldview does not tolerate such corruption.

The fear of unscientific subjectivity has led indeed to a reluctance to include value matters in respectable research. Jane Loevinger has observed that "psychologists, shaky about their standing as scientists, tried to avoid any topics that were possibly tainted with values" (Koch, 1985, p. 454). Even so, the idea that science excludes all evaluation and limits itself to recording "the facts" is untenable. In biology, to use an obvious example, one cannot deal meaningfully with the theory of evolution without distinguishing between factors that enhance life and others that obstruct it. Similarly, psychology acknowledges the positive value of survival and reproduction, favored by nature through inbred instincts. These instincts are supplemented in psychology by corresponding social and personal values. Psychiatrists consider not only the objectives pursued by their clients but also their own conception of what constitutes a desirable existence; and medicine is based on the assumption that to be alive is better than to be dead.

Art is often said to be morally neutral. According to Badt, the work of art is beyond the norms of custom, law, and faith. "It dwells purely within itself, equally able to present good and evil without abandoning any of its artistic power and in fact justifying its own existence precisely by this freedom" (Badt, 1971, p. 126). But does not freedom of artistic description require ethical evaluation as an indispensable aspect of reaching the truth? Francisco Goya's Saturn, who devours his children, is depicted as a monster, whereas the serene virtuousness of Raphael's Sistine Madonna is a cardinal aspect of her nature. In the drama, the playwright pronounces moral judgment by showing the villain destroyed by violations of the laws of life.

The value problem also comprises the judgment of quality. Art historians are constantly faced with the task of deciding which materials are suited for their purpose. As they do not simply collect everything accumulated under the exceedingly broad heading of "art," the selection depends on whether one intends to compile a history of the best works, in which case one excludes works that are second-rate. But historians may also aim at what is stylistically typical or influential or at whatever seems to be culturally symptomatic. Every one of these purposes involves judgments of what is of value for the particular case.

Artistic quality is not simply a matter of critical taste. It is relevant for the investigation of theoretical principles because one of the characteristics of works of high quality is that they display the essentials of art most

purely. Inferior works are contaminated by accidents of a personal, economic, or social nature. A very similar problem exists in the natural sciences. An unpurified chemical is unsuitable for valid demonstration because the effects of the various given ingredients are not surveyable. Psychology also looks for cases exemplifying the phenomena under investigation as purely as possible. In every field, specimens of the highest quality are barely good enough for the determination of basic principles. If one undertakes, for example, to explore the nature of artistic motivation or of pictorial composition, one is likely to be led astray if one uses material of mediocre quality.

But how is quality determined? The physical sciences can measure purity or intensity with desirable precision. In the life sciences, the quality of organisms or mental behavior is less easily ascertained. Connoisseurship in the arts requires training, experience, and an ability to "see" well. In the last analysis, personal judgment is often decisive.

Let me sum up this discussion by recalling that nothing has value in and by itself. Value depends entirely on the purposes to be satisfied. The endless variety of human needs and desires makes for a corresponding range of what is considered good or bad. If we want to reach for more general standards, we can refer to Baruch Spinoza's definition of "good" as "that of which we know with certainty that it is a means of moving us more and more closely to the exemplary image of human nature to which we aspire" (*Ethics*, part 4, preface).

My purpose has been to show that in many ways the procedures and methods guiding work in art history and in psychology are largely the same, simply because all human knowledge is based on the same set of basic principles. Both areas of inquiry seem to develop in directions that will make their cooperation more intimate and fruitful. Art historians are increasingly concerned with problems of perception, motivation, and social relations, about which psychologists are becoming more competent. Psychologists, in turn, are approaching levels of mental maturity to which the understanding of works of art can greatly contribute.

REFERENCES

Arnheim, Rudolf. 1986. *New Essays on the Psychology of Art*. Berkeley and Los Angeles: University of California Press.

Allport, Gordon W. 1937. *Personality*. New York: Holt.

Badt, Kurt. 1971. *Eine Wissenschaftslehre der Kunstgeschichte*. Cologne: Dumont Schauberg.

Droysen, Johann Gustav. [1858] 1960. *Grundriss der Historik*. Darmstadt: Wiss. Buchgesellschaft.

Freud, Sigmund. 1941. "Der Dichter und das Phantasieren." *Gesammelte Werke*, vol. 7, 1906–1909. London: Imago.

Kleist, Heinrich von. [1810] 1947. *"Essay on the Puppet Theater."* *Partisan Review* (January–February), pp. 67–72.

Koch, Sigmund, and David Leary (eds.). 1985. *A Century of Psychology as Science*. New York: McGraw-Hill.

Valéry, Paul. 1938. *Introduction à la poétique*. Paris: Gallimard.

Wölfflin, Heinrich. 1946. *Kleine Schriften*. Basel: Schwabe.

PART IV

THE MELODY OF MOTION

A NYBODY COMING FROM the visual arts or literature to dance and music performance notices with some envy how naturally the dancing and the singing derive from everyday life. They seem to be born with all of us, and they grow through the years to accompany our daily pursuits and heighten our ceremonies. It is also true, however, that the last three centuries have removed the performing arts from their natural context by separating the doer from the watcher or listener and the stage from the audience. This social isolation of the arts, which holds true for the arts in general, has also distinctly influenced the style of the productions by removing them from the needs, activities, and responses of the population and turning them into a specialty for the connoisseurs. In the field of dance, classical ballet is the most conspicuous example of this detachment.

It has become less and less apparent that these refined creations have their roots in the soil of our civilization. And yet it is these roots that supply the sap of subsistence to the performing arts. Therefore, the danger of a separation has been increasingly felt, and in response to this danger modern dance, through the better part of our century, has been characterized by an explicit return to the natural physiology of the human body behaving as an organism in physical space. Among the early pioneers of the modern dance, Rudolf Laban most explicitly stressed this renewed contact with the conditions and resources of the body. The theme of his lifework as a dancer, teacher, and theorist was the indivisible unity of what one might call organic mobility, a basic aspect of biological existence that reaches from the simple gesture of a flower turning toward the light to the most esoteric choreography. Thus, it was natural for Laban to look beyond

Derived from the keynote address, Laban Centennial Celebration, Laban Institute of Movement Studies, New York, June 1979.

127

the professional dance performance of the stage to the broader context of gymnastics and physical rehabilitation and even to the rationalization of work movements in industry. This approach implies psychological considerations that are not out of date.

Laban was convinced that the body can act properly only in the service of the mind. Although the training of a healthy and efficient body was essential to him, he did not like the traditional gymnastics of moving the limbs separately and not functionally, as though they belonged to a mindless robot. Nor did he believe in competitive sports that push isolated functions of the body to peak performances and thereby distort natural coordination. The body as a manifestation of the spirit was for Laban a matter of human dignity, but he also understood that by coordinating the body with the mind one makes it work well. More recently, this principle has found acceptance in physical therapy. In fact, I remember that as far back as the 1920s one of my teachers in Berlin, psychologist Kurt Lewin, had among his many experiments one dealing with encephalitic children. These children had difficulty initiating and controlling motor behavior. To make an arm reach and move in a prescribed direction was a problem for them. Lewin constructed a revolving drum that rotated slowly behind an opening in a screen. A number of hooks were attached to the drum, and the children were asked to slip a small metal ring on each hook when it appeared in the opening. This they did remarkably well, apparently because the experimental setup shifted their attention from the arm to the target. To concentrate on the bodily instrument of the arm in isolation was unnatural and therefore impossible. But when the instrument assumed its natural function as a means to an end, it operated more willingly and efficiently. The voluntary innervation of the arm, especially the act of decision, was all but absorbed by the dynamics of the situation, which called for a spontaneous, reflexlike compliance.

The gradual transition from the training of the single implement to the mastery of the total operation is, in fact, characteristic of learning processes, especially in motor behavior. The young actor, reacquiring the art of walking on the stage as a conscious activity, stumbles over his legs until his mind, and thereby his body, comes to control the total performance as a meaningful, goal-directed procedure in which each component's role is determined by its function. This integration not only gives practical efficiency to the performance; it also brings about the delightful melody of coherent motion that we admire watching a skillful craftsman, a good skater, a virtuoso violinist, an experienced bartender, or, indeed, an accomplished dancer.

There is a direct connection between practical efficiency and visible

artistic expression. Any well-coordinated sequence of dynamic actions carries meanings of general human impact, regardless of whether it is executed with artistic intention or with a purely practical purpose in mind. Slashing or pushing, bending down to pick up something or extending the arms to receive, pointing or compressing or stamping, all return in the vocabulary of the dancer as ways of transmitting visual symbols of human responses. Pantomimic expression occurs most naturally and fully as a pervasive aspect of practical behavior. This was overlooked, at least in theory, as long as, in acting and figurative painting, expression was understood as the standardized conveyance of peak emotions. Fear and contempt, joy and sadness in the face of the performer were illustrated in textbooks such as that prepared by the seventeenth-century painter Charles Le Brun. Actually, in the presentations of the dancer, the choreographer uses peak emotions as sparingly as the composer does in music. In certain styles they are entirely absent. Instead, the symbolical overtones of expression accompany human behavior throughout, and although they tend to fade in the practice of the day, they resonate faintly or more pronouncedly in everybody's awareness. They enrich the experience of being alive beyond the mechanical execution of duties, and no distinction exists in principle between such enriched motor behavior and the inventions of the dancer carried out for the purpose of meaningful expression.

Something similar holds true for the various ways of doing gymnastics. Some of the Asian practices go much beyond the mechanical exercise of the limbs. By engaging the body as a whole in movements not derived from an imposed athletic geometry but from the subtle tensions and relaxations sensed in the muscles and tendons of the body, the gymnastic training creates a refreshed awareness of one's being actively alive.

In gymnastics, of course, the performance remains limited to a sequence of single and simple motions designed to train particular physical functions. Simple though these functions are, however, they are also the elements on which the more complex choreographic structures are based, and each of them has, by itself, the power of a basic symbol. Rudolf Laban paid much attention to the various levels of both the appearance and the meaning of performances. At the more elementary level, he attributed importance to choric groups introduced to play an essential part in social ceremonies or rituals. A simple march, for example, employs no more than a few letters of the dancer's alphabet of motion, and the same is true for a chorus of uniformly dressed men and women raising their arms in a gesture of worship. But such a limitation of the statement is not only justified but indeed required when presented as a part of a larger whole. In fact, the more a work of art is intended as a mere component of a larger

performance or architectural setting, such as a religious, tribal, or civic ceremony, the more it adapts its contribution to its particular function. Conversely, the more self-contained the work, the more comprehensive its own statement needs to become. Laban, in his book *Gymnastik und Tanz*, distinguishes between ritual gymnastics and temple dancers. "One might say that on the one hand there is exercise—of course, in its highest meaning—an exercise intended to give people the sense of the absolute, the law, the ideal; and on the other hand there is art, the tension of heightened enthusiasm to the faithful" (1926).

In the history of Western dance, the royal ballets were still closest to a worldly version of what Laban calls the temple dancers in that they heightened the enthusiasm of the devotees by the art they added to the splendor of the palace. Characteristically, they also limited the narrative aspects of plot and costume largely to the attractions of pure expressive movement.

This draws our attention to a further property of the dancer's medium, namely, the abstractness of the dancer's instrument, which is most obvious when the dance dispenses with any spoken text and theatrical story. Just as pure music is reduced to the expressive display of scale, intensity, and rhythm, the dancer's body is limited to the twelve basic directions arranged by Laban in what he calls his space crystal, that is, the polyhedric framework in which the body moves and from which the whole range of spatial relations derives. This repertory of spatial action is enriched, of course, by the expressive qualities of motor dynamics, the variety of speeds and rhythms, and the connotations of the human body with its sextet of players, the trunk, the head, the arms, and the legs. There are also the spatial patterns available to group dance.

With all this, the dancer's thinking is based on the highly abstract instrument of his body, which makes for a simplicity that, if I am not mistaken, is not limited to the dancer's way of conceiving his work but extends to his handling and viewing of his life. In some measure, of course, all artists are subject to a double style of managing their affairs. On the one hand, they are worldly citizens dealing with personal and business matters shrewdly, intellectually, conventionally. On the other hand, they are artistically selecting, organizing, and directing compositions as they organize shapes, colors, sounds, or, indeed, body motion. This latter manner of behaving artistically influences the conduct of life to various degrees, creating frequent trouble because the materials of the studio are one thing and the flesh and blood of fellow persons are quite another. But the experience of organizing matters thoughtfully and thoroughly also makes for a kind of wisdom that reflects on the artist's view of life.

It seems to me that the projection of ways of handling one's artistic

medium on the conduct of one's life is particularly intimate in the case of the dancer, for reasons already mentioned. Because the dancer's artistic instrument is also the means by which he carries on his life, namely, his own self, there may very well be a more direct connection between the two activities. Is it true that dancers behave more nearly as dancers all the time?

I enjoy seeing a dancer walking in the street, skipping up the stairs, or standing or crouching somewhere in the room. What I notice is the opposite of affectation: an easy control of every stance and gesture that has become second nature. In this respect, dancers may typically differ from actors, who often seem to lack this spontaneity. Actors, too, tend to move as actors when they are away from the stage, but rather than present a perfected shaping of their own selves they more nearly seem to impersonate a figure they have conceived as their image. If this is so, it may be due to the difference between spending one's professional life creating the figures of invented persons, as the actor does, and impersonating one's own self in various life situations, as does the dancer.

Are we then to infer that the dancer's handling of his medium has consequences for his looking at the world and responding to it? Laban writes of the human gesture that "it has always been the most concentrated and precise means of understanding among people. Using words, one can talk around true understanding, one can talk oneself into believing that understanding has taken place, and yet there has been misapprehension. But the gesture, the stance and expression of the body cannot be misunderstood." He then says that the gesture expresses mainly those "simple components of our inner life which remain the basic carriers of an effective existence. By making a person study gesture, one leads him to a realm of the simplest, most fundamental forms of life, and one makes these forms of life reawaken in him with a most intensive animation."

Laban himself was an example of how the human body's translation of our way of life into pure motion is reflected in the person's reasoning and behavior. When he looked at the world and spoke about it, the petty intricacies of our usual existence dropped out, the nooks and crannies were straightened, light swept unhampered along generous perspectives, the eyes faced a simply shaped distant goal, and visions, thoughts, and actions moved to attain it.

REFERENCES

Arnheim, Rudolf. 1981. "Review of Irmgard Bartenieff, *Body Movement*." *The Arts in Psychotherapy*, 8, nos. 3–4 (Winter), pp. 245–248.

Bartenieff, Irmgard, with Dori Lewis. 1980. *Body Movement*. New York: Gordon and Breach.

Laban, Rudolf von. 1926. *Gymnastik und Tanz*. Oldenburg: Stalling.

———. 1975. *A Life for Dance: Reminiscences*. New York: Theater Arts Books.

PERCEPTUAL ASPECTS
OF ART FOR THE BLIND

S O THOROUGHLY HAVE the arts of drawing, painting, and sculpture been monopolized by the sense of vision that the term *visual arts* seems to be the only one we have in English to distinguish them from the rest of the fine arts. Although the contribution of the haptic senses has been acknowledged at least since the days of the art historian Alois Riegl, touch was not considered anything more than an accessory to visual experience. Even now, those of us who are blessed with sight find it hard to conceive of a kind of two-dimensional or three-dimensional art from which vision is excluded. When it became known that the blind had some capacity for the perception and creation of art, it was commonly referred to as a partial, miraculous acquisition of vision: the hands can see!

It is precisely the conception of an autonomous haptic art, however, that has enabled the education of the blind to take a decisive step forward. It has also enriched the psychology of perception with a new chapter, which deepens our understanding of vision by contrast, the way a foreign language makes for better understanding of the native tongue. One of the most intelligent books on the subject, Selma Fraiberg's report on blind children, is called *Insights from the Blind*. Blindness ceases to be simply the absence of the all but indispensable sense of sight. Characteristically, the displays arranged at some museums for letting the blind explore sculpture and textures by touch are no longer reserved for blind visitors but are becoming museums of touch that reveal a wealth of tactile experience to the general public. Haptic art education is becoming the purest access to a neglected resource of human cognition and creation.

The corresponding psychological approach should primarily be geared

First published in the *Journal of Aesthetic Education* 24, no. 3 (Fall 1990), pp. 57–65.

not to what sightless people are missing; rather, it should conceive of the haptic world first of all in its own terms as an alternative to the world of vision. If the two are compared, one fundamental difference is immediately apparent. The visual field is filled, practically from the very onset of life, with a teeming image, barely organized at first, but beginning almost immediately to crystallize into structured units. Equally soon, the image begins to detach itself in depth, affording a first distinction between the self of the viewer and the outer world. In this world of vision, sound remains limited for some time to the role of an accessory.

The sightless world, on the contrary, is primarily empty—empty like a canvas on which nothing is painted. On this empty ground there appear occasional auditory signals, discontinuous in both space and time. Because those sounds typically do not relate to anything around them nor offer the kind of happening that invites prolonged attention, the appeal to the infant is weak. While the sighted infant begins in the early months of life to follow with his eyes the trajectory of things moving through space, the blind child remains all but unaffected by what happens at a distance. Things do not leave traces.

Fraiberg has given us an impressive description of the pathological symptoms closely resembling those of autism that are frequently produced by "gross impoverishment in the stimulus nutriments for early sensorimotor organization" in the blind child (1977, p. 4). For normal development these children depend on ample haptic stimulation. When such stimulation is provided by the persons handling the infant, the haptic experience does not simply replace, within its limited spatial range, visual experience. It is characteristically different.

Haptic perception comes about by the cooperation of two sensory modalities, kinesthesis and touch. Kinesthesis provides information about the tensions in the muscles, tendons, and joints of the body. It reports about the behavior of the body, not about shapes. It tells the difference between tension and relaxation, straightening and bending, pushing and pulling, hugging the ground and rising, keeping in balance and shifting weight—all this in a purely abstract, that is, shapeless, fashion. Kinesthetic experience does not inform us as to what an arm or a neck or pelvis looks like but limits itself to the biologically most important properties: it tells what the body parts are doing, how they handle the relations between physiological and physical forces, how they organize in space. These are the perceptual signals by which a dancer controls the composition of her movements. Their abstractness closely resembles that of the sounds of music.

Musical sounds are pure dynamics, pure expression. Whereas vision tells us that music is produced by sound-makers, the music itself contains no

such instruments. Music exemplifies the abstractness of the auditory world in general. The auditory world is limited to the activity of things, the voices of humans and animals, the noises of water and wind, the cracking and banging and whistling of materials manipulated by nature and humans. Therefore, as I mentioned, the auditory world is empty, reduced to occasional, mostly discontinuous signals. Whereas the visual world makes its presence constantly known and offers attractive targets and lures, sound appeals less to elementary attention. Fraiberg observes that the creeping of unimpaired infants is motivated essentially by visual targets, things they want to reach, and that therefore children born blind will not creep unless they are given special incentives.

Combine the auditory experiences, on which the blind so heavily depend for their knowledge of the outside, with the kinesthetic percepts reporting about the behavior of the body, and you get the sense of a thoroughly dynamic world, a world limited abstractly to action. But how about the equally indispensable knowledge of the objects performing the actions? Much of the information about the shape of things is supplied to the blind by the sense of touch. And it turns out that this sense is equally dynamic.

Touch lacks the abstractness of kinesthetic experience. It is geared to apprehending the presence of objects within bodily reach and to discovering their location, size, and shape. At the same time, however, its conscious dependence on the body hampers the kind of detachment from the self that is promoted by vision. To understand the difference between the self and the outer world is the primary task of human cognition. This achievement is necessarily delayed in the blind person because of the intimate haptic connection between the perceiver's own body and the objects perceived by touch.

The central position of the self is counteracted in visual perception by the direct awareness of an outer world organized around centers of its own. It is much less contested in haptic experience. The body of the perceiver occupies the largest space in the narrow territory of tactile reach. The body is constantly alive with the network of tensions that keeps its activity present in consciousness, whereas outer objects transmit no such kinesthetic aliveness. Even so, the perceiver's self and the things it can touch are closely connected. From the base of the self's body, arm and hand reach unmistakably outward toward the object to be conquered. And while the exploration supplies knowledge about the objective dimensions of the physical things under scrutiny, the gestural operations by which the information is obtained preserve the dynamic abstractness of reaching, searching, meeting, pressing, embracing, etc.

Consequently, the properties of the haptically explored objects are per-

ceived in an equally dynamic fashion. The hands moving toward, say, a clay vessel standing on the table are met first of all by an active resistance, an obstacle that blocks the path of the exploration. The belly of the vessel bulges forward and outward. As the fingers grip the neck and converge around it, they experience it as an active constriction, which then reverts into the gaping aperture on top. Such dynamic perception is not alien to the sense of vision either (Arnheim, 1977, p. 257), but it is particularly compelling when the haptic sensations turn mere shape into a dramatic encounter intimately involving the self of the observer.

Dynamic perception, we remember here, is the very base of aesthetic experience. Shape and space must be felt as interplays of active forces if they are to convey expression. And expression is the language of art. This means that the sensory modality by which blind persons approach the objects of our world predisposes them for the particular sort of cognition we call artistic.

Needless to say, social taboos inhibit the free unfolding of these virtues. A manner of perception that invades and modifies its targets by muscular action represents a very personal involvement and therefore makes for trouble. The child, whether sighted or blind, learns soon that the world is full of things that must not be touched. And if one can perceive the next person's face and body only by caressing them with one's fingers, one is asking for impermissible liberties. The blind have to live in a society that suffers from a serious neglect of the sense of touch, a society in which, for example, the many hours of television viewing transform the world into a distant spectacle. The natural intimacy of handling things by which human beings normally learn remains excluded. The education of the blind should be viewed, therefore, in the broader context of the need to reeducate an entire sensorily crippled population.

It used to be maintained that haptic perception is limited to relatively small elements, which cannot be integrated into unified wholes. Therefore, it was thought, the blind are deprived of the gestalt conception so indispensable in the arts and so dominant in vision. This opinion derives from a misinterpretation of both sense modalities. To be sure, vision profits from the full and constantly present image of the visual field. But this background scenery is nothing more than the foil on which true perception operates. Active perception creates the whole image by means of successive acts of fixation. Sharp vision is limited to the very small area of the retinal fovea so that images of any size must be built up by scanning. This limitation of the area of optimal vision is not simply a matter of biological parsimony. Rather, any perception of structured wholes must rely on the

perusal of its components. The mind can organize a complex gestalt, but it cannot process all its components in a single act. (A photographic camera can record a whole image simultaneously because a mechanical registration involves no structuring.)

It is true that the constant presence of the total visual field greatly facilitates the synthesis of the fixations. The sighted person is capable of seeing a human figure and even an entire landscape as an integrated whole, an ability not equally accessible to the blind. This does not mean, however, that haptic perception is limited to making do with a sequence of elements that at best can be patched together intellectually. Rather, the need to integrate the elements of a coherent whole is as dominant in haptic perception as it is in any other organic process.

In fact, the receptor organs of touch are spread all over the surface of the human body, from head to toe, and touch is directly coordinated with the complexity of kinesthetic sensations inside the body. Consider, for example, how the recognition of an object by touch is helped when the internal sense of balance supplies the spatial dimensions of verticality and horizontality and how within this framework the perception of the object is supplemented by the directions in which torso, arms, and fingers are reaching. The two hands, with their many independently mobile joints, make for a whole orchestra of touch stimuli to whose simultaneity vision has no equal. At any one moment the eyes are limited to a single projective view of the world whose one-sidedness can be corrected only by the viewer's perambulation in time. In the days of Cubism, some painters played with the vain hope that modern physics would supply them with a fourth spatial dimension capable of letting them visualize the all-around shape of things in a single percept (Henderson, 1983). Any blind sculptor can grasp the front and the back of a vessel or its hollow inside and its convex outside in a single sensory input, which makes for an integrated percept of the whole.

In human development, the mouth is the primary organ of tactile perception. Fraiberg tells us that in healthy, normally developing, but blind infants, perception remains mouth centered until well into the second year. "When the mouth remains the primary organ of perception, the distinctions between 'inner' and 'outer,' 'self,' and 'not-self' will not emerge. Perceptual experience is restricted to a narrow range of objects—those that stimulate the mouth in some preferred way" (1977, pp. 35, 62). This powerful oral combination of cognition and instinctual satisfaction is likely to tinge the exploring, handling, and creating of objects beyond the early years and influence a person's relation to the outer world, especially in

their haptic aspects. Even after the hands have taken over, an erotic quality of need fulfillment can be expected to enhance the human relevance of manual activities, among them modeling and carving.

Aristotle reports that in the opinion of Anaxagoras, man is the most intelligent of living beings because he has hands. Aristotle himself considers it more likely that man has been given hands because he is the most intelligent being. Immanuel Kant, in his *Anthropologie in pragmatischer Hinsicht*, says more explicitly:

> Man is characterized as a rational animal even by the shape and organization of his hand, his fingers, and fingertips. Their structure and subtle sensitivity indicate that nature has designated him not for just one kind of handling things but for dealing in an unspecified way with all of them. This makes him suited for the use of reason and defines him as a rational animal by the technical abilities inherent in his species. (Part 2, E).

In fact, the versatility of the hand not only endows the higher vertebrates with their supreme skill in manual operations and the making and handling of tools; it also enables the blind artist to create works of some complexity, worthy of the mind's sophistication. Especially in sculpture, the gamut of manual devices makes for a corresponding variety of expressive shapes. Haptic scanning affords the almost musical sequences of expansion and constriction, gradual and sudden changes, straightness and curvature. It distinguishes among textures, hardness and softness, and so forth. Poking, squeezing, tearing, and bending are aggressively active manipulations of mouldable materials that often produce similar or opposite qualities in the shapes of the work. In the clay figures of blind sculptors published as early as 1934 by Ludwig Münz and Viktor Löwenfeld, the heads and limbs of the figures invade the surrounding space dramatically; they bulge and push, strain and bend, squeeze and swell. It is a highly dynamic performance, characteristic of much haptic sculpture, wherever its maker is left free to follow the demands of his tactile experience. Figure 28 shows the German sculptor Erich Kühnholz, who was blinded during World War II, at work on a pietà in 1981.

I am looking at an almost life-size portrait head of my sister done by a sighted artist. It is a serene and silent image, ruled by its eyes, which are forward directed with a concentration that, however, knows no viewer. Now I close my eyes and approach the sculpture by touch. The experience is, first of all, that of a caress issuing from myself in an almost too personal gesture. Then my hands move along the curves of the jaws converging toward the bow of the chin, which approaches me. The roundness of the chin is paralleled by that of the lips. The nose, finely honed, moves toward

FIGURE 28.
The blind sculptor Erich Kühnholz at work. Courtesy of Dr. Max J. Kobbert.

me, and the cheeks converge in the shallow depressions I know are the place of the eyes, although these depressions hardly indicate the eyes' presence.

Without question, such a tactile exploration aims from the beginning at a coherent image of the face and does eventually attain it. Nor do I doubt that the tactile image can convey a distinct individuality, which, however, is clearly different from the one received by my eyes from the sculpture. The tactile image is probably simpler, and its expression seems to be limited to the tensions of the muscular surface. It does not seem to convey the particular quality of revealing a mind that is located in the head, looking at the world through the eyes and projecting an inner cheerfulness by a slight upturning of the lips. To my hands, the sculpted head is rather like a piece of architecture.

A sculpture made *by* haptic perception is also made *for* haptic perception, unless the artist is distracted by the misguided ambition to meet certain specifically visual conditions. The blind artist is limited, first of all, by a range of size. The larger the piece is, the harder it is for him to conceive of its compositional unity. Intricate detail also is not easily traced by the fingers. In creating works of their own as well as in appreciating the works of others, the blind prefer symmetry and other simple form relations. They are therefore inclined toward styles of art meeting these conditions. They tend to prefer a Brancusi to a Bernini, an African wood carving to the curlicues of a Chinese jade. But just as we have learned to attribute as much value to art of elementary shape as to the virtuosity of certain late styles, the sculpture and the sculptural taste of the blind deserve to be appreciated in their own terms.

Composition in general tends to rely on one of two principles. It either builds the whole from configurations of relatively self-contained parts, or it takes off from an overall totality, which is modified secondarily by subdivisions and refinements (Arnheim, 1977). This choice between a conception "from below" and one "from above" depends on stylistic preferences and perhaps on personality differences, but both aim at the attainment of integrated wholes. Probably the approach from below goes more readily with early stages of development. Accordingly, the blind prefer to ascertain the shape of components while proceeding toward the complexity of the whole.

Clearly specific to haptic experience is the practice of hollowing the cavities for the eyes and then placing eyeballs into them or digging the mouth and then closing the lips over it. Even more significant are the so-called *Pathosstränge*, or "emotive ties"—heavy ridges by which some blind sculptors represent the kinesthetic tensions of the face running from

the eyes to the mouth or vertically across the forehead (Münz & Löwenfeld, 1934, pp. 35, 43). I would not describe these features as "symbolic," as does Münz. They are concrete equivalents of haptic experience represented with the means of the sculptural medium.

We are meeting here a general principle essential to the understanding not only of haptic sculpture but also of haptic drawing. Figural representations are not copies of their models but equivalents of the model's structural features. These equivalents are derived from the properties of the medium. The manifestations of this principle became strikingly evident in the raised-line drawings of the blind, with which educators have experimented for many decades. The results confirm what we have learned from the drawings of the sighted.

When it became evident that blind persons took to the use of lines without hesitation, once they could control them by touch, there was considerable surprise: how could one understand the meaning of lines without the help of vision? But, of course, lines are not copies of linelike shapes observed in nature. They are the spontaneous graphic equivalent of the boundaries or elongated shapes of physical objects. They translate boundaries into what corresponds to them in a two-dimensional medium when a stylus is used as the tool for making shapes. By the standards of mechanical copying, line drawings of visual objects are just as remote from their three-dimensional models as are the drawings of things perceived by touch. Both sense modalities rely on the same natural and spontaneously convincing manner of translation.

Because perceptual cognition consists in the grasping of structural features, the blind find it easier to recognize simple line drawings than realistically complex ones. This is true for sighted people as well when they are faced with visually intricate pictures for the first time. It is especially true for projective images involving foreshortening, overlapping, and central perspective. A blind person exploring, say, one of Lorenzo Ghiberti's reliefs for the bronze doors of the Florence Baptistery will be as hopelessly lost as a tribesman looking at his first photograph because these products of a late Western culture present a flattened compression of spatial depth for which neither spontaneous visual perception nor haptic experience has an equivalent.

Blind persons can be given an idea of size reduction in visual projection when they are asked, say, to touch the two nearest corners of a short but fairly broad tabletop with their hands and compare the angle formed by their arms with the narrower one obtained when they touch the two more distant corners (Kennedy, 1980). But there is a far cry from such a demonstration in space to a projection on a pictorial surface. Drawing per-

spectively distorted objects and deciphering perspective line drawings are tricks that can be learned but will remain a distracting and all but useless artifact for the sightless.

This is the best example I can think of to illustrate the basic principle that, in my opinion, should guide art education for the blind. The arts of our century have taught us that realistic representation is only one among many equally valid styles. Just as most art teachers today know better than to drill children prematurely in the tricks of realistic picture-making, so it is the task of the art teacher for the blind to convince his students that the aesthetic standards of the social majority are not automatically binding. Rather than be urged to make up for the lack of sight beyond what is practically useful, they should be encouraged to take pride in the unique contribution they can make to the culture to which they belong as a respected minority.

<div align="center">REFERENCES</div>

The special haptic abilities of blind persons and their earliest shape perceptions observed when they acquire sight after an operation have attracted the attention of philosophers and writers from John Locke (1959, book 2, chap. 9), Denis Diderot (1759), and Johann Gottfried Herder (1778) to Hermann von Helmholtz (1922, vol. 3, para. 28, pp. 220–227) and psychologists of our own time (Wertheimer, 1951). The two classic publications on haptic art are by the art historian Münz and the art educator Löwenfeld (1934) and by Géza Révész. The latter's work is valuable for its extensive material, even though it is old-fashioned in its artistic standards, as, for example, when he concludes that haptic perception "lacks the needed preconditions for aesthetic experience" ([1938] 1970, p. 13). Recently, John M. Kennedy has given much thought to the nature of pictorial line (1974) and has made experiments on the drawings of naive blind subjects (1980). An excellent theoretical and practical survey of art education for the blind in Germany has been edited by Klaus Spitzer and Margarete Lange (1982). In the United States, the Lions Gallery of the Senses at the Wadsworth Atheneum in Hartford, Connecticut, has done pioneering work since 1972.

Arnheim, Rudolf. 1977. *The Dynamics of Architectural Form*. Berkeley and Los Angeles: University of California Press.

———. 1986. "Victor Lowenfeld and Tactility." In *New Essays on the Psychology of Art*. Berkeley and Los Angeles: University of California Press.

Diderot, Denis. 1759. *Lettre sur les Aveugles*.

Fraiberg, Selma. 1977. *Insights from the Blind*. New York: New American Library.

Helmholtz, Hermann von. 1922. *Helmholtz's Treatise on Physiological Optics*. New York: Dover.

Henderson, Linda Dalrymple. 1983. *The Fourth Dimension and Non-Euclidean Geometry in Modern Art*. Princeton, N.J.: Princeton University Press.

Herder, Johann Gottfried. 1778. *Plastik*. Riga: Hartknoch.

Kant, Immanuel. 1798. *Anthropologie in pragmatischer Hinsicht.*

Kennedy, John M. 1974. *A Psychology of Picture Perception.* San Francisco: Jossey-Bass.

————. 1980. "Blind People Recognizing and Making Haptic Pictures." In *The Perception of Pictures.* Edited by Margaret A. Hagen. New York: Academic Press.

Locke, John. 1959. *An Essay Concerning Human Understanding.* New York: Dover.

Münz, Ludwig, and Viktor Löwenfeld. 1934. *Plastische Arbeiten Blinder.* Brünn: Rohrer.

Révész, Géza. [1938] 1970. *Psychology and Art of the Blind.* Toronto: Longmans.

Spitzer, Klaus, and Margarete Lange (eds.). 1982. *Tasten und Gestalten.* Hannover-Kirchrode: Verein zur Förderung der Blindenbildung.

Wertheimer, Michael. 1951. "Hebb and Senden on the Role of Learning in Perception." *American Journal of Psychology* 64, pp. 133–137.

THE ARTISTRY OF PSYCHOTICS

THE REALM OF ART is getting broader, more comprehensive. By admitting work that has been excluded but legitimately belongs to it, the community of art serves its own good. An elite that was holding a misleadingly narrow conception of its own boundaries has come to recognize art as a fundamental human activity. It reaches beyond the studios of professionals, museums, and prosperous collections. The drawings, paintings, and sculptures of mental patients are among the more recent admissions to the hallowed precinct.

Such work has been produced for some time. In Europe and in the United States, thousands of institutionalized patients took hold of pieces of stationery or toilet paper, wrappers, bread, or wood to give visible expression to the powerful feelings of mental upheaval generated by their anguish, their frustration, their protests against confinement, and also of their megalomaniac visions. None of the usual principles of artistic value were applied to these products either by their makers or by art experts, and even psychiatrists noticed them simply as the symptomatic discards of psychic disturbance. Only an occasional, prophetic forerunner sensed the diagnostic possibilities of these uncanny images and perhaps speculated on their oblique significance for the nature of human creativity. The first drawing by a schizophrenic known to have been reproduced in a professional publication appeared in the French psychiatrist Auguste Ambroise Tardieu's "medical-legal study of insanity" of 1872 (Figure 29). The drawing represents the magnetic fluid emanating from the female figure in the center.

It was left to the young German psychiatrist Hans Prinzhorn to collect

Derived from "The Artistry of Psychotics," *American Scientist* 74 (January–February 1986), pp. 48–54.

FIGURE 29.
From Auguste Ambroise Tardieu, *Etude médico-légale sur la folie*, 1872.

systematically from the major mental institutions of Germany, Austria, and Switzerland some six thousand art objects and deposit them at the Psychiatric Clinic of Heidelberg, which he had joined in 1919. These objects had been produced between about 1890 and 1920 by 516 patients—a wealth of material, which in subsequent years was shown in occasional exhibitions and made accessible to some visitors at the clinic. But it was not until 1980 that the first large show of the Prinzhorn originals toured some European museums. It reached the United States in 1984.

The existence of the Heidelberg collection had become known to interested intellectuals almost immediately through the publication in 1922 of Prinzhorn's richly illustrated book, *Artistry of the Mentally Ill* (1968). Among such modern artists as Paul Klee, Jean Arp, Max Ernst, and Alfred Kubin the book created a sensation. Its author was ideally suited to convey the broad humanistic relevance of the material. His academic preparation had been not only in psychology but also in philosophy and the history of art, and he had received musical training as a singer before deciding to study medicine. Consequently, his book, far from being only a professional monograph, explores the nature of human creativity and analyzes its aspects of expression, ornamentation, symbolism, and play so as to point to parallels between the art of psychotics and certain trends in contemporary painting and sculpture. In a 1919 article Prinzhorn wrote, "It will be necessary to trace the roots of the formative impulse, which is manifest in visual activity. Of course, the problem is not limited to the psychological processes in the mentally ill but must be supported by reference to the general phenomenon of artistic creation." And in 1922 he added, "The art

of the mentally ill approaches modern art so closely because it corresponds to the most secret aspirations of our time."

What, then, is psychotic art? Whoever has occasion to visit the Prinz-horn collection or to view the works reproduced in the publications of Prinzhorn and other more recent specialists such as Alfred Bader and Leo Navratil (1976) will notice a remarkable variety of skill, originality, and talent. The subject matter varies, and so do style and technique. A closer examination, however, reveals distinct common features that are relatable in some cases to manic-depressive psychosis and more markedly and in-terestingly to the mental traits of schizophrenia.

The manic-depressive reaction, essentially a pathology of moods, is mir-rored in the alternation between high and low levels of energy, with vig-orous strokes and unbridled scribbles in drawings of the manic phase and more delicate and hesitant lines in those of the depressive phase. Schizo-phrenia is mainly a cognitive derangement, which causes the individual's detachment from reality. It interferes with the relation between the person and the social environment and leads to striking distortions of outlook. This affects artistic form quite tangibly. About 70 percent of the works received and selected by Prinzhorn came from schizophrenic patients. This ratio is at least partially due to the psychological affinity acknowledged by sensitive observers between this form of psychosis and the social situation of our century. Our time has been diagnosed as one in which shared beliefs and values and the functional integration of citizens in the give-and-take of the community are threatened by the atomization of the social group and the isolation of the individual. Among the attempts to describe this symp-tomatic attitude around the time when Prinzhorn was forming the collec-tion, I mention the philosopher Karl Jaspers's "pathographic analysis" of a writer and a painter, August Strindberg and Vincent van Gogh (Jaspers, 1926).

If the analogy between the mental state of psychotic patients and that of an entire cultural period seems disturbing, one should remember that the distinction between the diseased and the normal mind is essentially a mat-ter of practical convenience. We speak of illness when a person is unable to lead a productive, happy, and safe life and therefore requires treatment. Such a separation of the normal from the pathological, however, prevents us from realizing that psychotic states are malignant caricatures of types of character or temperament found in the general population and often par-ticularly pronounced in the minds of great thinkers, artists, scientists, and statesmen. We can rely here on another seminal publication of the 1920s, a monograph on "physique and character" written by the sensitive and

eloquent psychiatrist Ernst Kretschmer (1921). Kretschmer traces the syndromes of manic-depressive psychosis, or cyclothymia, and of schizophrenia through the intermediate stages of the cycloid and schizoid temperaments to what he calls the cyclothyme and the schizothyme personality type of normal individuals.

The schizoid state of mind, on which I am concentrating here, is characterized by Kretschmer as an excessive sensitivity that protects itself against the provocations of the outer world by an ever more impenetrable shield. Certain metaphors are commonly used to describe this detachment from reality. Patients report that they feel as though they are enclosed in a bottle or as though a sheet of glass separates them from other human beings. As it was said of a nineteenth-century poet, "He is like a drop of fiery wine in a barrel of ice."

This typical interruption of normal intercourse with the social environment seems to me to offer the key to our understanding of the principal formal features of schizophrenic art. Our sense of vision depends for the comprehension of the outer world on what we call form, or shape, the perceptual means by which the visual array is articulated into an arrangement of segregated, identifiable objects. The human nervous system is governed by a tendency to keep these shapes as simple as possible, so that the stronger the formative influence of the outer world is, the more complex the shapes will become. Conversely, when the perceptual input from the outside weakens, the basic shapes will become more dominant. The resultant patterns look more abstract or decorative. I have tried elsewhere to describe the effect of psychotic detachment from outer reality on visual form as follows: "Since the sensory sources of natural form and meaning are clogged and the vital passions dried up, formal organization remains, as it were, unmodulated. The tendency to simple shape operates unhampered in the void" (1974, p. 148).

Because schizophrenic artwork is as manifold as are the individuals creating it, the best one can do to characterize it is to point to certain formal features that are characteristic for the syndrome as a whole but that show up in some examples more clearly than in others. The felt-pen drawing, Figure 30, by a sixty-two-year-old psychotic woman, represents three barn owls and shows geometrical patterns all but overcoming the zoological features of the birds. Sunbursts of unmodified straight lines are present, and the anatomical parts of the face give way to calligraphic circles and curves. In many other cases, the shapes crystallize into more explicitly geometrical and symmetrical patterns, such as in Figure 31, a drawing by a patient suffering from religious monomania. The large central figure

FIGURE 30.
Drawing by a psychotic patient. From Alfred Bader and Leo Navratil,
Zwischen Wahn und Wirklichkeit, 1976.

represents a monstrance but also the "Lamb of God," in which the patient
identifies himself with the suffering of Christ. The mixture of images,
abstract shapes, and writing is also quite typical.

When such an assault on the sense of outer reality occurs in a capable
artist, the image of the visual world may resist more actively. Even so,
some of Vincent van Gogh's last works, such as a drawing done in Auvers
shortly before his suicide (Figure 32), seem drowned by formal imposi-
tions. They are driven by an uncontrolled sense of shape and the sponta-
neous motor behavior of the artist's hand. In Van Gogh's mature work,
beautiful balance obtains between the live quality of nature and the ex-
pressive presence of brush and pen performing the interpretation. In the
Auvers drawing, however, the cottages and trees vanish in subjective
waves that no longer reflect the authentic sense of the countryside. Reality
recedes and is replaced by a dialogue between a withdrawn mind and
self-generated shapes.

A retreat to abstract form opens the possibility for a multiplicity of
meanings. This was shown already in Figure 31, where the same circular
shape stands for a monstrance and a human face. More radically, this sort
of visual punning makes for compositions held together by purely formal
relations and speculative associations without regard to the reality context
of the components. The pencil drawing of the "miraculous shepherd" (Fig-

FIGURE 31.
Johann Knüpfer, The Lamb of God. From Hans Prinzhorn,
Artistry of the Mentally Ill, 1972.

ure 33), done by a schizophrenic electrician, fits a number of incongruous
elements into an overall rectangular pattern like a jigsaw puzzle. The con-
ception starts with an upright serpent that is flanked by the figure of the
shepherd and the large legs. A man's profile face is fitted to the armlike
horizontal section of the snake, and his hair enlarges to the bark of a tree.
The lower foot is broken from its leg by a female genital, indicating the
"downfall of man, who is led to sin by woman."

Displays of psychotic artwork touch vulnerable aspects of the human

FIGURE 32.
Vincent van Gogh, Landscape with Houses and Trees. 1890.
Stedelijk Museum, Amsterdam.

mind so directly that they arouse emotional public responses almost everywhere. When selections from the Prinzhorn collection were shown after World War II in Europe, however, they evoked special reactions deriving from the political and cultural conditions of the period. Before the war, when the Nazis took over in Germany in 1933, they brought with them a mendacious taste for pretty, realistic art that featured healthy nudes and heroic athletes in the mode of many dictatorial regimes. This led to a persecution of modern art, especially the paintings and sculptures of the Expressionists. Probably the Prinzhorn collection would have fallen victim to the vandalism of the new rulers had they not chosen to use it as a means of illustrating their contention that the shocking imagery of the artwork testified to the patients' hopeless insanity and justified the kind of mass murder they planned for inhabitants of mental institutions. Beyond that, a resemblance between psychotic and modernist art enabled them to denounce the work of the Expressionists as degenerate products of diseased minds. In the infamous exhibition "Entartete Kunst" (Degenerate Art) of 1937, samples of the Prinzhorn collection were shown for comparison with works by Oskar Kokoschka, Emil Nolde, Otto Dix, Paul Klee, and others

FIGURE 33.
August Neter, The Miraculous Shepherd. From Hans Prinzhorn,
Artistry of the Mentally Ill, 1972.

so as to denounce the artists as mentally degraded and to advocate their persecution.

It is of psychological interest that an exactly opposite evaluation of the same artwork served after the war to arouse similarly radical feelings, which derived in that case from leftist opposition to the corruption and injustices of bourgeois society. Intellectuals, artists, and some psychiatrists

came to consider psychosis a legitimate reaction to a diseased culture. The Scottish psychiatrist R. D. Laing wrote in his 1965 book, *The Divided Self,* "I am aware that the man who is said to be deluded may be in his delusion telling me the truth, and this in no equivocal or metaphorical sense, but quite literally, and that the cracked mind of the schizophrenic may *let in* light which does not enter the intact minds of many sane people whose minds are closed" (p. 27). Even much earlier, in 1925, André Breton, the spokesman of the French Surrealists, impressed by the high artistic quality of the Prinzhorn collection, published "An Open Letter to the Chief Psychiatrists of the Mental Asylums," which stated: "The insane are the preeminent individual victims of dictatorial society. In the name of this individuality, which alone constitutes humanism, we demand that the prisoners of this sensitivity be liberated, since the force of the law is unable anyway to imprison all thinking and acting persons." The same insistence on "the absolute legitimacy of their understanding of reality" led to political demonstrations against mental institutions by leftists and anarchists on the occasion of postwar exhibitions of the Prinzhorn collection in Germany.

These highly emotional attempts to proclaim psychotics either symbols of degeneration, as did the Nazis, or martyrized prophets, as did the postwar radicals, illustrate the inclination to relate mental illness to more general human functioning. As far as the arts are concerned, a need exists to speculate on the conditions that produce similar artistic manifestations in mostly untrained patients and in professional painters and sculptors of our century. But let me observe here that Prinzhorn's selection cannot be considered a cross-section of the artwork produced in mental institutions. Prinzhorn's concern with creativity clearly led him mostly to select works of high quality. In reality, the whole range of quality, from the poor scribbles produced by the large majority of persons to the exquisite creations of the very few, are represented among the inmates of institutions in a similar manner as in the population at large. Present psychiatric opinion holds that psychosis does not generate artistic genius but at best liberates powers of the imagination that under normal conditions might remain locked up by the inhibitions of social and educational convention (Bader & Navratil, 1976).

Prinzhorn concludes in his book that psychosis does not introduce truly novel components into visual representation: "Only variants come about of what is commonly found elsewhere" (1970). In an experimental study in 1970, O. F. P. Maran reported that neither artists nor laymen could distinguish patients' work from that of professional artists. This, however, would hold true only for select material because even many works in the

FIGURE 34.
Max Ernst, Le surréalisme et la peinture. 1942. Menil Collection, Houston.

Prinzhorn collection betray their origin by certain telltale signs. In particular, the combination of daring use of form and color with a lack of technical skill and the reckless intertwining of images and writing are easily diagnosed.

Nevertheless, the resemblances are striking, and they were readily acknowledged by artists. In an often-quoted entry in his diary in 1912, the painter Paul Klee maintained that the art of children and early cultures as well as that of the mentally ill had to be taken very seriously, "more seriously than all the art museums, when we approach the task of reform" (Klee, 1957, #905).

When one observes similar manifestations in different areas of behavior, looking for similar causes is a psychologically sound practice. Because detachment from the social environment is the crucial symptom of the schizoid attitude, an analogous psychological condition in modern artists seems relevant here. Artists are no longer safely installed as cogs in the wheel of society, busy producing their paintings and sculptures on commission for the princes, churches, and growing middle class. Isolated from their patrons, artists work typically on their own initiative, impelled by the uncertain hope that someone will receive what they have to offer. By the end

of the nineteenth century, this rupture of the bond between supply and demand made for the kind of tragic life story that Émile Zola, using his friend Paul Cézanne as a model, portrayed in his novel *L'oeuvre* (The Masterpiece). The reverberations of personal frustration extended to a nightmarish image of social life as a whole. Emancipated from the demands of public taste, the Expressionists of the early twentieth century felt free to give vent to their passions by using colors and shapes as forceful as those released by psychosis in unskilled patients, although generally much superior in quality and formal organization. The weird combinations of incongruous elements characteristic of many schizophrenic products return strikingly in the works of Surrealists such as Max Ernst (Figure 34) or René Magritte and explain why the adherents of that school proclaimed Prinzhorn's book their bible.

The powerful visionary imagery of the mentally ill could evoke the profound response of the art world only because it derived from deep-seated psychological sources shared by all human beings. But to gain access to these unorthodox manifestations, the culture as a whole had to move from the external portrayal of the world's visual surface to the bold symbolism of elementary passion for which the arts of our time were preparing the ground.

REFERENCES

Arnheim, Rudolf. 1974. *Art and Visual Perception.* Berkeley and Los Angeles: University of California Press.

Bader, Alfred, and Leo Navratil. 1976. *Zwischen Wahn und Wirklichkeit.* Luzern: Bucher.

Breton, André. 1925. *La revolution surréaliste.*

Jaspers, Karl. 1926. *Strindberg und Van Gogh.* Berlin: Springer.

Klee, Paul. 1957. *Tagebücher, 1898–1918.* Cologne: Dumont Schauberg.

Kretschmer, Ernst. 1921. *Körperbau und Charakter.* Berlin: Springer.

Laing, R. D. 1965. *The Divided Self.* Baltimore: Penguin.

Maran, O. F. P. 1970. "Ein Urteil von Künstlern und Laien über moderne Malerei ohne Rücksicht auf den psychiatrischen Zustand des Malers." *Confinia Psychiatrica* 13, pp. 145–155.

Prinzhorn, Hans. 1919. "Das bildnerische Schaffen der Geisteskranken." Zeitschr. f.d. ges. *Neurologie und Psychiatrie* 52, pp. 307–326.

_____.1922. "Gibt es schizophrene Gestaltungsmerkmale in der Bildnerei der Geisteskranken?" Zeitschr. f.d. ges. *Neurologie und Psychiatrie* 78, pp. 512–531.

_____.1968. *Bildnerei der Geisteskranken.* Berlin: Springer.

Tardieu, Auguste Ambroise. 1872. *Etude médico-légale sur la folie.* Paris: Baillière.

THE PUZZLE OF
NADIA'S DRAWINGS

In 1977, Lorna Selfe, an educational psychologist at the University of Nottingham, shook the world of art education with the publication of drawings that had been done by an autistic child at the age of three and one-half and for some years thereafter. The drawings were spectacular in at least two respects. The abilities displayed in the artwork seemed to be inconsistent with the severe limitation of this child's cognitive, linguistic, and social responses and with her lack of motor dexterity in daily life. Even more remarkably, the drawings showed a pictorial maturity commonly found only in skilled adults and unheard of in the drawings of young children. According to accepted theory, what Nadia did could not be done.

Remarkable though Nadia's case was, her drawings did not automatically disprove the rule that had been demonstrated in the work of thousands of children throughout the world. A scientific rule or law, we remember, is an "if-then" proposition: it asserts that if a particular constellation of conditions prevails, then certain consequences will necessarily follow. When an instance occurs that contradicts the expectation, everything depends on whether the premises—the "independent variables," as they are called by psychologists—were in force. If they were, a single contrary case will undo the rule forever. If they were not, the particular causality of the maverick case has to be investigated.

The typical development of a normal child's artwork has been exemplified to perfection by Sylvia Fein's 1976 case study, *Heidi's Horse*. The drawings of horses, done by a normal, though gifted, child between the time she was two and the time she was seventeen, show the development from the simplest geometrical shapes and relations to subtle and detailed

Derived from "The Puzzle of Nadia's Drawings," *The Arts in Psychotherapy* 7 (1980), pp. 79–85.

155

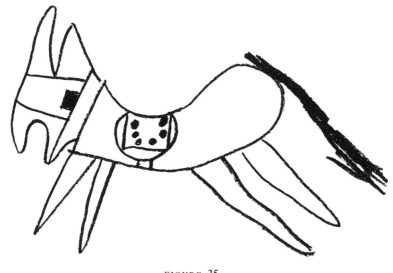

FIGURE 35.
Child's drawing at 4 years, 10 months. From Sylvia Fein, *Heidi's Horse*, 1976.

renderings that are highly expressive of the animal's appearance and motions (Figures 35 and 36). Looking through the chronological sequence of Heidi's drawings, one observes an ever increasing differentiation of shape, angle, texture, shading, and volume. As much difference exists between her earliest and her latest drawings as between the intellectual and behavioral functioning of a toddler and that of an adolescent.

The typical development from the simple to the complex is paralleled, of course, by what generally occurs in organic growth and behavior, motor coordination, problem-solving, language acquisition, and so on. As I have pointed out elsewhere (Arnheim, 1974, chap. 4), the psychological understanding of this process in the field of representational drawing has been hampered by the prejudice that visual perception duplicates the optical images projected on the retinas of the eyes and that therefore drawings, even at their earliest stages, should be recognizable as attempts to reproduce these optical projections. Early representational drawings from throughout the world however, do not display any such tendency; instead, they clearly derive from basic visual shapes, such as circles, straight lines, parallels, and rectangles.

This phenomenon explains itself by the fact that percepts are not mechanical copies of retinal images but cognitive means of grasping the visual essentials of the objects constituting the outer world. These essentials are represented in the geometrical elements of early drawings. Although in the

FIGURE 36.
Child's drawings at 15 years, 6 months. From Sylvia Fein, *Heidi's Horse*, 1976.

youngest children a lack of motor ability makes for an imperfect rendering of these early shapes, they are nevertheless distinctly recognizable. All the more striking were the accomplishments of young Nadia, which looked as though she had skipped the entire developmental sequence so beautifully and explicitly illustrated in the work of Heidi.

The normal way of perceiving and depicting the outer world has been described as a "conceptualizing" of the objects of nature. This notion, however, must not be misunderstood to mean that children, instead of drawing what they perceive, produce images of intellectual concepts. Instead, it is quite acceptable to speak of "perceptual concepts" (Arnheim, 1966, pp. 17–50). With this proviso, the following explanation of the Nadia case by David A. Pariser may be said to point in the right direction. In Pariser's opinion, "Nadia's capacity for representational realism was, in part, the result of her inability or refusal to conceptualize that which she drew" (1979). Pariser also maintains that "the complexities and literalness of Nadia's work may reflect an *inability* on her part to go beyond the immediately given visual world. . . . If she did lack any but the most rudimentary conceptual categories, then she may have been free to see objects in their purely perceptual/optical manifestation" (1979).

Why this might be so can be understood when we think of an autistic child as a person whose functional interaction with the world is largely blocked. We are told by Lorna Selfe that "the over-riding impression of Nadia [at the age of six and one-half] was of lethargy and impassivity. . . . She was largely impassive to social approaches. Her vocabulary was limited to some ten single-word utterances heard over this five-month period. She did not respond to command or instruction, and it was extremely difficult to know whether she merely did not comprehend or whether she was refusing to co-operate" (1977, p. 3). Given this barrier between Nadia and her surroundings, one can imagine that many things of this world appeared to her not as challenges and tasks but as mere images to be passively absorbed rather than actively responded to. Therefore, she recorded what she saw with something like the faithfulness of a photographic lens (Figures 37 and 38)—an ability that was bound to invite the admiration of anybody for whom skillful realism represents the highest accomplishment of art. But the biological deficiency of this attitude is equally evident.

In the meantime, Lorna Selfe, encouraged by her discovery of the Nadia case, has been able to find a few other children in the same age group fitting the same syndrome (1983). They are all autistic, that is, they are linguistically and socially impaired. "All have shown marked obsessional and ritualistic behavior and, in all cases, many of these symptoms showed a very early onset" (Selfe, 1983). All of these children have displayed an unusual drawing ability comparable to Nadia's and notable for naturalistic shapes, mastery of perspective, overlapping, and so on. In keeping with the children's detachment from their environment, most of these drawings were not done from nature but from pictures found in books or elsewhere. Significantly, the models were not directly copied but were reproduced from memory, sometimes weeks after they had been seen. The faithfulness of some of these copies is all the more remarkable. All this, by the way, is different from the artwork of another group of anomalous children, the mentally retarded. Typically, their drawings do not differ from those of normal children, but they stay at an earlier stage of development corresponding to the children's overall retardation.

What, then, are we to make of the naturalistic faithfulness of autistic artwork? It is helpful here to consider the peculiar ambiguity expressed in the general attitude toward reality in naturalistic art. On the one hand, a faithful rendering of the objects and actions observed in the environment bears witness to a close involvement in the practical business of living. On the other hand, the detailed recording of whatever happens to present itself, with all its accidental aspects and configurations, can indicate a suspension of meaning through a lack of understanding or interest. In the extreme case, when the draftsman's attention is reduced to the bits of

FIGURE 37.
Autistic child's drawing at about 4 years. From Lorna Selfe, *Nadia*, 1977.

colored shape recorded by the eyes, the objects represented in a picture can all but vanish, as we know from some Impressionist work. Here, then, it is relevant to consider the different attitudes toward reality found in normal and in autistic children.

Horses play a dominant role in the samples taken from a normal child and an anomalous child in our illustrations. But the two children differ significantly in their relationship to their favorite subject matter. Both girls are captivated by horses. But the normal child's interest in this theme is intimately connected with her real-life experience. Heidi grew up in the Californian countryside of small ranches and rode a horse from early on. She was thoroughly acquainted with the handling of horses and with the use of their gear and equipment. As soon as she became technically able to do so, she explored in her drawings the activities of horses running,

wonderful!

FIGURE 38.
Autistic child's drawing at about 5 years. From Lorna Selfe, *Nadia*, 1977.

jumping, feeding, and being trained; she portrayed herself, as well as cowboys and Indians, on horseback. And while a horse-centered world unfolded in all its aspects, the image of her favorite animal enriched and refined itself from month to month.

Nadia had only a fleeting acquaintance with horses, whom she knew mostly from pictures. Although her draftsmanship was startling, she did not draw from the endless variety of appearances offered by horses in real life but limited herself to the petrified and preshaped images available in

pictures. In addition, the top quality of her work was reached almost immediately after she started to draw. There was no development, and the standard of her best artwork vanished, apparently forever, after a few years.

Nevertheless, the technical skill of Nadia's drawings leaves us with unanswered questions. If we adopt Pariser's interpretation, we understand that Nadia did not break all the records of artistic accomplishment by racing through the stages of apprenticeship and reaching a level far beyond that of the normal child. Instead, we conceive of the slow growth through stages of great simplicity in the normal child as an indispensable benefit to the maturing of a human being intent on finding a place in a complex world. And we look on Nadia's work as resulting from a specific mental faculty running out of gear. One is reminded of the spectacular feats of idiots savants, mentally deficient persons who carry out unbelievable tasks of memory and calculation. Nadia seems to have attained her virtuosity at the price of losing the principal cognitive value of drawing. Whereas Heidi's youthful drawings reflect adventure, love, exploration, and mastery, Nadia's images remain, to the best of our understanding, alien creatures, substitutes for normal experiences that are detached from their maker's conduct of daily life.

But to interpret Nadia's work as the remarkable outcome of a pathological deficiency—the pearl in the oyster, as it were—is not enough of an answer. The mere uncoupling of the drawing ability from its normal cognitive function will not, by itself, explain the particular quality of the work. Drawing skillfully from the model is by no means a mechanical copying task. Also, Nadia's style of draftsmanship has a character of its own that is quite different from the insipid neutrality of the picture book illustrations she used for models.

It has been suggested that we are dealing with the effect of eidetic imagery, and, in fact, the physiologically based persistence of percepts in visual memory might account for the ability of Nadia and the other autistic children studied by Selfe to make faithful copies of models, weeks after they have been seen. Eidetic imagery, however, is an unusual property of perception, not one of pictorial representation. Its effect on drawing should be no different from that of looking at a model directly, unless we assume that the children were able to project their memory images directly on their drawing paper, the way a slide projector creates images that can then be copied by tracing. To the extent, however, that Selfe could compare drawings with their models, the drawings were not simply mechanical duplicates of their prototypes.

One of the most striking features of Nadia's drawings is the self-assured

bravura of her graphic stroke, a facility known only from seasoned professionals. This feat is all the more dazzling when one realizes that it was performed by a child described as "clumsy, poorly co-ordinated and excessively slow in her movements." What the drawings seem to indicate is that Nadia's motor handicap in daily behavior was not an inherent deficiency but an inhibition that resulted from her psychological difficulties in dealing with the environment. Outside of the range of these inhibitions she enjoyed a normal motor spontaneity, at least in her arms, wrists, and hands. A normal child's drawings demonstrate a basic difference between the reckless verve of early scribbles and the careful control of contour lines that takes over once particular shapes are intended. Rhoda Kellogg (1969) has shown in detail how visual control comes to be imposed on free motor activity. In Nadia's work, such visual control, although by no means absent, is wedded to prominent motor behavior. Here again we are decisively helped by Pariser, who observes that Nadia's drawings might be described as "the hypertrophy of the so-called scribbling stage." In fact, some of the drawings contain outbursts of straight scribbling, to which the graphic style of her representations is closely related.

It may not be out of place to be reminded here of certain rapidly done sketches by Rembrandt or Delacroix in which an arm or leg is rendered not by an explicitly recognizable shape but by means of strokes, patches, or pen marks generated by the artist's motor behavior. An observer's attuned eye can integrate such hints to stand visually for known objects, but they presuppose a highly sophisticated stylistic convention.

Psychologically, the acceptance of such a procedure implies that the draftsman, at least for the purpose of the particular drawing, is not primarily concerned with the functional and practical character of his objects as reflected in their tangible outlines, surfaces, and volumes but with their purely visual expression and appearance. He aims at these external, momentary appearances with the lines or patches traced by his rapid pen or brush. As we look with the eyes of Frans Hals at the lace collar of a Dutch gentleman or with those of Claude Monet at a distant lady and her child dissolved into specks of color by the summer light, we share the artists' slightly irresponsible tasting of reality as an assortment of tidbits of pure vision. Conceivably, it is a somewhat similar detachment of vision and action from the functionality of the perceived world that endows the drawings of the estranged child with an aesthetic charm acquired at so high a price.

REFERENCES

Arnheim, Rudolf. 1966. *Toward a Psychology of Art*. Berkeley and Los Angeles: University of California Press.

————. 1974. *Art and Visual Perception*. Berkeley and Los Angeles: University of California Press.

Fein, Sylvia. 1976. *Heidi's Horse*. Pleasant Hill, Calif.: Exelrod Press.

Kellogg, Rhoda. 1969. *Analyzing Children's Drawings*. Palo Alto, Calif.: National Press Books.

Pariser, David A. 1979. *A Discussion of Nadia*. Technical Report no. 9. Cambridge, Mass.: Harvard Project Zero.

Selfe, Lorna. 1977. *Nadia—a Case of Extraordinary Drawing Ability in an Autistic Child*. London: Academic Press.

————. 1983. *Normal and Anomalous Representational Drawing Ability in Children*. London: Academic Press.

THE ARTIST AS HEALER

A RT THERAPY IS based on the two poles of art and therapy. Therefore, one can say in a simplifying way that its practice relies essentially on two kinds of persons, therapists and artists. Therapists, one might say, are moved primarily by the tribulations of human existence. Sometimes a deep engagement in their own difficulties has led them to share in the problems of other people, and a strong desire to help and heal is the guiding impulse of their vocation. They have found the arts to be an effective means of exploring and caring for the human mind, and perhaps they themselves have gotten relief from some artistic activity. They may have entered the art studio as outsiders intent on acquiring the techniques they need to carry out their therapeutic mission.

If I may equally simplify the countertype, I would say that artists are persons who live essentially with their work. W. H. Auden has said that poets are people who "like hanging around words listening to what they say" (Auden 1948). Similarly, other artists are people who like to hang around paints and chisels or musical instruments or whatever else their medium happens to be. This passionate involvement with things to be made or performed presupposes a kind of personal encapsulation, a need to shut oneself off to some extent from the challenges of human intercourse. Such a full dedication to the demands of what artists are creating does not mean, of course, that they feel indifferent about the world. On the contrary, they typically love the world, they savor its every manifestation, or they hate and reject it. Basically, however, they do all this as observers. Their vocation is to show what world and life are like, to interpret and perhaps judge them. This requires a particular blend of in-

First published in *The Arts in Psychotherapy* 17 (Spring 1990), pp. 1–4.

volvement and detachment. One must be close to what one wants to deal with, but one also cannot be truly and actively engaged and at the same time be an independent observer.

Of course, there is also a strong social component to the makeup of the artist's mind. Artists like to share what they have to offer. They like to be appreciated. But I believe it is fair to say that the wish to share is not the prime mover of their being, which is the concern with their work, but is an additional facet of the artist's complex personality. It is far from easy to reconcile the demands of art with those of the social community. In the particular case of artists deciding to become therapists, their motivational constellation tends, I believe, to be the following: the artist is so fully inspired by the benefits of artistic activity that he or she feels impelled to make this blessing available to others. Some artists also have had the personal experience of obtaining rescue from mental trouble through the exercise of their profession. This makes them willing and indeed eager to make this resource helpful to others similarly plagued by personal difficulties.

The particular approach of the artist to working as therapist, therefore, is that of making the client something of a colleague. To say, however, that therapist and client enter a kind of partnership is true and then again not true. To keep the therapeutic relation on the right track, there must be a clear understanding of the differences between art as a profession and art as therapy.

On the one hand, persons who have never attempted before to paint a picture or perform a dance and to whom this looks like a demeaning and perhaps silly occupation may be reassured by the fact that the activity they are asked to undertake in therapy sessions is the same kind of work the therapist does professionally. It may keep clients from feeling that for the purpose of furthering their mental health they are asked to submit to a kind of kindergarten game, quite in contrast to what a grown-up man or woman is accustomed to doing. Here now they meet a professional who introduces the procedures and standards by which he or she makes a living. It is serious matter, not childlike frivolity.

On the other hand, the differences between the two kinds of occupation are essential. For artists who take their profession seriously, every work is, one might say, a will and testament. Beyond being a particular statement— for example, the representation of a landscape—a painting is a world of its own, a small, homemade universe. As such, it imposes demands on its maker. The artist becomes the executive of the work's requirements and benefits in turn from what the work has to give him.

Some of this is true also for what the artwork should mean to the client

and, in fact, for what it needs to be to exert its curative function. At the same time, of course, the work in the therapy session is meant to serve its clinical purpose; therefore, it should be geared as much as possible to the particular mental situation of the client. Such an attitude would be an obstacle rather than a benefit to an artist. Although artists look at the world from their particular personal perspective, they must not obstruct their way when they create that world of their own. A self-centered vista is so contrary to the true artist's approach that it is unlikely to come about even when as a person he or she is under great stress.

To illustrate this point, it is useful to compare the artwork typically produced in therapy sessions nowadays with the paintings and sculptures that originated in mental institutions before art therapy came into existence. What strikes us when we look at the color plates illustrating Hans Prinzhorn's famous book of 1922 on the artistry of the mentally ill (Prinzhorn, 1968) is how many of them look like works of art. In part they do so because the author, a psychiatrist and art historian, selected for his publication works distinguished by high artistic quality and similar in style to the Expressionist art of his generation. But in addition those works differ in other ways from the primitive drawings typically issuing from today's therapy sessions. They were created spontaneously by individuals inclined to paint or sculpt without encouragement or direction. Although they certainly reflected the mental problems of their makers, they rarely did so intentionally. More often they were objectively oriented vehicles of complaints, protestations, petitions, religious fantasies, wishdreams, or fanciful conceptions of world and universe. By reaching beyond the merely personal and symptomatic, they came to look like works of art. For the same reason, they were suited for psychological interpretation only partially and indirectly.

An extreme example of the problem created for clinical interpretation by what one might call the artistic attitude are the seventy drawings made by Jackson Pollock in 1939 while he was the patient of a Jungian analyst (Pollock, 1970). Although intended to open communication with Dr. Henderson, these drawings do not show their purpose (Figure 39). To be sure, they are pervaded by violent turmoil, and they undoubtedly reflect much of the anxieties and obsessions that were upsetting Pollock at the time. Nevertheless, being produced by an artist, they are inevitably works of art in the sense that they represent general states of the human condition. If they reveal information relevant to diagnosis and therapy, they do so through epiphenomena, that is, through secondary traits of a much broader and more widely significant conception.

Compare this with the kind of artwork typically produced nowadays in

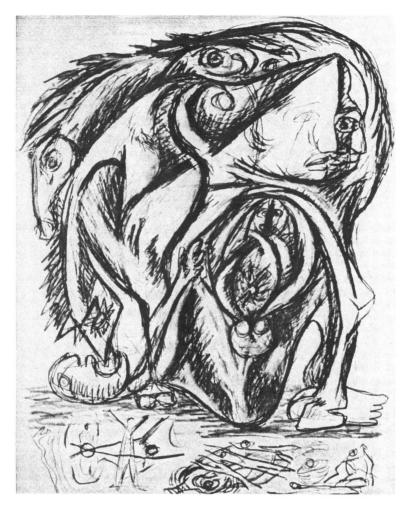

FIGURE 39.
Jackson Pollock, Colored pencil, lead pencil, 1939.
Copyright 1990, Pollock-Krasner Foundation/ARS, New York.

art therapy sessions. Today's material is not limited to clients who have a particular inclination toward visual expression or a special talent for it. Furthermore, much of the work comes about in response to definite instructions prescribing the topics and subjects to be treated. When drawings are done by persons of little or no training, they are more nearly diagrams, that is, schematic indicators of certain properties representing the psychological situation to be described.

Obviously, if the therapist is an artist, such diagrams are less interesting to him or her than is work distinguished by some visual talent. And yet,

even the diagrammatic patterns produced by the average client speak the artist's language. One might say that they reduce that language to its elements. For example, the differences between large size and small size, nearness and remoteness, light and darkness are indeed elementary, but their symbolism is equally present in the rich inventions of artists and the more nearly idiographic signs produced by many an untrained person.

Think, as an example, of an ever so simple and artless drawing representing a family constellation in which one person is shown as clearly holding the center or be banished to the periphery. Such spatial symbolism is as spontaneously readable in the work of an unskilled amateur as it might be indispensable in the composition of Raphael or Picasso.

In the arts as well as in therapy, visual symbolism has a property that has proved particularly helpful in psychiatric practice. It presents meanings without making them explicit to the consciousness of the image-maker. It communicates attitudes and beliefs to which the person would be unwilling to confess. How exactly is this obtained? What makes for this basic difference between visual and verbal communication? We need to consider here that every word is an attribution of a concept to a given phenomenon. When looking around in somebody's garden, I may exclaim, "What a beautiful oak!" I am classifying the tree conceptually. Similarly, when I talk about my father, I am identifying him unequivocally. Not so if I refer to the picture of a tall tree that stands at some subconscious level of my mind for my father but is not consciously identified with him. The picture allows me to deal with my conception of my father without my having to admit that this is what I am doing. The picture of the tree arouses in me a whole compound of resonances, which serves as a cloud cover for the particular reference I have in mind but am not prepared to reveal.

When in art therapy sessions clients use the world of natural objects to create symbolical pictures, they are relying on a very general ability of the human mind, namely, that of perceiving all experienced things and events as metaphors. I see my neighbor laboring to rake the autumn leaves from his front yard, and I am saying to myself, "There is no end to the chores of cleaning up the untidiness of life!" I experience the particular instance as an image of the human condition in general.

Artists are forcefully reminded of this human ability when they deal with clients in therapy. It is a useful reminder because it makes them remember that the validity of their own artistic statements depends on this universally valid symbolism. One cannot paint a tree intelligently without making a statement on what it is like to be rooted in the ground, rise to the sky,

invade open space. Animals are seen as carriers of character traits in paintings of lions or eagles or serpents. This suggested some time ago to a German therapist the design of an animal family test (Brem-Gräser, 1970). The children to be tested were asked to imagine that the members of their family were animals and to draw a picture of them. By describing, say, the father as an elephant or the mother as a bird, the children defined implicitly and nonverbally their conception of the nature and role of each family member.

Another fruitful choice of a visual symbol was made by two therapists at the Hahnemann Medical College when they used the drawing of a bridge as a projective technique (Hays & Lyons, 1981). So loaded with potential symbolism is the notion and image of a bridge that when adolescents were asked to draw "a picture of a bridge going from some place to some place," they almost automatically depicted some development of their own, such as moving from one stage of life to another, overcoming an obstacle, or making a transition from a bad state of affairs to a better one. Mental patients subjected to the same test used the psychological connotations of the bridge in an even more pronounced fashion.

What I have been saying is familiar not only to therapists but also to artists from their own studio work. This double relevance points to a development that is at the base of our entire modern approach to the problems here under discussion. We have come to dismiss the traditional distinction between the normal and the abnormal, the healthy and the sick. The insane asylums of past centuries were repositories for persons considered distinct from the average citizen. They were seen as being struck by an evil curse, from which everybody else was exempt, and there was no resemblance between their state of mind and that of the normal population. It is true that there was also a long-standing belief connecting madness with creativity. Cesare Lombroso in particular made the influential assertion that human genius is directly related to the mental degeneration that produces psychosis. This notion, however, was based on the assumption that both madness and creativity were outside the precinct of the normal mind. Both were abnormal.

Only in our own time have we come to realize that the concept of illness, whether physical or mental, has a purely practical definition. The functioning of body and mind is normally subject to the same disturbances that call for treatment when they amount to serious obstacles; and the pathological processes that devastate body and mind when they take over are not entirely absent from the more normal states of daily life. Similarly, we have come to see that the genius of great talent, in the arts or elsewhere, relies

on no other resources than those generally available to the mind.

We have arrived at a unified conception of organic functioning that makes it possible to view the relation between therapist and client more productively. Instead of considering therapists as belonging to one class of human beings, privileged by special virtues, and clients as belonging to another class, deprived of certain indispensable traits, we realize that therapists and clients share the same mental resources and impediments and that this basic resemblance enables some human beings to be helpful to others.

Let me conclude with the thought that the kinship among all kinds of artistic activity, no matter by whom they are practiced, can make us see art therapy as a helpful model for dealing with certain insufficiencies that are interfering with the arts of our time. One can hardly overlook the fact that too many of our generation's painters and sculptors suffer from a sense of emptiness, as though their work were about nothing. Although talented and highly skilled, they feel guilty of pretending that they have something to say, because actually they are not aware of any such substance. I believe that this deplorable situation is due to many artists' surrender to the commercialization of the art market. Too many neglect their own impulses and standards and struggle instead to adopt the latest fashion, the model that sells. Within the range of styles agreeable to art dealers at a particular time, these artists search for originality, that is, for some device that will distinguish their product from that of their competitors. This derailment of motivation leads inevitably to the alienation about which artists have been complaining.

I believe that the function of the arts in therapy can serve as an effective reminder of what is the true and wholesome impulse of art in general. Art as a helper in times of trouble, as a means of understanding the conditions of human existence and of facing the frightening aspects of those conditions, as the creation of a meaningful order offering a refuge from the unmanageable confusion of the outer reality—these most welcome aids are grasped by people in distress and used by the healers who come to their assistance. But the blessings experienced in therapy can reach further: they can remind artists everywhere what the function of art has always been and will always be.

REFERENCES

Auden, Wystan Hugh. 1948. "Squares and Oblongs." In *Poets at Work*. Edited by Charles D. Abbott. New York: Harcourt Brace.

Brem-Gräser, L. 1970. *Familie in Tieren*. Munich.

Hays, R. E., and S. J. Lyons. 1981. "The Bridge Drawing: A Projective Technique for Assessment in Art Therapy." *The Arts in Psychotherapy* 8, pp. 207–217.

Pollock, Jackson. 1970. *Psychoanalytic Drawings*. Text by C. L. Wysuph. New York: Horizon.

Prinzhorn, Hans. 1968. *Bildmerei der Geisteskranken*. Berlin: Springer.

PART V

BUT IS IT SCIENCE?

IT WAS IN October 1976, less than a month before he succumbed to a fatal illness, that Dan Berlyne made good on his promise to chair a debate between James J. Gibson and myself. The American Society for Aesthetics was holding its annual convention in Toronto, and when the hour of our meeting came, Dan was rolled in on a wheelchair. Barely able to talk, he not only introduced us two speakers but also insisted on reading a theoretical statement he had prepared for the occasion.

This sense of professional discipline pervaded everything Dan did. It also determined his conception of science. Science was defined morally by the precision and clarity of its statements and by the objective reliability of its assertions. What one might call the Hippocratic Oath of the social sciences had fairly recently taken the form of a prescribed procedure. An observation was considered true if a sufficient number of witnesses agreed adequately on the nature of the phenomenon. It was necessary furthermore to keep the object of research simple so that the number of variables involved could be held under control.

This latter condition was not easily met in a world in which few things are simple. One could cope with the situation by extracting elements from their more complex setting and submitting their purity to an analysis that helped reveal the nature of the ultimate building stones of which our world is made. Or, if one was willing to be more daring, one could accept the behavior of isolated components as indications of how these same components acted in the whole. This was a comfortable but risky approach to examining intricate objects without having to bother about their total structure. Finally, if one wanted to be even bolder, one could extirpate

Written for *Emerging Visions: Contemporary Approaches to the Aesthetic Process*, edited by Gerald C. Cupchik (forthcoming).

175

one trait or a few traits and treat them as valid representatives of the whole. That was a pleasant and striking way of making the world look simple.

These various expedients made for obvious trouble in the investigation of organic life and its manifestations; within this field, the psychology of art is a particularly difficult subject. For not only is the human being the most refined of organisms, but among its various activities few involve its most developed abilities in so highly integrated a manner as do the ones we call aesthetic. In psychophysical terms, few vital human concerns sublimate so radically as do the arts from the basic human drives, from which nevertheless they must continue to derive their primary energy. Cognition travels a long way from the practical needs it fulfills in daily life to the imagery serving the same needs in the arts. No other human activity connects as intimately as do the arts perception with reason, intuition with intellect, and the excitement of discovery and frustration with the coolness of control.

If we remain aware, as indeed we must, of the awesome complexity of our task, we are tempted to feel that the yield of the scientific psychology of the arts since the days of Gustav Theodor Fechner has been disappointingly meager. It has been ample in quantity but narrow in outlook. In part, this has been so because too many of the researchers trained as psychologists were insufficiently acquainted with the arts, their methods and objectives, their history and their makers. More importantly, however, this meagerness of results was due to the self-imposed constraints of method to which I referred. The ascetic reduction to measurable phenomena that had to be simple enough to be controllable made most researchers limit the objects of their curiosity to what fitted the rules of their scientific game. How remote much of this remained from the true wealth of artistic creation was obvious when one compared it with the insights provided by the writings and sayings of artists, chroniclers, and thinkers available through the ages.

And yet, there is a remarkable cross-connection by which—in a manner that, to my mind, is most enlightening for our entire undertaking—precisely the simplest perceptual factors point to the most central aesthetic themes, so that what we find out about the visual or auditory elements embarks us directly on the royal road to the understanding and experiencing of works of art or music. I will illustrate this by an obvious example, which makes my point the more radically because it came about with no intended reference to aesthetic matters. I am referring to Max Wertheimer's rules of grouping (1923), those simple demonstrations in-

tended as a first introduction to the inherent structure of gestalt patterns.*

Any organized visual or auditory pattern, be it simple or highly complex, can be used to demonstrate some of Wertheimer's rules. Units close together in space will combine spontaneously as against others from which they are separated by distance. Units resembling one another as to size, shape, color, or motion connect with equal spontaneity. But structural ties of this nature serve not only to turn physical patches of shape or sound into organized patterns and thereby make them perceivable. What makes them so decisively valuable for the artist is that the formal connections thus established in the cortical projection areas of the receiver's brain point to the very essence of the artist's statement. This means no less than that the innocence of vision, whose existence has been so eagerly but vainly denied by theoreticians, offers the most direct access to the very key of artistic expression.

Think, for example, of the visual eloquence of distances between pictorial units. A representational painting of the traditional kind may show a group of figures characterized by their costumes, their age and sex, their gestures, their setting, etc. More directly to the point of the artist's theme than these clues to the subject matter, however, are the basic perceptual parameters, such as the varying distances between the characters: Which figures belong together? Who is concerned with whom? Who comes from an alien or hostile realm? The narrative elements must be seen, first of all, in their derivation from and in their inseparable relation to the very elements of human experience, such as the difference between nearness and remoteness.

The symbolic relevance of the perceptual traits is perhaps even more indispensable for the understanding of abstract media such as music, modern dance, or nonmimetic painting and sculpture. Remember here the many hapless attempts to explain the meaning of music as an imitation of natural sounds or as an application of conventional symbols or to interpret "abstract" visual images as purely formal plays of shape. Instead, I am convinced that the value and sense of art reveal themselves only when they are derived from the spontaneous significance of perceptual expression.

This is—if I may refer to a personal experience—why my own systematic attempts to analyze problems of art psychologically began with the extraction of perceptual features from the artistic media. My study of the

*This most influential set of demonstrations needed none of the prescribed procedures of scientific verification to be accepted as a proof for the validity of certain perceptual ground rules. To see what one pioneer had seen sufficed to persuade an entire profession. The same has been true from time to time at other happy moments of our history, such as when Albert Michotte showed his experiments on perceptual causality or when Gaetano Kanizsa drew the illusory contours of his beguiling ornaments.

silent and monochromatic film did not take off from the subject matter of its plots but from such perceptual features as the reduction of spatial depth, the brightness scale of black and white values, the omission of sound, the confinement of space and time, and so forth (Arnheim, 1957). A similar analysis was applied to radio as a medium of pure sound deprived of vision (Arnheim, 1972). And when, somewhat later, I dealt with visual art in general, I started from whatever psychological studies were available on the perception of shape, color, light, space, and movement (Arnheim, 1974).

In all these areas, however, the experiments that had been made with simple geometrical shapes turned out not to be sufficient when I tried to reduce the patterns of paintings, sculpture, or architecture to their elements. The shapes and spatial relations routinely used by artists were rarely to be found among the circles and triangles of the psychological laboratory, and what looked simple under experimental conditions called for indispensable refinements in the arts. This meant that, to the best of my ability, I had to elaborate on what was known about such phenomena as figure and ground, perspective gradients, or the interaction between light and spatial volume. These additional explorations derived mostly from intuitive insight rather than confirmed experimentation.

A further problem presented itself soon enough. There was considerable satisfaction in finding some simple, general principles accounting for complex phenomena such as works of art. The feeling of covering so much with so little could not but make for a sense of accomplishment. At the same time, however, I came to be aware of a disparity between the inexhaustible wealth of the object actually explored and the barrenness of the statement made. I had to realize that the ultimate wisdom granted to the human mind does not dwell simply at the highest level of abstraction. It aims at the synthesis of the abstraction attained with the concreteness of the reality in which the experience of life practically resides. In fact, it became clear to me that in some of the most exhilarating statements of great science there reverberates in the construct of thought the perceivable presence of the world in its full actuality.

To be sure, in the sciences as well as in philosophy a powerful reality can be reflected in theoretical systems, even though they are confined to an abstract realm. There is enough justification within the intellectual precinct of, say, the periodic table of elements or the quantum theory, and in psychology we may content ourselves, perhaps somewhat hesitantly, with the Freudian mechanism of motivational forces, even though it may look like a mere x-ray image compared with what we experience when we watch the behavior of an actual human being. In the cognitive exploration of the

arts, however, the problem of the discrepancy between abstract theory and the actual specimens known from experience seems to me particularly irksome because many of the problems in our field of study are not simply traceable at a relatively broad level of generality. They require a closer look at the particular qualities of individual works. After all, what we would like to understand is what happens when we are exposed to an actual work. To use an example from music: the Schenker analysis of a composition may reveal the very core of the structure, but much of the music has dropped out of the sound image.

What seems to be called for to remedy the dilemma is not an inventory of all elements contained in a work of art. Duplication of the object of study is not the intention of science in any area. Rather, what is needed to get beyond the understanding of single traits is a conception of the comprehensive structure in which the particular traits exert their function. Comprehensive structure is not mechanical completeness. The complete work is only the limiting case of the structure. It presents itself to the thoughtful viewer or listener as a hierarchy of structural levels, all of which would need to be apprehended by an ideal receiver, but each of which may be profitably singled out by an investigator for his particular purpose. Which level or levels of abstraction are to be selected depends on the particular theoretical task.

A good example is the psychological study of visual composition. My own analysis of the formal parameters, with which here again I was concerned, had given me some insight into the particular functions of such devices as balance or parallelism or dynamic tension, but it also seemed to me to fall short of the meaning of any work of art as a whole. By demonstrating, for example, the nature of color contrast in a painting of Henri Matisse, I was able to illustrate the nature of a perceptual feature showing how it operated in vivo; but in a way I also betrayed the artist when I misused his work for exemplifying a detail. This made me shift my station point. Whereas for the purpose of *Art and Visual Perception* I had taken off from the concepts and findings of perceptual psychology and looked for examples in the arts to illustrate their application, my more recent study of visual composition, *The Power of the Center* (1988), made me take my position within the arts themselves. It made me search for the structure of paintings, sculptures, and buildings and ask what they all had in common. The level of abstraction appropriate for this rather generic question had to be quite high, but it also had to encompass the structure of any work as a whole rather than limit itself to isolated components. An example will illustrate this procedure.

The compositional scheme developed in *The Power of the Center* is based

on the dynamic activity of focal systems, from whose centers radial forces are given off or attracted to. These centric systems interact according to their location, relative strength, etc. As most works of art are organized around a primary center, to which the others are subordinated, it is necessary to distinguish more specifically between centric systems and the eccentric systems interacting with them. The two principles of centricity and eccentricity in their interplay account for the composition of works of art.

Let me use as an illustration a Chinese statue of the Sung dynasty representing Kuan-Yin or Bodhisattva (frontispiece). To take a hold of this complex pattern of shapes, we locate the principal center of the compositional structure at the navel of the figure. From this center, powerful radii issue in the various directions of space, upward through the torso and head, downward as a pressure against the base, forward by way of the left leg, and rightward by the other leg. We envisage as the theme of the work a center of powerful energy radiating its influence through the world of its surroundings. Within this system, however, we notice secondary centers, especially the head of the figure, functioning as subsystems. The head operates as a visual center of energy of its own, emitting the vectors of the arms and also of the torso. In relation to the primary system governing the whole, the head is an eccentric system that interacts with the primary one.

Other such eccentric systems can be said to act even outside the confines of the statue itself. In the vertical dimension there is the contest between the force of gravity, located in the ground, and the aspiration to overcome terrestrial weight by rising toward the heights. Gravity is visually expressed in the downward trend throughout the body of the figure: the weight of the torso, the limbs pointing toward the ground, the humble giving-in of the slightly bent head. In contrast to this downward pull, the figure as a whole rises like a proud monument from its base toward the sky and lifts the right leg as though about to climb.

In addition to this compositional theme in the vertical dimension, another almost equally decisive theme deflects the figure from its frontal symmetry to make it turn sideway and incline toward its right. The symmetry base from which it is seen to be moved into action is that of the supreme Buddha—present in the memory of all the faithful—who, detached from earthly concerns, reposes in a state of meditation. The Kwan-Yin remains at a secondary level of Buddhahood. She is the goddess of mercy deflected to a mission of concern with the suffering of the mortals. Here again the visual dynamics of the figure calls for a twofold interpretation: the leaning toward the outer world is generated centrically by an

impulse of the figure itself and eccentrically by the attraction from an outer situation calling for response.

It will be seen that this configuration of dynamic factors could be analyzed further to the smallest detail. Such asymptotic advance toward completeness would add refinements to the basic theme I have traced at a level of relatively high abstraction. What matters is that even at this abstract level, the compositional structure is grasped as a whole, namely, as a configuration of perceptual components symbolizing the psychological theme of the work by direct visual reflection. The example also shows what I meant when I said that the basic perceptual features point directly to the deepest meanings of the artistic statement, even though, to do so, they need to be seen in the structural context of the whole.

An analysis such as this one is certainly psychological, but is it scientific? I have made no attempt to establish validity, which could be done, for example, by interrogating a number of observers. I am reminded here of an anecdote told me by Max Wertheimer, who one day at the University of Berlin walked into the office of a friend, the physicist Max Born. "What are you doing?" Wertheimer asked him. Born replied that he was writing up an experiment. When, asked Wertheimer, had he done the experiment? "I shall do it tomorrow," said Born.

The procedure I demonstrated is phenomenological. It presupposes some trust of the analyst in his own ability to view certain psychological appearances objectively and relevantly. His verdict, however, need not remain unchecked. It can and should be subjected to the judgment of other viewers, professional and otherwise. When, however, an object of research is too complex to be treated adequately with the experimental procedures now available, I have never been willing to reduce it to the level for which we now have the instruments. Without remorse I have settled for the most careful observation and description of which I was capable, this being my definition of science. The ostensive method, the pointing with the index finger, the "Don't you see that . . . ?" is not without risk, but, particularly in teaching, it has always been my choice.

Furthermore, the approach here presented is cognitive. It is based on an aesthetic philosophy according to which art is one of the principal means by which the human mind orients itself in the environment of its life space. It follows that a mere copying of nature cannot meet art's requirement because mere imitation is hardly enlightening. Faithful copying, as practiced under certain stylistic conditions in the history of art, can serve to record valued sights or demonstrate a craftsman's skill or express one's gratitude for the beauty of existing things, but it falls short of the true

function of art, namely, that of helping us to understand the things we see by interpreting their structure. In that sense, all representation is interpretation.

This demand, however, is not supported in theory by the tradition of naturalism as proclaimed in the Western world since the Renaissance. Although the practice of good art continued to go beyond mere copying, aesthetic writings insisted that art had to imitate nature faithfully. This doctrine determined the strategy of psychologists when they began to occupy themselves with art; and it has continued to influence the thinking of many of them. "The artist," a hypothetical figure, is assumed to aspire to the faithful imitation of nature, and it is therefore considered the task of the psychologist to determine how such perceptual features as spatial projection, color reflection, or volume are correctly rendered. This clinging to a fictitious standard of correctness is all the more curious given that for more than a century the visual arts of our culture have increasingly deviated from naturalistic norms and have developed perceptual styles such as Impressionism, Pointillism, Expressionism, Cubism, Surrealism, and Abstractionism, which offer plenty of fascinating topics for psychological research.

The concern with mechanical copying of nature, however, is not the only example of outdated aesthetical notions deflecting psychological research from subjects and approaches more pertinent to what truly matters in the arts. Another example is hedonism. Pleasure and pain had long been considered the mainsprings of human motivation; but in general psychology it became evident that reward and punishment were not the final answer. Rather, they had to be thought of as biological devices introduced into organic experience through evolution for the purpose of obtaining behavior indispensable for survival. Sexual activity became pleasurable because will-endowed creatures would otherwise have no incentive to practice it. The psychological question, therefore, had to be in each case, Pleasure because of what and what for? Freud, for example, related pain to the increasing of tension and pleasure to the easing of it. Berlyne made the measurement of arousal aesthetically relevant when he used it as an indicator of the level of complexity most congenial to the apprehension of perceptual patterns (1971, p. 191 ff). More commonly, however, psychologists abided by a notion widely accepted in aesthetic philosophy that pleasure was the end of art because art was to be defined as an "emotional" experience. This led to literally hundreds of preference studies designed to find out which colors, shapes, subjects, etc., various groups of the human population preferred—studies of no conceivable usefulness, except perhaps for market research.

One more example will demonstrate the constrictive effect of popular aesthetic notions on the orientation of psychological studies. Formalism became dominant in the critical writing of the early twentieth century. It asserted that the aesthetic attitude was distinguished by an exclusive concern with form. What mattered about a work of art was not what it represented, what meaning or message it conveyed, but what pleasurable relations obtained among its colors, shapes, sounds, etc. The doctrine was newly strengthened when "abstract" art eliminated subject matter. This seemed to confirm the notion that art is about nothing but itself. In the psychological investigations of art, this favored the conviction that all there is to know about perceptual phenomena is their stimulus characteristics and the structural principles that organize such material. Essential though such studies are for the analysis of perception in general, they make sense in their application to the arts only if their semantic function is made clear. Unless one understands what the artist is saying by means of his shapes and colors or musical sounds, there is no real point in examining the formal conditions by which a picture or dance or sonata is held together. Here again my discussion of the Chinese statue may serve as an example.

What, then, is the kind of program to be recommended for future research in the psychology of art? It will be evident that the answer depends on the investigator's ideas about the nature of art. From my own convictions it follows that needed, first of all, is much concrete knowledge of what artists are trying to achieve and how they go about it. Furthermore, formal analysis must be carried out in the context of the work's total structure at a level of abstraction appropriate to the particular objective of the study. And, finally, any analysis of compositional form must be designed in relation to what the meaning of the work is understood to be.

I will conclude with a single suggestion, which may make my point. A great deal is known by now about the psychology of color. We know how the nervous system processes retinal stimuli. We have a scientifically exact inventory of hundreds of color shades. We know how colors influence one another's hue, brightness, and saturation. There are informal observations on the spontaneous expression of the various colors and their symbolical application to the rituals of various cultures. Art historians have collected much information on the color schemes employed by particular artists in relation to their stylistic periods. But we know next to nothing about how artists convey meaning through color relations—the equivalent of the many symbolic properties of shape constituting the elements of shape composition.

Statements on color composition have been limited to what interior decorators have in mind when they decide which colors go together and which

ones clash. But harmony barely touches the function of composition. As we know from the study of shape, much of the meaning conveyed depends on what is shown to belong together and what is detached. Similarity of hue or brightness pulls colored shapes together even when they are spatially distant from each other. More dramatically, complementaries "seek" each other magnetically to form tight wholes, and color contrast expresses conflict. All this is well known, but next to nothing has been done to show how these spontaneously evident relations are used by artists to display underlying meaning to the eyes. And yet it is precisely this kind of exploration that distinguishes the study of art from the many other tasks that can keep psychologists busy.

REFERENCES

Arnheim, Rudolf. 1957. *Film as Art.* Berkeley and Los Angeles: University of California Press.

————. 1972. *Radio, an Art of Sound.* New York: Da Capo.

————. 1974. *Art and Visual Perception.* Berkeley and Los Angeles: University of California Press.

————. 1988. *The Power of the Center.* Berkeley and Los Angeles: University of California Press.

Berlyne, Daniel E. 1971. *Aesthetics and Psychology.* New York: Appleton-Century-Crofts.

Wertheimer, Max. 1923. "Untersuchungen zur Lehre von der Gestalt II." *Psychologische Forschung* 4, pp. 301–350.

COMPLEMENTARITY
FROM THE OUTSIDE

THE SCIENCE OF physics, although one of the younger acquisitions of our culture, has at times provided the older disciplines with key concepts that have sharpened ideas at the very center of psychology and philosophy. More rarely, ideas originating in the humanities have stimulated theoretical progress in physics. When this happens, it may behoove the parent disciplines not certainly to check on the physical correctness of the facts under discussion but to examine the concepts within a broader scope. It may also be pertinent to examine the logical and psychological soundness attributed to these concepts by the physicists. One of the more fascinating examples is the notion of complementarity introduced into quantum physics by Niels Bohr in 1927.

Complementarity was a response to the dilemma that had arisen when physicists had to deal with discontinuity in a tradition based on continuity. Discontinuity was not a newcomer, however; in the history of philosophy, atomism was one of the venerable forerunners of early physics. Psychologically, the human mind's elementary conception of the world was that of being made up of separate elements or building blocks. Each of these elements was characterized by its shape, size, and location. At the early level of thinking, the only way of understanding the complexity of any one thing was by seeing it as composed of such isolable units. An ingenious contrivance of the early mind was that of imposing the most radical simplification conceivable on the variety of appearances by reducing this variety to an infinite sum of invisibly small elements, all alike and open to variety only by their relations.

Clearly, however, such accumulation of static elements was not the whole story. The world was also alive with action, motion, and change. In fact, a worldview equally as elementary as that of atomism saw motion and

change as primary. The obvious handicap of this view was that if every-thing was in flux, nothing could be taken hold of. Thus, the Heraclitic vision, as bold as that of the atomists, was just as incomplete. What was needed, and what we may call the most fundamental and universal con-ception of reality, was a notion of the world as comprising definable ele-ments that were inhabited and activated by directed forces.

It is in the nature of the neatness and simplicity distinguishing early worldviews that this basic duality observed a strict separation between its two components: the material elements, clearly definable in and by them-selves, and the mobilizing vectors, equally isolable and defined. In this view, materials were needed as bases and targets of the forces, and forces were needed to apply to materials. Such a duality was still explicit in the relation between matter and electromagnetic radiation as it presented itself at the beginning of our century. Light was known as a continuous play of waves. Matter was a discontinuous agglomeration of particles. Together they constituted the physical universe.

It is well known how the neatness of this accepted order was upset by the further developments of quantum theory, which involved the discovery that in both realms, that of radiation and that of matter, continuity and discontinuity existed together. To describe what the experiments reported about the behavior of light, recourse was needed to both waves and par-ticles. The same turned out to be true for the behavior of matter. In both cases, the two contradictory modes of existence had to be applied to the same aspect of nature.

Attempts to bridge the conflict by interpreting the two modes as mere different aspects of an identical phenomenon were not lacking. Note, for example, Erwin Schrödinger's suggestion that "there are in fact no discrete energy levels and no discontinuous translations between stationary states, apparent discontinuities being simply changes from one vibrational mode to another, analogous to 'beats' in acoustics" (quoted in Murdoch, 1987, p. 43). But as yet no such reconciliation has gained recognition.

It was in this critical situation that Niels Bohr proposed that the quan-tum paradoxes should be accepted as "deeply rooted in nature and, at present at any rate, unavoidable" (Murdoch, 1987, p. 46). To this end, he introduced the notion of complementarity as a legitimate way of describing the relation between pairs of phenomena that precluded each other but were both needed for a complete account of the fact under discussion. Continuity and discontinuity, although contradictory, were both needed to completely cover the two aspects of electromagnetic radiation as well as those of matter.

To buttress the acceptability of his proposal, Bohr, a broadly educated

man of many interests, took the unusual step of illustrating his physical doctrine of complementarity with examples from psychology, the arts, and experiences of common sense. This sort of argument encourages the outsider to take a critical look at the nature and solidity of the concept under discussion.

If in some of the formulations we are invited to accept contradiction as an inherent property of a form of existence, we have to remember, of course, that the very definition of contradiction prevents us from doing so. To acknowledge the "terrible difficulties" to which Victor Weisskopf has alluded in this connection (1989, p. 79), we must be sure not to make do with examples that look like instances of contradiction, although they merely involve different aspects of the same instance. Thus, Plato in the *Phaedo* (102) lets Socrates assert that Simmias "is said to be great and is also said to be small, because he is a mean between them, exceeding the smallness of the one by highness and allowing the greatness of the other to exceed his smallness." Greatness and smallness, if taken as different quantities, cannot be treated as contradictory because they involve different perspectives. In a similar vein, Max Planck refers to "pseudoproblems." He says:

> The room in which we now sit, has two walls, a right hand one and a left hand one. To you, this is the right side, to me, sitting facing you, that is the right side. The problem is: Which side is in reality the right-hand one? I know that this question sounds ridiculous, yet I dare call it typical of an entire host of problems which have been, and in part still are, the subject of earnest and learned debates, except that the situation is not always quite so clear. (quoted in Henle, 1986, p. 184)

Nor are we permitted to use mere pairs of opposites as examples of complementarity if they do not apply to the same object. The colors red and green are opposites. They also complete each other, so much so that we call them complementaries, but they do not meet the physicist's definition of the term. To do so, it is not sufficient that they be mutually exclusive and complete each other to form a whole—a condition easily met; they must also designate a concept that applies logically and empirically to one and the same object or event. Only then do they present the paradox of complementarity in the sense in which the physicist is struggling with it.

Once we limit the discussion to a single phenomenon, there are only two ways out. Either we must admit that we are not pretending to make a statement about reality itself but are satisfied with thinking up two theoretical models, which, although logically exclusive of each other, are both

needed to fully describe the properties of an object or event of nature. Or we must treat the notion of the object held together by complementarity as a preliminary theory, while a more unified way of understanding the actually existing whole is pending. I note that in physics the leading thinkers take either the one or the other view.

Traditionally, we require an acceptable description of a phenomenon of natural science to be *anschaulich* (a German term roughly translatable as intuitive), meaning in the classical sense that the description enables us to form a mental picture of the thing or action in question. This condition requires that the phenomenon be made unitary. It must be pervaded by the natural law of causality because causality is the basic manner by which we perceive things as acting on one another in this world. Classical causality, however, is precisely the property from which the uncertainty principle has excluded the realm of quantum physics. And this seems to be tantamount to preventing us from obtaining a perceptual image of what holds the atom together.

At this point, a discussion of the double meaning of "image" offered by Arthur I. Miller in a discussion of "redefining visualizability" is of considerable interest to psychologists concerned with visual thinking (1984, chap. 4). Miller makes it clear that recent developments in physics call for two kinds of imagery, which were not kept apart in earlier science. Although the experimental evidence prevents us from forming a mental image bridging the wave-particle duality, such an image is available by *Anschaulichkeit* of another kind. It is the kind of image the physicist Werner Heisenberg had in mind when he asserted that, although the causality of classical mechanics has no access to quantum theory, quantum mechanics should not be considered *unanschaulich*, that is, excluded from imagery (Miller, 1984, p. 151). In what sense can this double meaning of imagery be made clear?

I hope I am not misinterpreting Miller's argument when I refer here to two kinds of visual image with which psychologists are familiar: images that record actual percepts, such as that of a tree or a steam engine, and images we receive from the description of an experiment of the classical type. One example of the latter is Albert Einstein's famous thought experiment in which he demonstrated the equivalence of inertia and gravitation by imagining an observer pulled through empty space in a closed container (Einstein, 1920, p. 45). Such images, however, lead by degrees of abstraction to others limited to spatial diagrams of a theoretical situation. Sigmund Freud, for example, writes in the last theoretical survey of his system, "We assume that the psychic life has the function of an apparatus, to which we attribute spatial extension and which we imagine as

being composed of several pieces, similar to a telescope or microscope" (Freud, 1941, p. 67). Although such an image serves as an abstract representation, it is in itself as concrete a perceptual image as one of the first kind. A diagram or chart has an *Anschaulichkeit* of its own. The advantage of this second kind of image for our present purpose is that it can represent a complementary situation in full concreteness to the extent that it can show two mutually exclusive components, known to add up to a complete whole, for example, a combination of a wave model and a particle model. This image cannot, however, show the two as united in one and the same percept and held together by the laws of nature, such as the force of causality.

Although such an image provides complementarity with a concrete percept of its models, it would not seem to provide it with a representable reality. In the humanities, it would leave us with what we call a black box, that is, a no-man's-land that is not known or that cannot be filled by an organized structure. In this connection, it is instructive to look at the examples cited by Niels Bohr and his adherents to demonstrate complementarity in psychology or the other social sciences. Dugald Murdoch says in the preface of his enlightening book on Bohr's philosophy of physics, "Nothing is said about Bohr's attempts to apply his notion of complementarity to subjects other than physics for I do not believe that they throw light on his philosophy of physics, indeed the contrary is true" (1987, p. ix). Other physicists disagree.

To provide psychological examples of mutual exclusion, an essential feature of complementarity, one can refer to pathological facts such as those of split personality. Gerald Holton in his essay on the roots of complementarity (1970, p. 1038) refers to this passage in William James, whose influence on Bohr is well documented: "It must be admitted, therefore, that in certain persons, at least, the total possible consciousness may be split into parts which coexist but mutually ignore each other, and share the objects of knowledge between them. More remarkable still, they are complementary (James, vol. 1, p. 206)."

In such instances, components of the same personality exclude each other, although they cannot be said to contradict each other. Nor can they be said to belong to the same object because psychologically the various consciousnesses of the person exist independently of one another, even though physically they belong, loosely speaking, to the same body. In a more general sense, the psychologist can refer to mutual exclusiveness in the relation between body and mind. As this relation involves, however, two epistemologically distinct realms, to call them two aspects of the same entity is not necessarily admissible.

The best psychological example of complementarity is probably the relation between figure and ground in visual perception. There, indeed, one and the same phenomenon changes into its opposite in front of our eyes. (See "Negative Space in Architecture" in this book.)

For the most part, the promoters of complementarity have had recourse to examples that involve mutual exclusion only if one uses a psychological approach open to different interpretations. To illustrate typical examples of complementarity, Holton (1970, p. 1049) quotes from a book by Robert Oppenheimer:

> There is the relation between the cognitive and the affective sides of our lives, between knowledge and analysis, and emotion or feeling. There is the relation between the aesthetic and the heroic, between feeling and that precursor and definer of action, the ethical commitment; there is the classical relation between the analysis of one's self, the determination of one's motives and purposes, and that freedom of choice, that freedom of decision and action, which are complementary to it.

To accept such relations, however, as involving mutual exclusion, one must adopt a psychological attitude that Bohr took from Søren Kierkegaard under the influence of his friend, the philosopher Harald Hoffding. Holton quotes from Hoffding's *History of Modern Philosophy*: "[Kierkegaard's] leading idea was that the different possible conceptions of life are so sharply opposed to one another that we must make a choice between them, hence his catchword *either-or*" (Holton, 1970). It is possible to set intuition against reason or instinctual constraints against decisions of the human will, and one can think of instances in which forces of the mind block one another, but it is equally possible and indeed necessary to stress the constant, productive interaction between these forces. How would we account otherwise for the creation of a work of art or the conception of a scientific theory, given that in both activities nothing is more characteristic than the intimate cooperation of intuition and intellect?

A related problem comes up when we learn from Holton that Niels Bohr chose for his Danish coat of arms a combination of the legend *Contraria sunt complementa* with the well-known Taoist symbol of the yin and yang. Does the Chinese *tai-chi tu* represent an example of mutually exclusive forces? Most probably not. The philosophical literature emphasizes that the symbol depicts interaction. Thus, the master of Lien-hsi, the first cosmological philosopher in China, explains the *tai-chi tu*, or diagram of the supreme ultimate, as follows: "The Supreme Ultimate through Movement proclaims the Yang. This Movement having reached its limit is followed by Quiescence, and by this Quiescence it produces the Yin. When

Quiescence has reached its limit, there is a return to movement. Thus Movement and Quiescence, in alternation, become each the source of the other" (Fung Yu-Lan, 1960, p. 269). To prove this conclusively, however, is difficult because interaction by its very nature can be brought about in practice and thus shown, say, in a film, but it cannot be represented either in a picture in immobile space or as a sequence in time (Arnheim, 1966, pp. 221–244). Therefore, interaction resists verbal description. A symbolic picture can enumerate the forces involved in the interaction. It can show them sharing a pictorial surface, invading each other (as the *tai-chi tu* does), or intertwining, as can be seen in earlier forms of the Chinese symbol. What a symbolic picture cannot depict is what it clearly means to represent, namely, the simultaneous interaction of its inherent forces.

In other words, a conceptual description of interaction can present its ingredients but not the process of interaction itself because interaction simultaneously involves all forces with one another. This is what takes place in any percept. When, for example, we look at a picture, we are presented with the global result of all effects exerted by all its components on one another.

The result of an interaction is what we call a gestalt. This has raised the problem of how a gestalt can be described as a lawful process. Causality is the only way we have to describe the lawful influence of things on one another, but the concept of causality by its very nature is linear. Therefore, gestalt theory, in attempting to describe the internal structure of a gestalt with some precision, has had to limit itself to speaking of linear relations between the whole and the parts and between parts and parts. But this is obviously a poor simplification and a mere approximation of what takes place when an interaction occurs, when, for example, we attempt to grasp the overall effect of a successful painting. The abundant but also articulate structure revealed at such an occasion prevents us from assuming that when a structure is unreachable by linear causality, it should be called devoid of lawfulness or perhaps irrational. The question arises whether it might be possible to reshape the concept of causality to make it accessible to other than linear relations. (See "Interaction—Its Benefits and Costs" in this book.)

Is it entirely out of place to be reminded here of the similar dilemma troubling quantum physics? The dichotomy between continuity and discontinuity seems to leave the image of quantum physics marred by a "black box," a gap in the structure of the atom, which interferes with its lawfulness as a whole. Yet there is weighty evidence to convince us that, on the contrary, the structure of the atom, displaying beautifully symmetrical shapes from the simplest to the most complex, is the matrix from

which the entire variety of our physical world is generated. In an impressive demonstration to this effect, Victor F. Weisskopf points to models of confined electron waves, which determine the behavior of the various atoms:

> They also help us to understand how atoms combine to form molecules and how atoms form regular arrays in crystals. The simple beauty of a crystal reflects the fundamental shapes of the atomic patterns on a large scale. Ultimately, all the regularities of form and structure that we see in nature, ranging from molecular structure to the hexagonal shape of a snowflake or the intricate symmetries of living forms in flowers and animals, are based on the symmetries of these atomic patterns. The world abounds in characteristic forms and shapes, but only quantum mechanics can tell us—at least in principle—where they all come from. (1989, p. 87)

Does this exalting perspective encourage us to expect, as Albert Einstein never ceased to hope, that it will be possible to overcome the dichotomy separating in today's minds what obviously belongs together? Only the future will tell.

REFERENCES

Arnheim, Rudolf. 1966. "Perceptual Analysis of a Symbol of Interaction." In *Toward a Psychology of Art*. Berkeley and Los Angeles. University of California Press.

————.1969. *Visual Thinking*. Berkeley and Los Angeles: University of California Press.

Bohr, Niels. 1961. *Atomic Physics and Human Knowledge*. New York: Science Editions.

Einstein, Albert. 1920. *Über die spezielle und die allgemeine Relativitätstheorie*. Braunschweig: Vieweg.

Freud, Sigmund. 1941. "Abriss der Psychoanalyse." In *Schriften aus dem Nachlass*. London: Imago.

Fung, Yu-Lan. 1960. *A Short History of Chinese Philosophy*. New York: Macmillan.

Henle, Mary. 1986. *1879 and All That: Essays in the Theory and History of Psychology*. New York: Columbia University Press.

Holton, Gerald. 1970. "The Roots of Complementarity." *Daedalus* 99, no. 4, pp. 1015–1055.

James, William. 1890. *The Principles of Psychology*. New York: Dover.

Miller, Arthur I. 1984. *Imagery in Scientific Thought*. Boston: Birkhäuser.

Murdoch, Dugald. 1987. *Niels Bohr's Philosophy of Physics*. Cambridge: Cambridge University Press.

Weisskopf, Victor F. 1989. *The Privilege of Being a Physicist*. New York: Freeman.

INTERACTION
Its Benefits and Costs

THE HUMAN MIND pays a price for every step in the progress of knowledge. As long as little is known about the many things the world contains and about the many ways they act on one another, the mind's conception remains limited to a few comprehensive elements and principles and to the simple relations combining them. But as our knowledge of the complexity of the world around us grows, the mind conceives of ever more elaborate interrelations. The task becomes more difficult but also more interesting, and our image of what exists becomes increasingly adequate.

An outstanding example of the changes and challenges such progress entails is the basic shift of human thinking from discontinuity to continuity, from summation to interaction, from particle to wave. This change involves an overhaul that continues to haunt us. At an early level, the human mind conceives of the world as made up of self-contained objects acting on one another in empty space. The finest presentation of this conception is a Latin poem of the first century B.C., *De Rerum Natura*, by Lucretius, who summarizes the atomic theory of Leucippus and Epicurus. "All nature therefore as it is in itself is made up of two things, for there are bodies and there is void, in which these bodies are and through which they move this way and that" (Lucretius, 1924, p. 31). From these basic building blocks the entire variety of actual entities derives: "So much can elements do, when nothing is changed but order; but the elements that are the beginnings of things can bring with them more kinds of variety, from which all the various things can be produced" (Lucretius, 1924, p. 61).

The advantage of such an approach are obvious. The mind proceeds from the comfortable base of persistent, immutable elements. On this base the fanciest structures can be erected as from a set of building blocks. This

holds true for creations of the mind as well as for handiwork. Early art, for example, composes its figures from simple arrangements of geometrical elements—circles, rectangles, straight lines—and tends to fuse them only later into more complex wholes (Arnheim, 1974, p. 191).

Although this worldview has remained attractive through the ages, there were indications even in antiquity of an awareness that atomism could not be the whole story. The agglomeration of invariant elements could not account for the fact that all things are in flux. The pre-socratic philosopher Heraclitus is reported to have said: "Upon those that step into the same rivers, different waters flow. . . . It scatters and gathers. . . . It comes together and flows away. . . approaches and departs" (Kirk & Raven, 1963, p. 196). More explicitly, the Taoist philosopher Chuang Tzu has the river god ask whether it is all right to call heaven and earth large but the tip of a hair small and receives the following answer:

> No, within the world of the real things there exist no limited standards, no standstill of time, no lasting situation; beginning and end cannot be taken hold of. Therefore he who possesses the highest wisdom surveys in the same manner what is distant and what is close by, so that the small things do not seem inferior, the large ones not important. He recognizes that there are no firmly confined standards. (Chuang Tzu, 1964)

This early awareness of relativism was the direct consequence of a dizzying worldview according to which everything depended on everything else. As a positive step, this view presented interaction as an unavoidable condition of an adequate description of reality. But it took Western science and the physicists of the nineteenth century to define the electromagnetic field as the tangible prototype of such a condition. James Clark Maxwell overturned the notion of action at a distance taking place in empty space and replaced it with a field theory whose "essential element is the description of changes that spread continuously through space in time" (Infeld, 1950, p. 11).

Similar discoveries imposed themselves in biology and the social sciences and found their theoretical underpinning in the gestalt psychology of our own century. Gestalt theory demonstrated experimentally that it was not possible to do justice to a field situation by reducing it to its elements. Misinterpretation was invited when such elements were described separately and the sum of the descriptions was presented as an adequate account of the whole. Nothing short of the total structure involving the interaction of all its components would suffice.

Not by coincidence has such interaction been observed and practically reckoned with particularly in the arts, for it is in sensory perception that

interaction is most tangibly evident. To quote just one example selected at random: Henri Matisse notes that "a glass of water with a flower is different from a glass of water with a lemon. The object is an actor: a good actor can have a part in ten different plays; an object can play a different role in ten different pictures" (Matisse, 1972, p. 247). Matisse's primary concern here is not with the practical functions the glass of water performs when it feeds the flower and dilutes the lemon juice; rather, Matisse is preoccupied with the different appearance of shape and color an object displays in different pictorial contexts, even though it remains identifiable in all of them.

The arts also effectively demonstrate that by talking about interaction, one does not refer primarily to the kind of free-for-all exemplified by the Brownian motion of microscopic particles. On the contrary, such "universal interactionism," as Wolfgang Köhler called it, is rare. It amounts to a homogeneous but chaotic texture about which little more can be said. It is not useful for a discussion of relativism because it does not admit isolable components among which such mutual dependence could be shown. Instead, the highly structured organization of works of art insists on the need to consider the relations between whole and parts. Any successful work of art relies on an overall pattern, more often than not a hierarchic one. In such a pattern, a dominant theme controls the subordinate subwholes (Arnheim, 1988). These subwholes, in turn, are not simply brought about by the dominant pattern but possess structures of their own. Their substructure gives them some self-containedness, which, however, exists only in interaction with the whole. It is an intricate principle of composition enabling works of art to function as conveyors of meaning. The same is true for biological structures such as the bodies of organisms.

Highly organized structures of this sort serve furthermore to show that while interactive fields make their components dependent on one another, they also counteract any plurality of appearance and meaning in the elements. In a painting, for example, the shape, brightness, and color of any part are strikingly influenced by its surroundings; but this very setting of surrounding features also keeps a firm grip on each part, stabilizing it and committing it to the single meaning the artist has selected for it. Similarly in biology, the shape and function of each organ are strictly controlled by the body as a whole.

An enlightening difference exists between these perceptual and biological examples and the typical electromagnetic or gravitational field. A physical field tends to be generated by one or several focuses of energy determining what happens everywhere else in the field. "The simplest example is an electric field of an electric charge that exerts a force on another charge

when the latter falls within its range" (Weisskopf, 1988, p. 70). Although each point of a field can be characterized by two arrows or vectors, as Infeld points out (1950, p. 114), such a description makes sense only as the effect of the focuses controlling the field. A similar description, however, is not sufficient for a perceptual field. In a painting, each isolable component is not determined merely by the influences from its surroundings but equally by properties of its own that are generated by the corresponding physiological stimulus. A square-shaped element, for example, is brought about by the corresponding configuration of shapes in the retinal image. Similarly, the color and brightness of a spot are due to the corresponding optical and neural excitation.

These physiological determinants act essentially in an independent, nonrelativistic fashion. Once represented in consciousness by their mental equivalents, percepts are subject to all the influences of the gestalt context. But the effects of what the unit owes "as such" to its physiological counterpart can never be neglected as a determining factor in the interaction of the whole. One can ascertain the brightness and hue of a spot in isolation from its context by measuring the spot with a photometer or colorimeter, which compares it with the standard of the instrument. One can also measure the psychological effect of interaction on a particular section of the visual image, as demonstrated, for example, by Josef Albers (1963). In each case, however, the unit's own character contributes to the strictly determined interaction of the whole.

Are there field situations in which interaction is generated exclusively by the interrelation of the parts? The example of atonal music comes to mind because it abandons the tonal center, which serves traditionally as the base of reference for the pitch distances within the scale. These distances determine the dynamic tension on which the musical expression of pitch relations is based. But it seems impossible to conceive of relations between elements that possess no character of their own. What would one be relating to what? In fact, no atonal music is conceivable in which the elements of the scale would be neutral in themselves and would depend entirely on relations. Even when music abandons the tonal center, it does not and cannot give up the inherent dynamic qualities of the intervals, which depend on such physiological auditory conditions as those of the octave or the fifth. The particular qualitative differences between what, for lack of better terms, we call consonance and dissonance are properties of the auditory conditions as such, not simply created by tonality or other musical systems. And it is those inherent qualitative traits from which any atonal music must derive its expression.

Interaction raises a theoretical difficulty when one asks how field situ-

ations can be dealt with by the principle of causality. We are accustomed to thinking of causal happenings as one-dimensional, that is, as sequential chains of events. Interactive fields, or gestalten, however, are often two- or three-dimensional. Does causality stop short of fields? (See "Complementarity from the Outside" in this book.) The problem becomes manageable when we remember that the traditional view of causality has a further limitation: causality is thought of not only as operating in one dimension but also as occurring to a sequence of isolated entities, one pushing against another. Here the physicist and philosopher Ernst Mach helps us with useful observations. "The traditional idea of causality," he writes, "is somewhat unwieldy: one dose of cause is followed by a dose of effect" (Mach, 1985, p. 73). We are thinking of causality in atomistic rather than interactive terms by picking isolated items from the coherent flow of events. Not only that, but we are limiting causality to a one-way street rather than considering that when it is interactive, it often works both ways, forward and backward (Mach, 1985, p. 74). For example, in the interaction between teacher and student or therapist and client a dominant vector acts in one of the directions without excluding the other. The relation affects not only the recipient party but the "causative" one as well.

In the statement by Matisse quoted previously, he confesses that he always refused to try to learn chess. "I can't play with signs that never change. . . . If you were to put little figures which look like so-and-so or such a one, people whose life we know, then I could play; but still inventing a meaning for each pawn in the course of each game. . . . The sign is determined at the moment I use it and for the object in which it must form a part. For this reason I cannot determine in advance signs which never change" (Matisse, 1972, p. 248).

Once causality is understood in an interactive way, the main obstacle is removed for the step from one-dimensional to multidimensional causality. Lawfulness does not stop when one moves beyond linear relations. Nevertheless, a further grave conceptual difficulty remains. Although it is easy to envisage interaction in the perceptual and physiological areas, such interaction is excluded in principle from intellectual reasoning. By definition the intellect operates with networks of self-contained entities and their interrelations. The networks are made up of linear, though often multiple connections. To account for interactive fields, the intellect can do no better than trace the "lines of force" constituting the skeleton of the structure. Elsewhere I have shown that discursive analyses of interactive situations are limited to four devices: mutual bombardment, circularity, networks, and hierarchic differentiation (Arnheim, 1966). Gestalt theory, for example, "had to limit itself to speaking of linear relations between the whole

and the parts and between parts and parts; but this is obviously a poor simplification and a mere approximation of what takes place when an interaction occurs." (See this book, "Complementarity from the Outside.") Similarly, when we deal with the inexhaustible complexity of a work of art, we must limit ourselves to discovering its principal centers, to descending the ladder of hierarchic layers as much as we care to, and to pursuing specific relations, guided always by what we have perceived of the full structure. These are the boundaries that confine the human intellect in all its exploits.

What, then, is the outcome of our investigation? We recognize that acknowledging interaction has immeasurably stretched our understanding of how our world is organized and how it works. We can no longer afford the much handier conceit of a world of stable units and their interrelations. Yet it is this conception of stable elements to which the intellectual department of the mind confines us. Direct experience, such as that of sensory perception, opens the mind to the variety of appearances and interpretations to which every fact we know is liable. Relativism cautions us against dogmatism, but it must remain equally far from implying that any one particular reading is as good as the next. No room exists for arbitrary interpretation of the way interactive fields derive from objectively stable bases, the generators of the forces to which interaction is due in the first place; and strict determination must be made of the ways in which the components of a whole control one another. Thus, it is our duty in each case to search for the most fitting description of the structure we happen to face.

REFERENCES

Albers, Josef. 1963. *Interaction of Color*. New Haven, Conn.: Yale University Press.

Arnheim, Rudolf. 1966. "Perceptual Analysis of a Symbol of Interaction." In *Toward a Psychology of Art*. Berkeley and Los Angeles: University of California Press.

_____. 1974. *Art and Visual Perception*. Berkeley and Los Angeles: University of California Press.

_____. 1988. *The Power of the Center*. Berkeley and Los Angeles: University of California Press.

Chuang, Tzu. 1964. *Basic Writings*. New York: Columbia University Press.

Infeld, Leopold. 1950. *Albert Einstein*. New York: Scribner.

Kirk, G. S., and Raven, J. E. 1963. *The Pre-Socratic Philosophers*. Cambridge: Cambridge University Press.

Lucretius. 1924. *De Rerum Natura*. Cambridge, Mass.: Harvard University Press.

Mach, Ernst. 1985. *Die Analyse der Empfindungen und das Verhältnis des Physischen zum Psychischen.* Darmstadt: Wiss. Buchgesellschaft.

Matisse, Henri. 1972. *Ecrits et propos sur l'art.* Paris: Hermann.

Weisskopf, Victor F. 1988. *The Privilege of Being a Physicist.* New York: Freeman.

WHAT IS GESTALT
PSYCHOLOGY?

E ARLY IN THE twentieth century, gestalt psychology developed as an amendment to the traditional method of scientific analysis. The accepted way of analyzing a complex phenomenon scientifically had been that of describing the parts and arriving at the whole by adding up the descriptions thus obtained. But work in biology, psychology, and sociology had begun to suggest that such a procedure could not do justice to phenomena that were field processes, that is, entities constituted of interacting forces. The need for a revision was felt first in the life sciences but inevitably extended to the physical sciences as well. Gestalt psychology thus became a component of a more broadly conceived gestalt theory that concerned scientific method in general.

This extension into the physical sciences became an integral aspect of the gestalt approach for two reasons. First, many psychological phenomena, especially those in sense perception, could be described but not explained by what was observable at the level of conscious experience. Although it was possible to determine by laws or rules which conditions led to which consequences, the only way to indicate the causes of such happenings was by reference to the physiological counterpart of the observed phenomena. As early as 1912, Max Wertheimer, in his monograph "Experimentelle Studien über das Sehen von Bewegung" (Experimental Studies on the Perception of Movement), offered a physiological explanation for the psychological phenomenon of "illusory motion." When immobile light signals follow one another in sequence, they are experienced as the unitary displacement in space of a single light. Wertheimer suggested that this perceptual effect, similar to the one that creates the sensation of motion on the movie screen, might be explained by "cross-connections" in the brain, a kind of short circuit between stimulations in the corresponding physio-

logical field. This hypothesis later led to extensive experimental studies by Wolfgang Köhler of brain correlates for perceptual properties such as size, shape, locomotion, and location (1969, chap. 3). Even though the specific physiological mechanisms cited by Köhler are still controversial, the principle of parsimony suggests that if gestalt processes are observed in perceptual experience, analogous processes are likely to account for them in the brain.

This procedure, then, implied a parallelism between psychological experience and correlated processes in the nervous system. The laws governing the functioning of the brain and, by extension, the physical universe in general were assumed to be reflected in mental activity as well. Such a view—and this is the second reason for gestalt psychologists to stress the link with the physical sciences—made it possible to coordinate the functioning of the mind with the organic and inorganic world as a whole. The alternative was to consider mental activity as happening on an unrelated island, subject to laws of its own or to no laws at all.

In psychology textbooks the gestalt approach is often exemplified by Max Wertheimer's "rules of grouping," which were readily accepted because easily reconciled with the traditional approach of describing the structure of visual patterns "from below" as the combination of elements. Wertheimer, however, had presented those rules only in preparation for what might be called a Copernican switch to a primary concern, "from above," with the total structure of phenomena. He gave examples in which an analysis derived from local relations between parts leads to erroneous predictions. Without reference to the organization of the whole, it is impossible to do justice to the structure of such patterns.

In his 1923 article "Untersuchungen zur Lehre von der Gestalt" (Laws of Organizations in Perceptual Forms), Wertheimer showed that the formation of gestalt patterns is governed by a principle best described as the simplicity tendency. The principle, which asserts that field processes tend to assume the simplest available structure, has been of great explanatory value, especially in the exploration of sensory perception. It shows, for example, why gradients and similar perspective distortions generate depth perception. Nevertheless, the simplicity principle alone is insufficient to account for perceptual gestalten. If it ruled unopposed, it would reduce percepts to an amorphous homogeneity, that is, to the limiting case of structure. What is needed as a counteragent is an anabolic tendency, which offers constraints to the organizing forces in the field (see "The Two Faces of Gestalt Theory" in this book). In perception, the principal supplier of such constraints is the world of stimuli impinging on the receptor organs of the senses, especially those of vision, hearing, and touch.

An example may illustrate the perceptual process as viewed by gestalt psychology. Let there be a physical framework holding four black balls erected in front of a white background as the stimulus target for an act of vision. The four balls will be held together by physical forces, which an engineer or architect would call structure. These physical forces, however, are not included in what is transmitted by the reflected light that carries the information from the stimulus object to the retinas of the viewer's eyes. What remains of the stimulus is the configuration of the four balls, which we will assume to be quadrate. The configuration carried by the flow of light is not a structure because its four elements are not held together by dynamics of any kind. Physically, the configuration is not a gestalt. Nevertheless, it exercises decisive control over the eventual percept by introducing the external constraint to which the organizing forces in the receptor field must conform, at least as long as the stimulation persists.

At the retinal level, little, if any, of the gestalt organization takes place. (The more recently discovered receptive fields in the retinas or the cerebral cortex of animals do not activate gestalt processes.) At the higher levels of the visual apparatus, the stimulus configuration constrains the physiological field process, which is primarily determined by the tendency toward simplest structure; that is, the physiological counterpart of the percept assumes the simplest structure compatible with the stimulus situation. A gestalt has come about through the interaction between the stimulus configuration and the organizing powers of the visual field. Needless to say, the perceptual process takes place in the context of a larger gestalt, namely, the human mind as a whole. Pertinent memory traces modify percepts through recognition, and motivational tendencies influence selection.

Gestalt structures vary all the way along a continuum extending between two hypothetical poles. At the one extreme, a state of total interaction would exist at which a maximum of entropy in the system would make for amorphous homogeneity. At the other extreme, the parts of a whole would be totally independent of one another so that what happened at one place in the constellation would have no effect on the remainder. Within these limits, subwholes come in all degrees of penetrability. Colors, for example, influence each other strongly. So-called optical illusions show the disturbing effects of a field structure on particular shapes. Nevertheless, strong perceptual shapes, such as circular or spherical ones, may be as unmodifiable as a piece of wood floating on water. Split personalities or split brains illustrate the effect of constraints that are strong enough to preclude all interaction among components of a gestalt.

In typical gestalten, boundary conditions of different degrees of permeability make for an endless variety of structures. One should be wary,

however, of the one-sided formulation that in gestalt structures the whole determines the parts. A one-sided stress on the approach from above was justified in the early days of the campaign against the description of entities from below. Actually, something much more complex takes place. The structure of the whole, certainly of dominant importance, is influenced by the parts, which in turn depend on the whole as to their shapes and interrelations. Neither the whole nor the parts are primary constants, primordial executives of influence. Rather, all components from the whole to the smallest detail exert their modifying effect, while they are being modified (Arnheim, 1966). Within the local boundaries, which organize complex gestalten, subordinated structures create their own smaller gestalten, dependent though they remain on their surroundings.

A successful work of art, for example, has its own completeness but changes its character when it is seen in the broader context of the artist's total lifework, the historical setting in which it came about, or the cognitive and motivational traits of the person who made it. As a perceptual analogy one may cite the "embedded figures" whose own identity can be made to vanish through the influence of the context (Gottschaldt, 1926). As a practical consequence, the range of a problem singled out for investigation cannot be arbitrarily staked out but depends strictly on what is relevant for the processes under scrutiny. To discover the proper range of a problem is nearly tantamount to finding its solution.

Interaction in a gestalt context is the very opposite of the functioning of machines, in which, in Köhler's conception, "the form of action in the system is entirely prescribed by the constraint" (Köhler, 1947, chap. 4). All action takes place along preordained channels. In this respect, machines resemble the networks of defined concepts that constitute intellectual reasoning, such as scientific theories. Note that although field processes in psychology and elsewhere must be understood as gestalten, a scientific statement itself can by its very nature never be a gestalt. Gestalten exist in perception, in mental imagery, in the dynamics of the human personality, in physiological and physical states of interaction, but they can be conceptualized only through networks of relations. Gestalt psychology therefore cannot request that scientific constructs take the form of gestalten; but it requires that those constructs do justice to the gestalten they describe by reflecting the hierarchic differences between central and subsidiary position, relevant and irrelevant relations, the correct orientation of dynamic vectors, the strength of boundaries, and so on. The validity of the scientific description depends on how faithful an equivalent it offers, with its own means, of the gestalt structures the description undertakes to match.

Gestalt structure extends in the time dimension as readily as in the space dimensions, and the principles governing time and space are similar. The gestalt analyses of spatial relations had very little competition, but when it came to sequences in time, gestalt psychology had to cope with a powerful tradition that explained all temporal connections by the laws of association. In the tradition's original form, for example, in Aristotle, associative connections were based on "something either similar or contrary to what we seek" or else on "that which is contiguous with it." Such criteria were compatible with the gestalt effort to derive connection from structural organization. But when, more recently, it was asserted that associations come about by mere frequency of occurrence, gestalt psychologists objected. They realized that a doctrine according to which if one thing had been the neighbor of another often enough, the two could become associated replaced meaningful belonging with a whimsical subjectivity.

Gestalt psychologists denounced conditioning by mere repetition as the lowest form of learning and opposed it with learning through understanding. Productive learning was asserted to occur when a person or animal acted according to the demands of a given structure. Just as in a simple perceptual situation certain elements "clicked" because they were fit to produce a mutual completion, so could effective learning come about only when the learner perceived the connections among the decisive elements of a given situation. To understand the functions of such connections—for example, for a chimpanzee to understand that a stick could be used to reach a banana outside the cage—was to learn by "insight." Such insight could occur at the simple level of purely perceptual affinity as well as at the highest level of scientific intuition.

A decisive difference between the purely perceptual grasp of a given structure and a "problem situation" in the more particular sense of the term should be mentioned here. In simple perception, problem-solving is limited to finding the structure inherent in the stimulus data. A harder task challenges the observer when a situation presents itself as organized in a way that conceals the connections needed for a solution. Sometimes a lack of order and unity in the given percept provides the incentive for the search. In other cases, a discrepancy between the percept as given and the image of the goal situation to be attained generates the tension that presses for the solution. Restructuring may consist in merely looking at the situation differently or may require an actual rearrangement of the components.

The restructuring of a gestalt is an eminently dynamic activity of field forces, but so is all structuring. In fact, a structure by definition never ceases to be a constellation of forces. Just as an apparently stable social

pattern, such as a family group, always remains a more or less balanced arrangement of various motivational forces, a perceptual pattern, a piece of music, or a picture is apprehended as a system of variously directed vectors. A perceived structural pattern of forces is called the pattern's expression. Expressive qualities are authentic and objective properties of all percepts. They can even be called the primary qualities conveyed by perceptual shape, size, movement, intensity, rhythm, and so on. They are what is perceived first. Thus, primitive physics is based on expressive qualities.

The immediacy and directness of the dynamic effects observed in naive experience are gradually emended by the discoveries of natural science. Even so, gestalt theory continues to possess, perhaps as its most characteristic aspect, a profound respect for the "givenness" of the world as an objectively existing cosmos held together by law and order. The scientific approach of gestalt theory has been pervaded, therefore, by a philosophy that must be called optimistic and trustful, as distinguished from a skepticism that is more in fashion but not necessarily closer to the truth.

REFERENCES

Arnheim, Rudolf. 1966. "Perceptual Analysis of a Symbol of Interaction." In *Toward a Psychology of Art*. Berkeley and Los Angeles: University of California Press.

Gottschaldt, Kurt. 1926. "Über den Einfluss der Erfahrung auf die Wahrnehmung von Figuren." *Psychologische Forschung* 8, pp. 261–317.

Köhler, Wolfgang. 1947. *Gestalt Psychology*. New York: Liveright.

_____. 1969. *The Task of Gestalt Psychology*. Princeton, N.J.: Princeton University Press.

Wertheimer, Max. 1912. "Experimentelle Studien über das Sehen von Bewegung." *Zeitschrift für Psychologie* 61, pp. 161–265.

_____. 1923. "Untersuchungen zur Lehre von der Gestalt." *Psychologische Forschung* 4, pp. 301–350.

THE TWO FACES
OF GESTALT THEORY

GESTALT THEORY, IMPORTED from Germany, began to haunt American psychology in earnest with the publication of Kurt Koffka's systematic treatise on the principles of gestalt psychology (1935). The immigration of its leading figures, Wolfgang Köhler, Max Wertheimer, Kurt Koffka, and Kurt Lewin, confirmed the presence of this innovative school of thought, although its principles were rarely used as working tools in the practical business of the profession. Gestalt psychology was treated rather as a curious facet of the total panorama. In the following years, some of its contributions were metabolized into the experimental practice and into the theoretical thinking of more established approaches and vanished thereby from public discernment, while at the same time it maintained its niche in historical surveys. Potentially helpful insights, however, do not remain submerged in the long run, and a recent substantial collection of papers (Kubovy & Pomerantz, 1981) was willing to call itself "the first volume devoted to perceptual organization since Köhler's last book, *The Task of Gestalt Psychology*, was published in 1969."

Nevertheless, enough time has gone by to break the personal continuity between the original team of gestalt psychologists and a new generation whose curiosity is perhaps less impeded by conservative prejudice but that relies on written and mostly secondhand source material rather than on direct communication. Thus, when those who trained under the founders of gestalt psychology read what is being said about gestalt theory today, they are often overcome by the sense of strangeness experienced when one meets familiar persons or places in a dream. In the following I am at-

First published in *American Psychologist* 41 (July 1986), pp. 820–824.

tempting to describe some of the discrepancies that account for this lack of ready recognition.

The average student is exposed to gestalt psychology only through isolated references to a few pieces of research, such as Köhler's investigation of problem-solving in chimpanzees or Wertheimer's rules of perceptual grouping. There is no explicit indication of how and in what context these studies derive from a common matrix. Students also learn to identify gestalt psychology with the slogan "The whole is more than the sum of the parts," which reduces the relation between whole and parts to a purely summative matter. This contradicts the very nature of gestalt theory. To do the theory justice, two principles need to be cited, namely, first, the fact that in field processes the structure of the whole interacts with that of its components and, second, the assertion that gestalt patterns tend toward the simplest, most regular, most symmetrical organization available under the given conditions. Both these principles are cited in fact in more sophisticated discussions of gestalt theory, yet how they belong together is by no means obvious. In much professional writing on the subject, the discussion focuses on one of the two principles with little consideration of the other—a fateful limitation because the relation between the two leads to the very core of the gestalt conception.

The statement about the relations between the whole and the parts has been reduced in experimental practice to the question, more compatible with traditional approaches, of what rules make the elements of perceptual patterns add up to larger units or segregate them from one another. Wertheimer's rules of visual grouping (1923) served as an alternative to the traditional Helmholtzian theory according to which perceptual grouping is derived from the combinations most frequently met in the environment. By using only the first part of Wertheimer's paper, one could interpret his rules in a strictly traditional, nongestalt way. They were then nothing but relations between elements, determined by factors such as distance, size, direction, or movement. Such an approach also reduced the difference between patterns at varying levels of complexity, symmetry, or regularity to a mere static morphology, an assortment of shapes whose presence and particularity were taken for granted. Their characteristics could be quantified by counting the number of their elements or symmetry axes or by measuring the amount of information required to construct them (Hochberg & McAlister, 1953; Garner, 1970).

Approaches such as these did not refer to the gestalt dynamics that gives rise to structurally distinguished shapes in accordance with the principles cited above; and although the quantitative indicators proposed in those studies did indeed serve to define levels of complexity by objective mea-

surement, they did so at the price of neglecting the structural qualities that characterize shapes perceptually and account for their general psychological relevance. So total was this neglect that in one of the most frequently cited studies of the subject (Attneave & Arnoult, 1956), the authors proposed to systematize and quantify the formal and relational gestalt factors by constructing "nonsense shapes" from random sets of elements and by assuming that when such sets were inserted in equally arbitrary larger contexts, they represented a common "stimulus-domain" on the basis of which experimental observations could be generalized. No more radical disavowal of the very phenomena the study purported to measure is conceivable.

When in recent investigations authors referred to what I called the second gestalt principle, namely, the tendency to simplest structure, they again endeavored to deprive it of its dynamics by describing it as a striving toward minimization, a preference for parsimoniously reduced shape. Thus, Attneave proposed to replace the gestalt principle with a system of his own: "Suppose that what the system *likes* is short descriptions and that the image is progressively changed, within the constraints of the input, until its description is minimized" (1981, p. 417). And James Pomerantz and Michael Kubovy (1981, p. 437) explain that in order to describe or model the world "in the simplest, best, or briefest way it can," perception not only capitalizes on regularities and redundancies in the world but also eliminates them from perceptual representation. For example, they explain, "when the system is presented with a symmetrical figure, it will (say) not represent both sides of the axis of symmetry in memory" (1981). Thus, once again, structure is reduced to quantity, and thereby the phenomenon to be accounted for is replaced by its very opposite.

In the thinking of the gestalt psychologists, the feature they could never lose sight of was the dynamic striving of systems toward a balanced state. Even when they concentrated on special problems of visual perception, they always viewed them as handy and concrete paradigms of action patterns ruling physical nature as well as biological and mental functioning quite in general. When Köhler (1966, chap. 8) formulated what he called the law of dynamic direction, according to which systems strive toward a state of equilibrium and potential energy reaches a minimum, he referred to physical and biological processes from which the corresponding psychological phenomena derived secondarily; and when he discussed the tendency toward simple, regular, and symmetrical shape, he used observations by physicists such as Ernst Mach and Pierre Curie to show that those handsome shapes were the necessary manifestation of the striving toward equilibrium. It took field processes, in which the whole and its

components interact, to give the tendency of "dynamic direction" a chance to exert itself, and it was this tendency that generated the "simple" shapes. This is what I meant earlier when I said that unless the two principal statements identified with gestalt theory are seen as referring to inseparable aspects of the same process, they lose their meaning.

Gestalt psychologists could not afford to think of those "simple" perceptual shapes merely as one species of visual patterns among others. Rather, from the beginning they paid homage to their biological and cognitive value. Köhler observed, "Let us distinguish between regulation as such, e.g., a tendency of a system to reach a standard status from various initial constellations, and regulation in a more special sense in which the standard status has particularly valuable properties, as for instance in the organism" (1966, p. 228). Those standard states were the outcome of gestalt processes promoting optimal functioning. Their cognitive virtues became a matter of prime interest to the German gestalt psychologists of the postwar generation. One of their leading representatives, Edwin Rausch (1966), characterized them in a programmatic analysis as offering distinctive and lawful order, the "pure embodiment of essence" as well as clarity, simplicity, and integrity. The very term *gestalt* indicates in German a sublimated or exalted shape or form. Works of art and music were frequently cited in the gestalt literature as outstanding examples of gestalten, not only because they depended so obviously on perfect structural organization but because they purified perceptual form to obtain the clearest and most incisive expression of the work's meaning. In this sense, Koffka wrote in the conclusion to an essay on the psychology of art, "A work of art presents a part of the world in such a way that the reality of this part, be it large or small, is epitomized by what I called its purity" (1940, p. 271). It is because of these functional values of organized structure that Wertheimer came to speak of "good" gestalten—a term that otherwise would make little sense. I shall show that for the same reason the term *prägnant*, so unrelated to its meaning when transferred from the German to the English language, came to be used as a synonym of the basic gestalt principle.

At this point it is necessary, however, to refer to a fundamental insufficiency from which the presentations of gestalt theory seem to me to have suffered from the very beginning. The shapes that make up the visual world cannot be generated by the tendency to simple structure alone. That tendency explains why shapes, once they exist, organize in certain ways, but it does not tell why they exist in the first place (Arnheim, 1974, chap. 9). If the tendency to simple structure had its way unopposed, it would create nothing better than a homogeneous field like lumps of sugar dissolved in water. Gestalt theory must provide for a countertendency, equal

in rank to the one promoting simplest structure, a tendency that articulates shapes. Only the constant interaction of both these complementary tendencies can account for the shapes of perception. Otherwise not even the most elementary phenomenon, the distinction between figure and ground, will find an explanation.

Of course, the need for articulation has been noted in the literature, and the predicament resulting from the one-sidedness of the simplicity principle became apparent. Wolfgang Metzger pointed out that with increasing simplification visual objects can become unfaithful to their original shape and that the gestalt "improvements" impair the validity of sensory information by "preventing us from seeing what is really there" (1975, p. 212). A one-sided conception of the gestalt dynamics made the percept look as though it unfolded like a flower, beautiful in its symmetry but unconcerned with its duties as an organ of information.

Köhler mentioned the problem in occasional observations. In an early paper he stated that a satisfactory theory of visual perception would require "knowledge of the particular concrete forces and events that balance one another in the optical sector" (1925, p. 197). But he did not develop the request to the point of specifying those forces and events to give them the needed status of a major countertendency in the theory. Koffka more explicitly spoke of "two kinds of forces, those which exist within the process in distribution itself and which will tend to impress on this distribution the simplest possible shape, and those between this distribution and the stimulus pattern, which constrain this stress towards simplification" (1935, p. 138). Borrowing from physics "certain maximum-minimum principles," Koffka asserted that "in psychological organization either as much or as little will happen as the prevailing conditions permit" (1935, p. 108). A minimum simplicity, he said, "will be the simplicity of uniformity, a maximum simplicity that of perfect articulation" (1935, p. 171). He weakened the usefulness of this distinction, however, by describing the two tendencies as alternatives rather than as antagonists inherent in every perceptual event: "When the organism is active, at a high degree of vigilance, to use Sir Henry Head's term, it will produce good articulation; when it is passive, in a state of low vigilance, it will produce uniformity" (1935, p. 173).

The prime illustration of what was needed for the theory was available in a paper by Friedrich Wulf (1922), undertaken under Koffka's guidance as a response to Georg Elias Müller's (1913) analysis of memory images. Müller had suggested that memory images dissolve over time into a state of increasing shapelessness—a conception we now recognize as an analogue of the entropy principle, the degradation of matter in thermodynamics. Wulf reported instead that when he used ambiguous figures, memory im-

FIGURE 40.
From Rudolf Arnheim, *Art and Visual Perception*, 1974.

ages displayed not only a tendency to "normalization," that is, an increasing resemblance to familiar objects, but also and more strikingly a deviation from the stimuli in two opposite directions. The resulting images simplified the model figures either in the direction of more regular, balanced, symmetrical shapes (leveling) or by accentuating their asymmetries in the direction of more clearly articulated shape (sharpening). That is, observers modified their memory images toward either decreasing or increasing figural tension and thereby weakened or strengthened the individual particularities of the patterns. Although Wulf's paper generated considerable controversy (Woodworth, 1938, chap. 4), its basic assertions were also supported (Goldmeier, 1941). The leveling tendency is familiar from much experimental evidence, and instances of sharpening have been reported, for example, in studies on the formation of rumors (Allport & Postman, 1954, pp. 399–401). Art historians distinguish periods of Classicism, with their emphasis on simplified form, from periods of Expressionism, with their emphasis on intensified dynamics.

Figure 40 shows a slightly asymmetrical stimulus (a) and deviations in the direction of leveling (b) and sharpening (c). In either deviation, both tendencies are at work, although in a different ratio. The two prongs of the figure resist the pressure toward further tension reduction by maintaining their aggressive push outward and upward. But even when in (c) their inequality is sharpened and tension thereby increased, the countertendency toward equilibrium tends to balance the size relation between the prongs in such a way that the dominance of the one over the other is neither arbitrarily excessive nor ambiguously slight. This aesthetic aspect of shape formation, familiar to every artist but active in all perception, characterizes perceptual shape as the product of a highly dynamic process in which a tendency toward tension-increasing articulation interacts with the countertendency toward equilibration in each case.

Where do the two antagonistic tendencies originate? The tendency toward tension-reducing equilibration is, as I mentioned, a general law of nature active in the physical world and reflected in perceptual experience. Correspondingly, the countertendency responsible for the articulation of

segregated objects resides in the physical, ultimately gravitational and electrical forces that act in opposition to the homogenizing increase of entropy. This same interplay of field forces is expected by gestalt psychologists to operate in the nervous system. In addition, it is fed in perception by the input of physical shapes whose optical images are imprinted as stimuli on the eyes. This world of tension-increasing stimuli, the carrier of environmental information, is subjected to the shaping efforts of the equilibrating force, which simplifies and clarifies the incoming raw material. The ecological pertinence of the resulting percept will depend in each case on the validity of the optical projection and the extent to which the sharpening and leveling effects of perception do justice to the represented reality situation. It seems essential to notice here, however, that the input of externally generated stimuli is more than a set of constraints limiting the activity of an exclusive organizing tendency toward simplest structure. The very absorption of exogenous stimuli is a manifestation of the articulating counterforce, which in interaction with its antagonist constitutes perceptual organization.

We notice that both antagonistic or complementary tendencies constituting the gestalt process make the stimulus simpler, more clear-cut, more unambiguous. One of them increases symmetry and regularity and cleanses the stimulus of distracting, unessential detail; the other intensifies its characteristic features. As I mentioned earlier, it is this cognitive and aesthetic improvement of structure that made Wertheimer speak of "good" gestalten. It also led to the use of the term *prägnant*. A deplorable confusion therefore resulted when these terms were applied one-sidedly to the tendency toward equilibrium or minimization alone. In present-day German, *prägnant* means "clear-cut," "succinct," or "concise," and it is in this sense that Wertheimer used it nontechnically as one of his favorite adjectives. "Im prägnanten Fall," he would write, or "in sehr prägnanter Weise," meaning "in clear-cut examples" or "in a very clear-cut fashion." (In the English sense of "fraught with significance or implication" the term occurred in German usage only in the past, as when Gotthold Ephraim Lessing wrote in his treatise on the Laocoön that in order to represent an action most effectively, an artist should not select the climax but "the most pregnant moment from which the preceding and the following action is best understood" [1766, sect. 16]).

As a technical term, *prägnant* is used by Wertheimer (1923, p. 316 ff) when he distinguishes the clear-cut versions of shapes and shape relations from mere approximations and intermediate stages. Among geometrical figures, for example, the right angle as well as the typically acute or obtuse angles are primary percepts, whereas in-between sizes are seen as devia-

tions, "not quite right," unpleasantly off key. Generally in the writings of gestalt psychologists the term *prägnanz* is used sparingly to describe distinguished, most perfect structural states. In the index of Köhler's (1947) programmatic presentation of gestalt psychology, it does not appear at all. In the comprehensive collection of his essays, it is mentioned once and at a characteristic occasion when Köhler speaks, half in jest, about the obsessions of normal people: "Gestalt psychologists have often called attention to the fact that the products of perceptual organization tend to be most clearly structured. This is the main content of what the school has called the *Law of Prägnanz*. Actually, a more striking *Prägnanz* may be attained in the development of an obsession than has ever been found in mere perception" (1971, p. 409).

My attempt to set off the character of gestalt theory against the popular image it has taken on in our country may be summarized as follows: rather than limit itself to offering a method of combining and segregating perceptual shapes, gestalt theory is concerned primarily with the complex dynamics of organization in field situations, be they physical or psychological. This dynamics is not fully described by the tendency toward simple, regular, symmetrical structure but requires acknowledgment of a countertendency that meets tension reduction with tension enhancement. The countertendency articulates physical and psychological units or objects in interaction with the equilibrating force. And, finally, although gestalt psychologists in what may be called their polemical period had to concentrate many of their demonstrations and discussions on the organizational and self-regulatory aspects of gestalt structure, they were very much concerned from the beginning with the biological, cognitive, and aesthetic reward of gestalt processes, namely, the creation of well-functioning, stable, and clarifying patterns in nature, science, and art—a perfection difficult or impossible to obtain otherwise.

REFERENCES

Allport, Gordon Willard, and Leo J. Postman. 1954. "The Basic Psychology of Rumor." In *Public Opinion and Propaganda*. Edited by Daniel Katz et al. New York: Dryden.

Arnheim, Rudolf. 1974. *Art and Visual Perception*. Berkeley and Los Angeles: University of California Press.

Attneave, Fred. 1981. "Discussion on Hochberg." In *Perceptual Organization*. Edited by Michael Kubory and James R. Pomerantz. Hillsdale, N.J.: Erlbaum.

Attneave, Fred, and Malcolm D. Arnoult. 1956. "The Quantitative Study of Shape and Pattern Perception." *Psychological Bulletin* 53, pp. 452–471.

Garner, Wendell R. 1970. "Good Patterns Have Few Alternatives." *American Scientist* 58, pp. 34–42.

Goldmeier, Erich. 1941. "Progressive Changes in Memory Traces." *American Journal of Psychology* 54, pp. 490–503.

Hochberg, Julian, and Edward H. McAlister. 1953. "A Quantitative Approach to Figural 'Goodness.' " *Journal of Experimental Psychology* 46, pp. 361–364.

Koffka, Kurt. 1935. *Principles of Gestalt Psychology*. New York: Harcourt Brace.

———. 1940. "Problems in the Psychology of Art." In *Art: A Bryn Mawr Symposium*. Bryn Mawr, Penn.: Bryn Mawr College.

Köhler, Wolfgang. 1925. "Gestaltprobleme und Anfänge einer Gestalttheorie." *Jahresberichte über die gesamte Physiologie und experimentelle Pharmakologie* 3, pp. 512–539.

———. 1947. *Gestalt Psychology*. New York: Liveright.

———. 1966. *The Place of Value in a World of Facts*. New York: Mentor.

———. 1969. *The Task of Gestalt Psychology*. Princeton, N.J.: Princeton University Press.

———. 1971. *Selected Papers*. New York: Liveright.

Kubovy, Michael, and James R. Pomerantz. 1981. *Perceptual Organization*. Hillsdale, N.J.: Erlbaum.

Lessing, Gotthold Ephraim. 1766. *Laokoön, oder über die Grenzen der Malerei und Poesie*.

Metzger, Wolfgang. 1975. *Gesetze des Sehens*. Frankfurt: Kramer.

Müller, Georg Elias. 1913. "Zur Analyse der Gedächtnistätigkeit und des Vorstellungsverlaufes." *Zeitschrift für Psychologie*, supplementary vol. 8. Leipzig: Barth.

Pomerantz, James R., and Michael Kubovy. 1981. "Perceptual Organization: An Overview." In *Perceptual Organization*. Edited by Michael Kubovy and James R. Pomerantz. Hillsdale, N.J.: Erlbaum.

Rausch, Edwin. 1966. "Das Eigenschaftsproblem in der Gestalttheorie der Wahrnehmung." In *Handbuch der Psychologie*. Edited by Wolfgang Metzger, vol. 1. Göttingen: Hografe.

Wertheimer, Max. 1923. "Untersuchungen zur Lehre von der Gestalt II." *Psychologische Forschung* 4, pp. 301–350.

Woodworth, Robert S. 1938. *Experimental Psychology*. New York: Holt.

Wulf, Friedrich. 1922. "Über die Veränderung von Vorstellungen (Gedächtnis und Gestalt)." *Psychologische Forschung* 1, pp. 333–373.

PART VI

BEYOND THE DOUBLE TRUTH

IT SEEMS THAT religion is floating nowadays in a vacuum. At one extreme, there are the many who act as unbending believers of some particular established creed. They not only tend to deny the validity of any other faith, but they also insist on the truth of facts handed down to them by ancient scriptures. Whenever it is in their power, they persecute those who show them that their beliefs are not tenable. They punish them and destroy the proofs of their own ignorance. Because, however, it is no longer possible to exclude our scientific knowledge of nature from the functioning of our society, these dogmatic defenders of traditionally accepted facts remove religion to an island on which its doctrines languish by their segregation from the sources of vital experience.

This is the one extreme, the isolation resulting from blindness. At the other pole, there are those who identify religion in general with the orthodoxies to which they object. They realize that no one such doctrine should be given the power to impose itself on society, or, more radically, they hold that any such doctrine is in conflict with today's enlightenment. By identifying these orthodoxies with religion in its more general sense, they seek to ban religion altogether from the life of the nation, which amounts to trying to suppress one of the fundamental needs and urges of the human mind. By purging our schools of religion, they drive the unsatisfied minds of the young toward all sorts of substitute cults.

Between these two camps there are the many disturbed seekers. They maintain loyalty to one of the traditional confessions because they do not conceive of any other form of religion, but they are committed at the same time to the knowledge attained by our age and the methods and applications it entails. This conflict sentences them to living in two separate worlds. The world of established knowledge is chilled by being reduced to

217

the naked scientific facts, while their faith copes with assertions revealed as patently archaic unless they keep them separate from what is undoubtedly known.

This harmful split in our Western culture between scientific knowledge and religious faith dates back to the thirteenth century, that is, to the time when Aristotelian philosophy reached northern Europe through the writings of Averroës, the Spanish Arab Ibn-Rushd. To be sure, the question of how the worship of God relates to what is actually known about him is raised already by Augustine, but for him the problem remains confined within the religious practice itself. The threat to religious tradition arose only when scholastic philosophy, accustomed to supplying intellectual explanations for theological puzzles, was challenged by the teachings of the *scientia naturalis*, absorbed and propagated at the influential universities of Paris and Padua (Maywald, 1858). It was there that the strategy of Averroës, who was anxious to respect the authority of the Mohammedan creed but described it as a mere means toward attaining the ultimate truth of philosophy, was developed into the doctrine of the double truth.

Averroës thought of the imagery of religious teaching as a mere husk needed to make philosophical concepts accessible to the unsophisticated masses. The professors of France and Italy had recourse to this same doctrine of double truth as a protection against the accusation of heresy. With ecclesiastic inquisition in full command, it was safer to assert that the truth of the Bible was one thing, while that of science was another, rather than to declare that a belief in immortality, resurrection, and miracles was incompatible with what was known as philosophical truth. Averroës came to be celebrated as the great interpreter of Aristotelianism but was condemned nevertheless as a heretic; and as late as the Italian Renaissance the philosopher Pietro Pomponazzi "made a sharp distinction between philosophy and theology, between the truths to which natural reason led, and the image of the universe based on revelation" (Trinkaus, 1970, vol. 2, p. 550).

In our own time, the notion of the double truth retains, as I mentioned, a good deal of its power. It is no longer needed as a protection against being burned at the stake, although it can still save its adherents a lot of social trouble. It is also of help to thoughtful persons who readily accept the disclosures of modern science but have found no true substitute for the beliefs and rituals of traditional religion. A recently published anthology of statements by leading physicists on "physics and the transcendental" offers telling examples (Dürr, 1986).

In a conversation with his colleague Wolfgang Pauli, Werner Heisenberg referred to Max Planck's "neat separation" between the objective aspect of

reality presented by natural science and the subjective aspect reserved to religious faith. Heisenberg felt uneasy about this separation. "I doubt that human communities can put up in the long run with the sharp split between knowledge and faith" (Dürr, 1986, p. 296). Pauli concurred, but Planck, in a well-known 1937 lecture on religion and natural science, admitted to no such uneasiness. He defined religion as "man's conjunction with God" and maintained that the belief in a divine creator was supported by the scientific finding that the elementary building blocks of the universe are fitted together according to a unitary plan. "In other words, all events of nature are dominated by a universal lawfulness we can recognize to a certain extent" (Planck, 1969, pp. 318–333). A divine plan, geared to an intended goal, was acknowledged, according to Planck, by the physical principle of least action, which went beyond the *causa efficiens* to imply a *causa finalis*. And who but a wise creator could operate with a view to a desirable future state?

There were also attempts to avoid the conflict by assigning different tasks to science and religion. Thus, Albert Einstein states in a paper on natural science and religion that any contradiction is eliminated when one assumes that "natural science can only establish what is, not what ought to be," whereas "religion is concerned exclusively with the evaluation of human thinking and deeds. It is not entitled to discuss real facts and their interrelations" (quoted in Dürr, 1986, p. 75). Even so, however, Einstein asserts in another paper that ethical behavior needs no religious foundation. "Mankind would be in a sorry way if it had to be curbed by the fear of punishment and the hope of reward after death" (quoted in Dürr, 1986, p. 69). Others again tried to find space for the tenets of traditional religion within the framework of natural science. Heisenberg, in his conversation with Pauli, dismissed as a simple misunderstanding the suggestion that the principle of indeterminacy in atomic physics points to an opening for the free will of individuals and for divine intervention (Dürr, 1986, p. 305).

Is it not remarkable that the efforts to cope with the split between the facts verified by knowledge and the beliefs of traditional religion still persist, considering that the decisive step toward overcoming the precarious expedient of the double truth was taken already in the seventeenth century by Baruch Spinoza when he identified God with nature? By removing the supernatural from our worldview, he eliminated with a single stroke the subterranean faults that were tearing at the foundation of our culture. A universe governed entirely by pervasive eternal laws was to him the only worldview worthy of our admiration and worship.

Why did Spinoza cling nevertheless to the concept of God, to whom in fact he constantly refers in his writings? It does not seem that his fervent

declarations of the love of God were mere devices to protect him against the attacks of the ecclesiastic and civil authorities. Reading him, one gets the impression of a passionate emotional involvement not quite capable of putting up with the depersonalized image of the divine that his intellect presented so lucidly and consistently. He did strip God of all his traditional attributes. Spinoza's awesome conception of a lawful universe could not admit a supernatural power, placed outside the world as an additional agent and sharing the properties of the human mind. "God is devoid of the passions," he says in the *Ethics*, "nor is he affected by pleasure or pain" (book 5, prop. 17). Spinoza refuses to attribute to God the "activity of living (actum vivendi), of hearing, attention, or willing" (*Letters*, #60). To give him the will of personal decision would be to accuse him of an arbitrariness that would make him violate the rule of supreme necessity. But God is not subordinated to this supreme law; rather, the law itself emanates from God's nature. "I consider God the immanent cause of all things," he writes to his friend Oldenburg, "not a merely transient one" (*Letters*, #21). The laws of nature are not decreed by anybody, as are the laws of man.

Nor is human nature exempt of the supreme rule. Human will is fitted to cosmic necessity without losing its cherished freedom. In what might well be considered the Magna Carta of psychology as a science, Spinoza says at the beginning of *Ethics*, part 3:

> Most of those who have written about the affects and the human conduct of life have done so as though they were not dealing with natural things obeying the common laws of nature but with things outside of nature. They seem to conceive of man in nature as a kingdom within a kingdom. For they believe that man disturbs rather than follows the order of nature, that he has an absolute power in his actions and is determined from nowhere but himself. They therefore attribute the cause of human weakness and inconstancy not to the common power of nature but to who-knows-what vice of human nature, which they therefore bewail, deride, and contemn or, as is more generally the case, detest, and he who knows how to revile the weakness of the mind most eloquently and cunningly is looked upon as though he were divine.

Spinoza disposes—once for all, one should think—of a problem that keeps haunting our philosophers and psychologists up to the very present, namely, the supposed incompatibility of free will and determinism. He calls something free when it exists and acts solely out of the necessity of its own nature, whereas he calls it coerced (*coactum*) when its existence and operation are determined by something other (*ab alio*) in a certain and determined fashion (*Letters*, #62). That is, instead of taking pride in the

absurd conviction that the human mind is free only when it can make decisions out of the blue without any determining cause whatever, he points to the distinction that matters, namely, that between decisions caused by man's own rational needs and such outer powers as his irrational instincts and other impositions (Arnheim, 1985). A new dignity of the human mind derives from this revolutionary conception. The will is steered by the requirements of the mind's own nature in accordance with the laws of the cosmos of which it is a part—a conception quite similar to the Chinese philosophy of Taoism.

A unitary world that knows of no conflict between knowledge and belief exists for all early cultures. The point was well made by Wolfgang Pauli when he said in his conversation with Heisenberg, "At the time when the religions came about, the entire knowledge at the disposal of a given community fitted, of course, the spiritual framework, whose most important content were the values and ideas of a particular religion" (Dürr, 1986, p. 296).*

There is nevertheless a fundamental difference between those early worldviews and the cosmic philosophy as conceived by Spinoza. Whereas a philosophy based on the lawfulness of nature excludes all willfulness, the spontaneous anthropomorphism of the young mind does the opposite. It denies any purely physical causality. Willfulness is the universal agent. All things of nature are possessed and moved by demons, ghosts, or gods, whose personal whims run the world. Those invisible agents operate at the same level of concrete reality as do human beings. A vivid image of such an early intact worldview survives in the Greek polytheism of Homer—a scenery dominated by the wrongheadedness of lusty, jealous, and vulnerable gods, who are distinguished from humans only by being more powerful and who cohabit with the mortals on a common ground. Rather than being supernatural, these gods are, as H.D.F. Kitto calls them, sublimated kings (Kitto, 1951, p. 196).

The secular gods and demons have all but left us, but the unbroken universes they inhabited should make us envious. Cultures not yet affected by the double truth should serve us as a model for a worldview no longer hampered by that affliction. At our own level of thought, Spinozism provides the needed foundation; and, in fact, beginning with the eighteenth

*To be sure, when the supernatural is identified simply as everything that is uncanny, strange, and incomprehensible to human and beast rather than as the transcendental realm that causes an ontological discontinuity, it is quite plausible to state, "The supernatural is a primary and fundamental element in religion, for men spontaneously react to phenomena which they deem supernatural. Religious attitude, that is, emotional, ritualized, or rationalized response to the supernatural, characterizes all cultures and every stage of history" (Wallis, 1939, p. 1).

century a steady stream of philosophers and poets, from Lessing to Herder and Schleiermacher, to Coleridge and Georg Brandes, have confessed their indebtedness to the great pioneer (Kayser, 1946, pp. 316–321). Goethe, in particular, said in a letter to the philosopher Friedrich Heinrich Jacobi that Spinoza's notion of the *scientia intuitiva* as the highest form of cognition (*Ethics*, book 5, prop. 25) had encouraged him to dedicate his entire life to matters within his reach, of whose formal essence he could hope to fashion an adequate idea.

Even so, the question arises whether Spinoza's cosmic panorama really has a place for religion. Because he identifies God with nature, the constant references to the deity seem redundant and indeed confusing. Not only is his conception of the world complete without any of the components traditionally called religious; it would be obstructed by any of them. If such a worldview is accepted as congenial to our own needs, we must ask, What becomes of religion?

Suppose we try to establish an inventory of the world to the best of today's knowledge and without the traditional distinction between secular facts and religious facts. For such an approach, science is the authority, and the question of whether divine powers exist is of the same order and is subject to the same methods of inquiry as our curiosity about subatomic particles or extraterrestrial beings. The answer must be that there is no known place for gods in the physical world, whereas they are effectively present in the realm of the human imagination. Man's need to create gods in his own image and after his likeness was compellingly described by Freud (1927), and Spinoza had already speculated that "if a triangle could talk, it might say that God was eminently triangular, just as a circle would think of him as eminently circular" (*Letters*, #60)—an argument anticipated by Spinoza's Presocratic ancestor Xenophanes, who observed, "But if cattle and horses or lions had hands, or were able to draw with their hands and do the works that men can do, horses would draw the forms of the gods like horses and cattle like cattle" (Kirk & Raven, 1963, p. 169).

Even with the gods in their place as great images created by the human mind, that is, as images similar to those of Job or Odysseus or Hamlet, our conception of the world would still be incomplete. It would still be limited to an inventory of factual phenomena, both physical and mental. Sigmund Freud was reminded of this incompleteness by an unnamed friend, for whom he had great admiration and who told him in response to his book on the future of an illusion that he had failed to appreciate the true source of religiosity. The friend speaks "of a particular feeling that commonly never leaves him and that he believes to be familiar to millions of people since many have confirmed it to him—a feeling he would be inclined to call

the sensation of 'eternity,' a feeling like that of something endless, unlimited, 'oceanic' " (Freud, 1930).

Although Spinoza does not explicitly refer to this oceanic feeling, he lays great stress on the intellectual attitude from which such religious experience follows spontaneously and almost necessarily. If thinking is to be valid, it must comprehend everything particular in the context of the whole. This is the meaning of his assertion that it is in the nature of reason to perceive things sub specie aeternitatis (*Ethics*, book 2, prop. 44). For as soon as a sensitive person sees the narrow span of human life from the viewpoint of infinite time and the limited location of our species in the endlessness of space, he or she will experience a sense of humility as well as the pride and gratitude of someone recognizing himself or herself as a legitimate part of unfathomable greatness.

Not by accident, our wisest scientists are most keenly aware of religiosity as the spontaneous consequence of their insight into nature and the laws of the universe. In his beautiful paper on religion and science, Albert Einstein describes "cosmic religiosity" as follows:

> The individual feels the insignificance [*Nichtigkeit*] of human desires and goals and the sublimity and marvelous order revealed in nature as well as in the world of thought. Individual existence appears to him as a kind of imprisonment, and he wishes to experience the totality of being as something unitary and meaningful. The beginnings of this cosmic religiosity are found already at early stages of development, for example in some of the psalms of David and in several prophets.

This aspect of religiosity, says Einstein, is more strongly expressed in Buddhism and in such great heretics or saints as Democritus, St. Francis, and Spinoza (Dürr, 1986, p. 69).

Not only does religious experience spring from an intense scientific concern with nature; it can also be the strongest impulse for persons to devote their lives to the exploration of nature, as was certainly the case with the poet Goethe's lifelong dedication to the natural sciences. Science becomes a way of living up, by one's own conduct, to the highest state of awareness of which the human mind is capable; and as knowledge is, after all, only a means to an end, it seems sensible to assert that to be truly imbued with the power, order, and harmony of our world and that to behave accordingly are virtues equal to having attained the ultimate sense of human existence.

What has been said leaves us with the notion of religiosity as a subjective response to what is known objectively about the universe and life. Beyond this, however, the history of thousands of years tells us that religion, to be

effective, must take shape in rituals and must translate "oceanic feeling" into images. It expresses itself in dance, music, and architecture. Would this cultural harvest be lost if humans abandoned the axioms of organized religion?

Surprisingly, a look at the arts reminds us that they can only serve and have always served the kind of secular religiosity we are discussing. To be sure, they have told biblical stories most effectively, but they have never been able to sustain the ontological split of the double truth. There is no artistically convincing way of showing the supernatural in interaction with the sublunar world. (See "Art as Religion" in this book.) Think of Michelangelo's Sistine ceiling: even at the level of Neoplatonic sophistication, the Lord walks as a physical being in physical space to meet the mortals on common ground. At best, he floats or flies. In a pictorial universe, everything is equally real, while at the same time everything, be it the serpent or the tree or the cherub with the flaming sword, is equally limited to the realm of fiction, created by nobody but the human imagination.

More importantly, the most powerful artistic heralds of religion, music and architecture, cannot pronounce any of the concrete features that are the content of traditional religion. Music as music cannot describe ecclesiastic pageantry; rather, it translates the abstract powers and harmonies of which cosmic philosophy speaks. This was most clearly seen by the young Arthur Schopenhauer when he said that there could be music even if there existed no particular world at all because music is the "direct objectivation" of what he calls the Will, namely, the ultimate force moving the universe. The world, he says, might be called embodied music (Schopenhauer, part 3, sect. 52).

The same is true of architecture, which houses traditional rituals but can depict only what the theologian Paul Tillich used to call the ultimate reality. Permit me to quote here a personal experience I noted down during a visit to the cathedral of Barcelona.

> My mind was elevated and purified not by the presence of the divine figures to which the worshipers, kneeling here and there on the benches, appealed in prayer but by the visual sweep of the pilasters that moved me upward to where they fanned into the vaults at the high ceiling. My re-creation came from the clean consonance of all shapes, the absence of any entangling smallness, and the dark silence of it all. (Arnheim, 1989, p. 285)

One step further and we are reminded that even the narrative arts, whatever their subject matter—and here I am referring to the representational arts as well as literature—attain true validity only when they display the kind of transparency by which the perceivable appearances of our

world are revealed as metaphors for what can be experienced as the nature of our life. It is this transcendental quality that makes us call the landscapes of Rubens or van Gogh, the still lifes of Chardin or Cézanne great works of art; it makes us say that Faust and even Raskolnikov are individual figures seen sub specie aeternitatis.

I conclude that the entire treasure of artistic beauty that has helped people through the ages to transform the facts of myths and sacred chronicles into the experience of worshipful reverence is equally available to a religion based exclusively on what we perceive and know today. The microscopic image of an insect, the latest vista of astrophysics as well as the visions of poets and the harmonies of dance spontaneously generate that fulfillment of human experience without which knowledge remains nothing but knowledge.

What, then, distinguishes the arts from the religious attitude? It certainly seems that the more resolutely we try to go beyond the accidentals of those two basic responses to the human experience, the less evident becomes the difference between them. I said of religion that it begins where factual knowledge gives rise to awe and trust and praise, and the same is true for art. Both also lead from experience to modes of conduct, to the ethical demand of behaving in accordance with what is felt to be real and true. Perhaps the most one can say is that the arts are only one of the sources generating religion but that they have proved to be its most generally effective means.

REFERENCES

Arnheim, Rudolf. 1985. "The Struggle for Law and Freedom." *Michigan Quarterly Review* 24, pp. 169–175.

_____. 1989. *Parables of Sun Light*. Berkeley and Los Angeles: University of California Press.

Dürr, Hans-Peter. 1986. *Physik und Transzendenz*. Bern: Scherz.

Freud, Sigmund. 1927. *Die Zukunft einer Illusion*. Vienna: Intern. Psychoanal. Verlag.

_____. 1930. *Das Unbehagen in der Kultur*. Vienna: Intern. Psychoanal. Verlag.

Kayser, Rudolf. 1946. *Spinoza, Portrait of a Spiritual Hero*. Vienna: Phaedon.

Kirk, G. S., and J. E. Raven. 1963. *The Pre-Socratic Philosophers*. Cambridge: Cambridge University Press.

Kitto, H. D. F. 1951. *The Greeks*. Harmondsworth: Pelican.

Maywald, Max. 1858. *"Die Lehre von der zweifachen Wahrheit."* Ph.D. diss., University of Jena.

Planck, Max. 1969. *Vorträge und Erinnerungen*. Darmstadt: Wiss. Buchgesell-schaft.

Schopenhauer, Arthur. 1859. *Die Welt als Wille und Vorstellung*.

Trinkaus, Charles. 1970. *In Our Image and Likeness*. London: Constable.

Wallis, Wilson. 1939. *Religion in Primitive Society*. New York: Crofts.

ART AS RELIGION

W HAT IS MEANT by the term *religious art?* The most obvious answer is that it comprises works of painting, sculpture, and architecture that serve the purposes of some organized creed, such as providing portraits of divine figures, illustrating stories told in holy scriptures, or building temples and churches. If, however, we speak of "cosmic religion" in the more philosophical sense, we have to look for different criteria. Traditional subject matter or purpose may not necessarily meet the conditions for which we are looking, while works not referring to religion in any traditional sense may impress us as profoundly religious.

To arrive at an acceptable description of religious art, we must not only redefine religion; we must also be more careful about what we mean by "art." Traditional religious imagery tends to be figurative; it represents human beings, animals and trees, buildings and mountains, water and light. But not all pictures are art. They may report informatively about their subject matter but may fail to transcend these surface facts. Only when they penetrate to the depth of general meaning that qualifies images as art are they able to convey religious experience.

Art, in order to be art, imposes certain rules, some of which create problems for traditional religious imagery. One of these rules asserts that art cannot make a coherent statement unless it adheres to what may be called a unitary reality status. An encounter of the supernatural with the natural cannot be shown in the same image. As long as superhuman powers are represented as differing from terrestrial life only by degree, no problem obtains. The Homeric gods, for example, are stronger and more beautiful and are exempt from the laws of nature, but otherwise they

Derived from "Visual Aesthetics," in *The Encyclopedia of Religion,* edited by Mircea Eliade (New York: Macmillan, 1987).

interact with mortals at the same level. Therefore, their nature and activity pose no difficulty for the painter. The same is true for biblical story pictures. I have pointed out that even at a time when the philosophical conception of the supernatural was as sophisticated as it was during the Renaissance, painters represented the divine as a human figure, the supernatural as natural (see "Beyond the Double Truth" in this book).

Invisibility offers no obstacle as long as it is represented as a phenomenon of absence within the visible world, but if a supernatural power is to be shown as transcendental, that is, as belonging to a universe of discourse disconnected from that of nature, the artist has only one solution, that of a complete separation. To show the supernatural as something purely spiritual, an artist can shift the entire presentation to a level of abstract shapes; he can symbolize properties of the nonvisual by the formal expression of the visual. If, for example, the Pentecostal outpouring of the Holy Spirit were depicted by stylized flames descending on a group of equally abstract dark shapes, the visually coherent image could work as a symbolic representation of an entirely spiritual event. A painter would be unable, however, to show the interaction of a spiritual, immaterial power with a material happening. One example of this limitation can be seen in Marc Chagall's Bible illustrations. Of these, Meyer Schapiro observes that "Chagall feels awe before the divinity. How can he render God, who has forbidden all images? He has given the answer in the *Creation of Man.* God's name is inscribed here in Hebrew letters in a luminous circle in the dark sky" (Schapiro, 1978, p. 130). I am illustrating the same pictorial solution with another lithograph from Chagall's series, showing God revealing himself to Moses in the burning bush (Figure 41). In these examples, the qualitative difference between the immaterial and the material is indicated by the insertion of a diagrammatic sign, which, however, can be understood only intellectually. It does not express the nature of the divine visually. This inherent break in aesthetic expression is circumvented in certain images created in medieval Europe and the Far East, where heaven, earth, and underworld are represented as separate entities within a continuous picture. Interaction is thereby sacrificed, and the supernatural is concretized into a part of the natural.

Visual imagery does not readily accommodate a worldview that suffers from a scission between what is considered accepted knowledge, especially scientific knowledge, and what is merely believed on the basis of what was held true in the past. In a work of art, everything is equally true, and all truth is known by one and the same means of visual evidence. The angel of the Annunciation is as real as the Virgin, and when on a painting by Tintoretto Christ walks the waters of the Lake of Gennesaret, the walk is

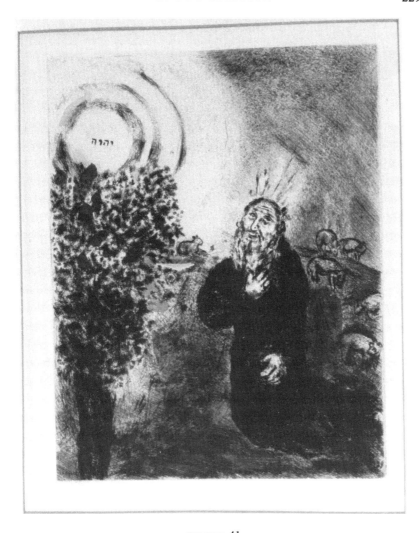

FIGURE 41.
Marc Chagall, The Burning Bush, 1893.
Haggerty Museum of Art, Marquette University, Milwaukee.

as real as the water and the boat. As far as aesthetic reality is concerned, no faith is needed where there is the certainty of sight. At the same time, however, no picture offers proof for the physical existence of anything it shows. A painted tree is no more real than a winged dragon. As a work of art, a painting or sculpture persuades only by the power of its visual presence. Thus, it can satisfy a viewer who accepts the story as literal truth and one who considers it purely symbolic, but it cannot do justice to a culture that wishes to express the cohabitation of both views. By its perceptual

nature, visual art favors a conception in which religious experience derives from the facts ascertained by knowledge.

Works of art, then, call for a unitary reality status of everything they show and refer to. That reality status, however, is not always the same. In traditional religious imagery, one can distinguish the following ontological levels.

First, the observer can accept the status of an icon that is worshipped, offered gifts and sacrifices, asked for help or intercession. Such an icon is clearly treated as a physically existent power residing in the world of the believer. At the same time, admission of an image to the world of the living is rarely the result of an illusion. Typically, believers are not deceived about the reality status of the icon's body. They know that they are in the presence of an object of wood, stone, or painted canvas. A naive psychology would see here a puzzling contradiction. Actually, this contradiction holds only for behavior in relation to the physical world. In perceptual experience, the visual expression of an image is very much of the same kind as that of a living being, and it is the dynamic power issuing from both to which perceivers tend to react.

Second, when an Egyptian sculptor does the portrait of Queen Nefertete or when Diego Velázquez depicts the surrender of the Dutch city of Breda to the Spanish conqueror, the artist is convinced that he is offering a likeness of someone who actually lives or lived or of something that actually took place. This conviction prevails regardless of how much or how little the artist knows about the actual appearance of his subject. Religious images can be intended as representations at the same level of truthfulness as historical documentation or scientific illustration; but there is no telling by mere inspection in which cases this is in fact the artist's attitude. Certainly, it would be a mistake to assume that in religious imagery the more realistic representations are necessarily the more "literally" intended ones and that, vice versa, the more stylized and abstract images are meant to be more remote from actual fact. An artist of the high Renaissance may have depicted the repentant Mary Magdalen very realistically for the purpose of sensuous enjoyment. He may have cared very little about the story he was telling, whereas certain early styles that to us look remote from nature may have been quite lifelike to their originators. They probably went with a deep belief in the truthfulness of their images.

Third, it is, however, in the nature of artistic perception that an image is seen not simply as an individual object, person, or happening but as the representative of a category of things, whose relevance goes beyond that of the individual. This symbolic quality of images is entirely compatible with the belief in their historical truth. When Dante Alighieri in his letter to

Can Grande della Scala explains that a biblical story such as that of the
departure of the children of Israel can be understood "in more senses than
one," he distinguishes the literal from the allegorical meanings. The in-
dividual story, revealed by its literal sense, may or may not be intended or
understood as historical truth. When such truth is excluded, the human
validity of the presentation may nevertheless be entirely preserved. We
enter the aesthetic category of fiction.

In fiction the historical truth of the subject matter is commonly con-
sidered irrelevant or even obstructive to the creative freedom of the artist.
In traditional religious art this raises the question of whether such an
attitude toward the subject matter is acceptable. One may ask whether an
artist who is not a believer can create a convincing image—if the term
believer is defined in the limited sense of someone convinced of the his-
torical truth of the depicted facts. A telling example of an enterprise that
had considerable religious and artistic success but also stirred up much
protest is that of the church of Notre Dame de Toute Grâce at Assy,
commissioned by the Dominican fathers in France during the early 1940s.
The story of that church, which William S. Rubin (1961) has described in
great detail, is complex. It involves the more general issue of popular
aversion to modern art but also the fact that prestigious painters and sculp-
tors, known to be atheists, communists, or religious Jews, were called on
to design such works as a mosaic for the façade, a tapestry for the apse,
and a crucifix. None of the artists testified to any particular difficulty with
the religious subject matter, nor did they feel that the task differed in
principle from the secular work to which they were accustomed. One is
justified in assuming, however, that the religious subject matter to which
the artists committed themselves, the Apocalypse, the Crucifixion, the
Virgin of the litany, and so forth, exerted on them the evocative power that
inheres in any great subject, whatever its origin. This underlying human
impact of the subjects on the artists may account for the more specifically
religious effectiveness of their contributions to the house of worship.

In a more general sense this raises the question of whether visual images
can ever be called religious when they lack the traditional subject matter
of any particular creed. One thinks immediately of representations of na-
ture as testifying to the existence and qualities of its creator. When Au-
gustine in his *Confessions* (book 10, sect. 6) inquires about the nature of
God, he reports:

> I asked the earth; and it answered, "I am not He"; and whatsoever are
> therein made the same confession. I asked the sea and the deeps, and the
> creeping things that lived, and they replied, "We are not thy God, seek

higher than we." I asked the breezy air, and the universal air with its in-
habitants answered, "Anaximenes was deceived, I am not God." I asked the
heavens, the sun, moon, and stars: "Neither," say they, "are we the God
whom thou seekest." And I answered unto all these things which stand about
the door of my flesh, "Ye have told me concerning my God, that ye are not
He; tell me something about Him." And with a loud voice they exclaimed,
"He has made us." My questioning was my observing of them; and their
beauty was their reply.

The things of nature give their answer to Augustine's question through
their "beauty" (species). When we view a painted landscape by Albrecht
Altdorfer or Poussin or Rubens, we note such qualities as power, inex-
haustible abundance, variety, order, and mystery. The greater the artist is,
the more compellingly does he present the objects of nature as carriers of
these virtues. What he cannot do, however, is to give them the voice by
which Augustine heard them answer, "He made us." A landscape cannot
do in a painting what it does in Augustine's verbal invocation.

Cause and effect can be shown in such a painting only as acting within
the realm of the forces of nature themselves, as, for instance, when in a
romantic landscape a cataract smashes boulders or when a blacksmith is
seen striking the glowing iron. To be sure, images can be used superbly to
illustrate the belief in a creator, as Augustine does with the sights of na-
ture, but the belief must be brought by the viewers to the images; it is not
pronounced by the images themselves.

In 1959, the Protestant theologian Paul Tillich was invited to give a
lecture on art and religion at the Museum of Modern Art in New York.
Significantly, he changed the title of his lecture to "Art and Ultimate
Reality," arguing that the quest for ultimate reality was an indispensable
aspect of religion and the aim of all true art. He proceeded to describe five
types of stylistic elements that he considered expressive of ultimate reality;
but actually his survey implied that any artistic attitude could meet the
criterion, provided the work attained the depth characteristic of aesthetic
excellence. In the discussion following his lecture, Tillich was willing to
conclude that "ultimate reality appears in what is usually called secular
paintings, and the difference of what is usually called religious painting is
real only insofar as so-called religious painting deals with the traditional
subject matters which have appeared in the different religious traditions"
(1960).

Even when such a thesis is accepted in a general way, certain kinds of
secular subject seem more congenial to common forms of religious attitude
than others. Thus, images of nature point more readily to supernatural
powers beyond the objects of physical appearance than do images of man-

made works. More generic views do better than more specific things or episodes. Stylized presentations transcend individual presence on the way to ultimate reality, and this makes a Byzantine mosaic look more religious than a naturalistic photograph.

The extreme case is that of nonfigurative art, where abstraction reaches a maximum. From the beginning, however, abstract art has been in a predicament: although it may claim, as the painter Piet Mondrian did, that it represents ultimate reality most directly, abstract art's relation to concrete experience may become so tenuous that it risks proclaiming everything and nothing. When, for example, in 1952 Fernand Léger decorated the side walls of the United Nations Assembly Hall in New York with large abstractions, the two gigantic tentacled clusters might well have conveyed a sense of consolidated forces; but this very generic meaning could have been channeled into a more specific application only with the help of the architectural setting and its known significance (Francia, 1983).

The limitation of nonfigurative imagery is enhanced when an absence of narrative subject matter is combined with an ascetic parsimony of form. The grids of the late work of Mondrian were threatened by a discrepancy between the range of what was intended and what was achieved (see "Sculpture—The Nature of a Medium" in this book). When the form is even more severely reduced while the suggested subject becomes more specific, we have the extreme case of the fourteen *Stations of the Cross* painted around 1960 by the American artist Barnett Newman. These paintings, limited essentially to one or two vertical stripes on a plain background, tend to transcend the boundary between the pictorial and the diagrammatic—a distinction of considerable relevance for the problems of religious imagery. A diagram is a visual symbol of an idea or set of facts; it often reflects some essential property of its subject. But although a diagram can evoke powerful emotions in the viewer—as when someone contemplates a chart depicting the increase of nuclear warheads—it does not create these experiences through its own formal expression; it merely conveys information. Something similar is true for traditional signs, such as the national flag, the cross, or the star of David. They, too, can release powerful responses, which are based on empirical association, not on visual expression inherent in the image.

The distinction between mere factual information, such as is given in scientific illustrations, and aesthetic perception points at the same time to one of two fundamental similarities between aesthetic and religious experience. To be religious implies more than to accept certain facts, such as the existence of God. The forces asserted to exist must reverberate in the believer's own mind so that when, for example, in the Book of Job the

Lord answers out of the whirlwind, the reader of the Bible is overcome by the greatness of the creation. This heightening of information into religious experience, however, is strongly aided by the poetry of the biblical language. It does not differ in principle from what distinguishes secular aesthetic experience from the mere conveyance of factual knowledge. One may learn all there is to know about Picasso's response to the Spanish Civil War in his painting *Guernica* and yet never experience the painting as a work of art unless the forces of suffering, brutality, resistance, and hope come alive in one's own consciousness. For this reason, the purpose of traditional religious art can be greatly enhanced when the images are of high artistic quality and thereby carry intense expression.

But is there really no difference between aesthetic experience and religious experience? Does not religiosity involve more than the mere contemplation of the world into which human beings are born? Does it not call for active worship of what we have come to admire and for a corresponding conduct of life demanding that we actively behave in a way that lives up to what we have experienced? In comparison, aesthetic contemplation may seem to be mere passive reception. Such a view of aesthetic behavior, however, is too narrow. First, the very fact of artistic creation is the artist's way of placing his most important behavior, his life's work, actively into the context of the world he experiences. The art historian Kurt Badt, recalling John Ruskin and Friedrich Nietzsche, has defined the activity of the artist as *Feiern durch Rühmung*, or "celebration through praise" (Badt, 1968). Such a definition does not turn art into religion, but it highlights the affinity of the two.

Second, no reception of a work of art is complete unless the viewer feels impelled to live up to the intensity, purity, and wisdom of outlook reflected in the work. This demand to emulate the nobility of the work of art by one's own attitude toward the world was strikingly noted by the poet Rainer Maria Rilke when he celebrated the beautiful forms of an archaic marble torso of Apollo. He followed his description abruptly with the admonition "Du musst dein Leben ändern" (You must change your life).

REFERENCES

Badt, Kurt. 1968. *Kunsttheoretische Versuche*. Cologne: Dumont Schauberg.
Francia, Peter de. 1983. *Fernand Léger*. New Haven, Conn.: Yale University Press.
Rilke, Rainer Maria. n.d. "Archaïscher Torso Apollos." In *Ausgewählte Gedichte*. Leipzig: Insel.

Rubin, William S. 1961. *Modern Sacred Art and the Church of Assy.* New York: Columbia University Press.

Schapiro, Meyer. 1978. *Modern Art: 19th and 20th Centuries.* New York: Braziller.

Tillich, Paul. 1960. "Art and Ultimate Reality." *Cross Currents* 10, pp. 1–14.

IN THE COMPANY
OF THE CENTURY

IF ONE HAS spent so many decades in the intimate company of the twentieth century, it is not inappropriate to ask what kind of bedfellows the two have been. It is not up to me to decide what help or obstacle I have been to my time, but the opposite question imposes itself whenever I look back at my own path—a path whose rises and descents, twists and vistas, were so largely determined by the formations of the landscape through which it led. It has made for the story of a person pushed around by the political upheavals of the 1920s and 1930s from country to country and thereby bestowed with a wealth of experience and opportunity that I, being sedentary by nature, would hardly have sought out on my own.

I was in time to see Emperor Wilhelm II lead his yearly parade on horseback, with his plumed helmet gleaming in the sun. The parade happened to pass the narrow street on which my father's office was located. It was a modest place. His elderly secretary wrote the bills for the customers by hand with a special ink that when moistened produced copies under a printing press. The dying years of the monarchy saw the clumsy beginnings of modern technology. Photocopying and word processors were undreamed-of achievements of the future, headphones were needed to listen to the radio, and the silent movies were accompanied on the piano. In some respects, it was an age of innocence.

Around us the world seemed still at peace. In hindsight, it has recently been asserted by some Zionists that the Jewish middle class in Germany deluded itself into believing that it genuinely belonged to its home country, while actually it had remained a foreign body. This is incorrect. To be sure, there were faults running below the unitary surface of the German

First published in *Cross Currents* 8 (1989), pp. 145–151.

population, as they do below every population, but this network of cracks had ceased to simply isolate the Jews. My own family, just like those of my Jewish and non-Jewish friends, had been detached from religious tradition for generations. Together we belonged to a liberal and educated layer of society, which distinguished itself most explicitly from a narrow-minded petite bourgeoisie, the future followers of Adolf Hitler. Equally distant but veiled by the halo of its Marxist mission was the proletariat. When the structure exploded and the country split into hostile camps, racial animosities found their place in the constellation of political passions.

I will add here that the lack of a religious upbringing threatened to interfere with the formation of the stock of significant images so indispensable for the functioning of a human mind. This need was particularly critical in my case because my entire mode of thinking, and hence the cast of my entire work, was based on images as the visual embodiments of reasoning. I managed to gather them from mythology and fairy tales and especially from the stories of Christianity to which my studies of Western art attached me so intimately. But just like the exploits of Jupiter and the evil deeds of Grimm's giants and witches, the holy figures of religion have served me mostly as metaphors to illustrate pure and extreme instances of human experience. Concepts such as omniscience, incarnation, transfiguration, or the Eucharist became indispensable to my persistent, though entirely secular, brooding about spirit, word, and matter.

To someone looking for an ideology to which to pledge allegiance, the Weimar Republic offered a wide-open field. The doctrines were many, but none looked perfect. The socialists had been caught unprepared for the task of taking over the reign of an abandoned empire; the communists frightened and bored us by the otherworldly intricacies of their internal squabbles; the militarists repelled us; the Abstractionist and Expressionist artists greatly attracted us in spite of their yet unconfirmed validity, and so did the writings of the psychoanalysts.

A profound sense of unreliability was the prevailing mood of the time. Its most ostensive symbol was the catastrophic inflation of 1923. During that year I spent part of my time helping my father at the small piano factory he owned. Every Friday, he and I had several suitcases filled at the bank with stacks of million mark bills to pay our workmen, who were forced to spend them the same day if they were not to lose half of their value. Years later, this sense of not being able to trust the foundations of our habitat was powerfully reinforced when, during the air raids in London, I saw buildings with entire walls torn off—buildings I knew had protected their tenants only the day before.

I did find the needed base of reassurance, however, in two areas of

study, namely, in my devotion to the arts and in the science of gestalt psychology. Great painting and sculpture as well as great architecture offered the perfection of harmony and order indispensable as a framework of reference by which to judge the precarious insufficiencies of the world surrounding me. Gestalt psychology was equally committed to the striving of organized forces toward a goal state of equilibrium, clarity, and simplicity. It also harbored an almost religious faith in the lawfulness of nature and the objectivity of facts, meanings, and values—an attitude that has kept me forever in opposition to the more fashionable relativistic trends of today's philosophy.

Gestalt psychology had its headquarters at the Psychological Institute of the University of Berlin. On two floors of the Imperial Palace, which had been abandoned by its occupant at the outbreak of the revolution in 1918, we conducted our experiments. The splendidly decorated rooms offered plenty of space for our apparatus, designed mostly to test problems of visual and auditory perception. Although those studies had quite specific topics, they were all intended to demonstrate one underlying phenomenon, namely, the gestalt character of organic processes. Biological, psychological, and sociological research had shown increasingly that one could not adequately represent the interaction of forces constituting a whole by adding up the whole's parts. This insight greatly complicated the scientific method, but it also let exact scholarship catch up with an intuitive awareness that had influenced Western thinking since the Romantics. And needless to say, it was indispensable for a more solidly founded psychology of the arts.

Structural problems of this kind accompanied my lifelong attempts to understand the nature of organic existence when it is at its undisturbed best—the purest realization of life processes, the peak experiences of the human mind, the greatest works of art. For this reason, my early concern with the new art forms of film and radio was basically a theoretical interest in two unexplored aesthetic and epistemological species. The silent film was an experiment in how to represent human experience through the limited medium of visual, mobile images. Conversely, radio plays explored the equally captivating possibility of depicting the world by mere sound and speech. Because of the theoretical nature of my interest, I was not deterred by the threat of extinction that faced these precious new media when the movies began to talk and radio broadcasting risked being obliterated by television. Fossils or not, it was the principles that concerned me in my first two books of theory.

Such, however, was the complexity of the stimuli that attracted a young man during the early decades of the century that the particular samples I

collected as specimens for my theoretical analysis also teased my critical sense by their individual weaknesses. Far from embodying the Platonic idea of the medium, film production was contaminated by commercialism, bad taste, and intellectual poverty. Thus, the premieres I attended week after week as a critic for magazines became my principal target for responding to the general sense of unreliability I mentioned above. I had received my doctorate in psychology, philosophy, and the history of art and music, but I interrupted my academic career for a time to try my hand at journalism and editorial work.

The founder of the weekly periodical *Die Weltbühne*, who had published a few first contributions of mine, had died, and when he was replaced by Carl von Ossietzky in 1928, I was hired to take charge of the cultural sections of the magazine under his direction. The politics were liberal, not committed to any party. Whereas the founder, Siegfried Jacobsohn, had been a theater critic who extended the range of the publication to a broad cultural and political sphere, the two personalities most influential after his death focused on political criticism and viewed the cultural scene from that center. Kurt Tucholsky, the principal contributor, was a brilliant polemicist. Born and brought up in Berlin, he embodied the satirical wit of the metropolis. A man of the pen rather than of practical action, he did his fighting from abroad. Carl von Ossietzky came from Hamburg, the more solidly rooted north of the country, a man of deep commitment who bore the responsibility for *Die Weltbühne's* entanglements with the military authorities of the republic and who refused to leave in 1933 when the Nazis came to power. Honored with the Nobel Peace Prize, he died after years of internment in a concentration camp.

I would call Carl von Ossietzky the only real hero I have ever known because his heroism did not emanate from vital exuberance but was a power of the spirit in spite of a personal frailty and shyness that were quite evident at first meeting. In personal contact a man of few words, he seemed reticent and almost inaccessible, a sensitive aristocrat with his eyes cast down and a cigarette in a slightly trembling hand. His editorials, written with a civilized refinement that brought to mind the French satirists of the Enlightenment, were pitilessly hard-hitting at the same time. There was never any doubt that he meant business.

Die Weltbühne had the limited distribution characteristic of such publications, and because it watched the issues of party politics as a mere observer, it could hope to influence events only in the general sense of upholding the values of humane decency, intelligent reasoning, and freedom. It was a critic rather than a worker in the vineyard of the republic, respected, adored by the young, and hated by the reactionaries. The Nazis

stopped our publication a few weeks after they took over. Some months later, not quite thirty years old, I left the country that had shaped my mind.

There was something almost immature about the German temperament and attitude as I looked back at it by contrast with my new companions in Italy. Here was a population marked from birth with the traces of two thousand years of struggle, deprivation, cunning, and the skeptical smile of those who have seen it all—a population, at the same time, still close enough to its agricultural past, to the peasant's wrestling with the sun, the rain, and the wind, to preserve the physical beauty and grace of the children of nature. From the windows of our suburban apartment we had the view of the Roman campagna, not yet invaded by the cement blocks of the expanding city. The white oxen with the lyre-shaped horns pulled their carts, the Alban hills undulated on the horizon, and at night the fireflies illuminated the trees along the country roads, while the nightingales sang.

The masses of Germany and Austria had greeted Hitler as their liberator. The Italian people coped with Fascism essentially as the latest tribulation in an unending chain of political troubles. I had taken a position at the International Institute for Educational Film, one of three League of Nations institutes located in Rome. Partly financed by the Italian government, we were a cosmopolitan island protected from the constraints of the Fascist regime but also beset with a few of Benito Mussolini's cronies, who had been given a sinecure in the Renaissance-style villa of the institute. There was hardly any contact between those curious pensioners and the hard-working editorial and research staff, and at no time were there any attempts by the institute's director to ask foreigners like myself for concessions to the ideology and practice of the regime.

The Italian film production was limited to what was acceptable politically, but we were able to screen a broader range of samples from the United States and the Soviet Union. The same was true for the official film school, where the students spent their years examining, with a monkish devotion and frame by frame, such works as Sergey Eisenstein's *Battleship Potemkin*. Those preparatory studies gave rise to the flourishing school of neorealistic cinema that emerged as though from nowhere immediately after the overthrow of the Fascists.

I cannot tell whether I would have chosen to spend the rest of my life in Italy if Mussolini had not adopted Hitler's racial laws in 1938. In the postwar years, such a choice would have made for a life of limited opportunity and influence, the life of a civilized foreigner surrounded by his books and inspired by the arts of the ages. The intensely intellectual provincialism of a Mediterranean setting limited to a minor, though magnif-

icently endowed language would have exerted its influence. In the long run, the switch from the spirit of the Romance language to that of English has been decisive for my work. Writing in English suggested to my thinking a concreteness that kept my theories from floating in the realm of rarefied abstraction. At the same time, a solid German background and a lifelong affection for French literature and philosophy made me immune to the gentlemanly disdain for systematic precision that tends to dilute some Anglo-Saxon reasoning.

In one of the Grimm fairy tales, the prince, freed from his transformation into a frog and traveling to his wedding, hears a repeated cracking noise, which makes him fear that the axles of the coach are breaking. What he hears is the breaking of the iron bands his faithful servant had forged around his heart to keep it from bursting while his master was in distress. I felt some such third band break from my heart when in 1940, after escaping from my native country, living as a stranger in Italy, and spending a first war year in England, I set foot on U.S. soil. It was, first of all, the end of exile. In a land of immigrants, one was not an alien but simply the latest arrival. Rather than be asked to abandon one's own heritage and to adapt to the mores of the new country, one was expected to possess a treasure of foreign skills and customs that would enrich the resources of American living. The foreign accent was a promise, and indeed, all over the country, European imports added spice to the sciences, the arts, and other areas. What one had to give was not considered inferior to what one received.

In still another sense a band was breaking as I entered American life. I remember that when watching American films during my last European years, I derived a sense of well-being from the loosened joints of American actors such as Gary Cooper, a freedom of daily behavior that suggested a relaxation of the mind quite different from the formality of social intercourse in the old country. In retrospect, the etiquette of the European hierarchy looked almost Asian. Introduced to a country where I could call the president of the college by his first name and the students expressed their respect for teachers without subservience, I experienced within myself a new spontaneity, an access to resources that had remained locked up.

In part, this feeling of liberation derived also from being moved to a new continent, to which I was not bound by the many conventions, commitments, and acquaintances that had me fettered in the old country like Gulliver when he wakes up with his limbs and hair tied to the ground. I was all but unaware of the history and conventions of my new homeland, and nobody seemed to mind my neglecting them. Friends were easily made, but they burdened me with few obligations. In fact, I could occupy

my place and fulfill my function while remaining untouched by 95 percent of the common culture; I have never had any contact with sports, popular music, television, or best-selling fiction, even though soon I began to consider myself as much of an American as the next person.

There would be much to tell about the forty years during which I was privileged to teach at different U.S. institutions; a small progressive college, a metropolitan adult education school, an exclusive Eastern private university, and a large Midwestern state university, each with its own opportunities and demands. Much also could be told about the innumerable institutions I visited as a lecturer. What mattered most was that I was able to return to an academic career, which meant that after a dozen years of journalism, criticism, and specialization, I now directed my work toward the broader problems of psychology in its relation to the arts.

My first major task was that of applying the experimental studies of visual perception to painting, sculpture, and architecture. I had to try making bridges, however tenuous their structure, between two human endeavors that had developed separately. Experimental psychology had grown since the 1880s into an exact science calling for quantification, objective proof, and the reduction of its targets to sets of surveyable variables. The arts dealt with complex creations whose particular nature could be approached only qualitatively, while much of the essential evidence was left to intuition. The gulf to be bridged had existed in the humanities ever since the difference between *Naturwissenschaften* and *Geisteswissenschaften* began to be faced, and the best one could hope to do professionally was to proceed on a necessarily one-way path without neglecting the stimulations and warnings coming from the opposite pole.

A related dichotomy existed psychologically between intellect and intuition, thought and perception. It had become evident to me that the labors of the artist involved all the capacities of the mind, including those of the intellect. Conversely, productive thinking was not merely intellectual but depended decisively on intuition. I was led to see that true reasoning, as distinguished from mere computation, necessarily relied on imagery because language, a purely referential medium, could not serve by itself as an arena for the handling of thought objects. This revelation placed me in opposition to the worship of language, considered the principal instrument of human cognition by philosophers and many social scientists. I was unhappy to be told that language preceded perception, although the opposite was so obviously the case. The controversy touched directly on my axiomatic faith in the validity of objective reality because perception offers itself to the mind as the carrier of the given world, while language is merely an artifact of the mind developed in response to that world.

One more task, to which much of my recent work has been devoted, needs to be mentioned. Although from the beginning I had been concerned with detailed investigations of the visual forms by which artists and other thinkers give substance to their inventions, I would never have done so had I not been convinced that all those forms existed not only for their own sake but for the purpose of conveying meaning. This led me to a theory of visual composition in which I attempted to describe the patterns conceived by painters, sculptors, architects, and dancers as revealing statements on the nature of human experience. The compositional schema I presented claimed to meet two conditions. It was universal enough to apply to the arts throughout the world regardless of place and time; and it deserved to be so universally applied because it symbolized a sufficiently basic psychological condition. Whether my discovery lives up to this ambitious claim remains to be seen.

All these various endeavors could have been undertaken only by a person sufficiently undisturbed by a century so mischievously inclined to do the opposite. When I think of the lives of so many of those who were exposed to similar circumstances, men and women persecuted, maimed, and frustrated, I am moved to a feeling of deep gratitude. I am indebted to innumerable persons who were ready to help when I needed them. As to the perils of our time's history, I am not sure whether they spared me because I kept my distance or whether they left me unimpaired just by oversight. If those historical forces steered me in the right directions, they hardly did so by good intention. The deeds and works they permitted me to do certainly show the attitude of remoteness that goes with a generality of thought. Whether the outcome justifies the privileges I have enjoyed is not for me to say.

INDEX

245

Compositor: Auto-Graphics, Inc.
Text: 10/13 Plantin
Display: Plantin
Printer: Malloy Lithographing, Inc.
Binder: John H. Dekker & Sons